Stereoscopic Perspective

Reflections on American Fine and Folk Art

Contemporary American Art Critics, No. 11

Donald Kuspit, Series Editor
Professor of Art History
State University of New York at Stony Brook

Other Titles in This Series

Stereoscopic Perspective
Reflections on American Fine and Folk Art

by
Michael D. Hall

U·M·I Research Press

Ann Arbor / London

Produced and distributed by
UMI Research Press
an imprint of
University Microfilms Inc.
Ann Arbor, Michigan 48106

Library of Congress Cataloging in Publication Data

Hall, Michael D.
 Stereoscopic perspective.

 (Contemporary American art critics ; no. 11)
 Includes bibliographies and index.
 1. Art, American. 2. Art, Modern—20th century—
United States. 3. Folk art—United States. I. Title.
II. Series.
N6512.H32 1988 709'.73 87-30050
ISBN 0-8357-1860-3 (alk. paper)

British Library CIP data is available.

For Bob Hall, Edgar Tolson and Peter Voulkos,
mentors on my möbius

The Author with His Sculpture *Sabbathday (A Theater of Resonance)*, 1979
Welded steel, painted, 20'8" × 25'8" × 10'10".
Warren Plaza, Detroit, Michigan.

Contents

Figures

x *Figures*

Foreword

This series offers a selection of the writings of master art critics. It does so on the basis of a proven track record. Lawrence Alloway, Joseph Masheck, Robert Pincus-Witten, Peter Selz, Dennis Adrian, Nicolas Calas, Peter Plagens, Dore Ashton, Arlene Raven, and Michael Hall are important not only for their sophisticated treatment of complex art, but for the independence of their point of view, and their self-consciousness about it. They have all thought deeply about the nature and practice of art criticism. Working often within the limiting format of journalistic articles, they have all managed to expand the conception of criticism beyond that of journalistic reporting. That may have been their model, but they transcend it through their intellectuality. One cannot help thinking of Oscar Wilde's sense of the anti-intellectualism that pervades the relationship to art, and that indeed is prevalent in society. These critics have forged a solid, nonideological, undogmatic intellectual criticism which shames conventional reporting of "newsworthy" art, promotional reporting of the artist stars of the moment. They offer us not hagiography, but analysis, functioning to sting us into consciousness. Even though they deal with the new, and can even be said to be obsessed with it, they never give in to sensationalism and parochial partisanship. They are passionate, but they also have the reserve and caution of reason. They reason hard to prove their points, rather than give in to opinion. They are the important critical minds of our day, and their work will last beyond it. Indeed, their conceptions have become the means by which art history assimilates the art they deal with, showing that art criticism at its best is the innovative cutting edge of art history. They show that art history can be a challenging intellectual adventure, as well as an account of documents and objects.

My prefaces were written without consultation with the critic in question. Each preface is my critical interpretation of his or her work, trying at once to give a conceptual overview of it as well as raise issues about

it, continuing the dialogue it began. The only way to be in good faith with criticism is to continue to be critical. For what is finally at stake in all this writing is the survival of the critical spirit.

Donald Kuspit
March 1987

Preface

Michael Hall is not just your usual artist/critic, criticizing other artists to make space for his own art, but an artist/collector/thinker. He is more like the early modernist artist/thinker than the late modernist artist/critic. That is, he thinks his way to his art and speculates about the meaning of art in general rather than simply creating a space for his art by clearing other artists out of their spaces. It is the difference between Wassily Kandinsky and Donald Judd—between an artist with a grand vision of art and an artist who makes a little art and thinks it grand because it holds a certain ground. It is the difference between an expansive and a narrow sense of art, between a sense of art as opening to and implicated in the lifeworld—extricating and symbolizing meanings buried in its dailiness—and a sense of art as a hermetic enterprise essentially perceptual in significance, that is, form but not symbolic form. (Indeed, Judd's work can be interpreted as an attempt to separate the formal and the symbolic—the so-called "literary"—and discard the latter as "non-aesthetic." This does more to inhibit and misguide the understanding of aesthetic form than rescue it from its own inherent symbolic character.) It is the difference between art as a psychosocially positive rather than negative process.

It is the part of Hall that collects folk art that interests me, because it is the major clue to his identity as a constructivist sculptor and a cultural interpreter of art. Hall's Constructivist sculpture is concerned in principle to articulate the communal—both to inhabit an already existing communal space, and to generate a fresh sense of communal space, sometimes utopian, sometimes ironical. Now folk art, whatever else it might be said to be, and for whatever other reasons it is worshipfully assimilated by fine artists—Georg Baselitz, Joseph Beuys, Kandinsky, Paul Gauguin, and Pablo Picasso are major cases in point—is emblematic of the communal, something the modern artist experiences as missing from his existence. It is emblematic of the yearning for the communal, more precisely, for the seamless connection between artist and society—for the lost sense

of art as grounded in and speaking for communal experience. Whatever folk art might mean formally, an implicit part of its "primitivism" is that it symbolizes this prelapserian, unalienated state of "instinctive" relationship between artist and society, and the artist's role as a special kind of spokesman for society, an acclaimed spokesman for what is deepest in it. In doing this—in suggesting to the modern high artist his special rootedness (if in mythical form) despite his feeling of rootlessness—folk art affords the artist a secure, even bedrock, sense of self.

It is the desire to achieve this sense of shared, "communal" self that I think is a major motivation for Hall's interest in folk art. And it is a measure of the desperateness of his desire that it must look for this sense of self in contemporary folk art. This desperation is not unique to Hall—one need only recall Paul Klee's famous remark that modern art lacks final force because it does not have the people behind it, that is, is not rooted in common experience—but his solution for it is. Hall has been justly celebrated as one of the first and most perceptive collectors of contemporary folk art as well as one of the important contemporary reinterpreters of traditional folk art as "adult," not simply naive, childish art. But what counts for me is that he turned to contemporary folk art not just because it was an unploughed, potentially very fertile field, or because recognition of its cultural seriousness was overdue, but because he regarded it as a major means of articulating and satisfying the need for a contemporary sense of community—rather than an archaic sense of community (at once insulating the artist from and defying modern society) as the early modernist artists did. It is important to realize that Hall teaches sculpture at Cranbrook, which is based on the notion of a community of artists dedicated to the (perhaps impossible) task of reconciling the traditional view of art as a service to the community with the modern sense of uncompromising artistic individuality.

What is also interesting is that Hall's sculpture has no folk look, as the work of the artists mentioned above can be said to have, in however transformed a way. This suggests that Hall's interest in folk art is really more of an ethical than an aesthetic matter. It ideologically rather than formally motivates his own art, reinforcing his interest in articulating a contemporary sense of community—one might almost say gives him the courage to pursue it as a real possibility, rather than resign himself to the fact that it will always remain a fantasy. For Hall, this sense of community seems the one thing seriously missing in modern high art, while folk art seems to come by its sense of community spontaneously or naturally, or at least without any difficulty. Constructivism, of course, presented itself as the authentically modern social art, partly by reason of its technological basis; but over the years its social authenticity seems

less significant, even questionable, for its authenticity does not imply or generate a sense of community identity—exactly what folk art offers. It leaves out what is perhaps most difficult to come by in modern society, and what, from a technocratic point of view, seems unnecessary. Hall would like the spirit of folk art to inform his Constructivist sculpture, giving it a new sense of purpose. It is, then, of symbolic, rather than literal, importance for his sculpture.

But as a person it is important for Hall literally, for it affords a greater sense of entry into the living culture he inhabits, and a more explicit sense of its effect on the self, than high art. This is Hall's unifying speculative theme: the sense—possibilities—of self afforded by American culture. Hall seems to suggest that folk art shows that there's still hope for American culture, as a place that is, in D. W. Winnicott's term, a "good-enough environment" for growing up and realizing oneself. While in his article on the Möbius strip Hall argues persuasively for folk art and high art as two sides of the same cultural coin, it is folk art rather than high art that seems to suggest a greater sense of realization of the self, for it seems more creative in itself, and suggests the creativity of the society at large rather than of a specialized group of creators called artists. This no doubt seems like a startling conclusion, but while Hall suggests that both folk and high art represent us as creative beings, my reading of him is that folk art finally makes more personal and creative sense to him than high art. This can be said simply on the basis of the attention he gives to folk art in contrast to high art. More importantly, for Hall, all art tends to the condition of "public art," as it were, in that it must hold its own in public space—a measure of its communal creativity, more precisely, of the artist's ability to "complete" his creativity by making it more than a private enterprise.

These essays are vigorously written, in defense of a cause. One of my favorites, "Marsh Trek: The Dilemma of Decoys," shows Hall at his best. Taking an object which, when not viewed functionally is commonly viewed sentimentally, Hall offers us a wealth of information about it while articulating its aesthetic-cultural significance. Towards the end of the essay Hall remarks, in what to me is the central issue of his work in general, that "The modern aesthetic demands that viewers employ both their sensory and their intellectual faculties in any confrontation with a work of art. Modernists, thus, insist that only by distancing decoys from the contexts in which they were made and used can the art of a carving be aesthetically confronted. Hunters, conversely, insist that the real appreciation of a decoy happens only at close range where context and object both come into sharp focus." The word "confrontation" suggests just how close Hall wants to come to official works of art and unofficial ones,

like decoys. It also shows how close he wants to come to the reader. His writing, while levelheaded and informative, has an argumentative undertone that is crucial to it, not just because it wants to make a case, but because art is always caught in the debate between distance and nearness. Is there any real possibility of reconciling these opposites, no doubt on a continuum?

Hall began his artistic life with the modern aesthetic, which he has become increasingly dissatisfied with. He is unhappy with the distance or detachment demanded by it—the contemplative separateness—which he thinks misses more than it comprehends. He wants nearness or intimacy, which he thinks is what art is about, as it were. How a work of art holds up near, in life, seems truer to what it means for the self than how it holds up at contemplative remove. For him, sensory and intellectual faculties are more alive, more engaged under conditions of nearness. Sight and insight are sharper. "Context" for Hall is clearly a metaphor for community, and the cultural object for the self. Both are more clearly in analytic focus when they are experienced through participation rather than abstractly. Hall, caught between the abstractness of his own Constructivist sculpture and the concreteness of folk art, has transposed their terms: through folk art, he has come to see high art as communally concrete, and through high art, he has come to see folk art as aesthetically and intellectually significant. Each has brought the other closer.

Donald Kuspit
August 1987

Acknowledgments

Some of the chapters in this book appeared originally in the publications listed below. For permission to reprint these articles in this collection, I wish to thank the following publications and institutions:

Chapter	Publication

1. *Arts Inquiry,* ed. Julian P. Riepe (Bellingham, Washington: Western Washington University, 1984).
3. *Power Passage (for Indianapolis),* ed. Carol Adney (Indianapolis, Indiana: The Herron School of Art Gallery, 1979).
4. *Detroit Focus Quarterly,* Vol. 5, no. 3, ed. Mary Ann Wilkinson (Detroit, Michigan: Detroit Focus, 1986).
7. *Folk Sculpture U.S.A.,* ed. Herbert W. Hemphill, Jr. (Brooklyn, New York: The Brooklyn Museum, 1976).
9. *Instruction Drawings: The Gilbert and Lila Silverman Collection,* ed. Roy Slade (Bloomfield Hills, Michigan: Cranbrook Academy of Art, 1981).
10. *American Folk Art: The Herbert Waide Hemphill, Jr. Collection,* ed. Gerald Nordland (Milwaukee, Wisconsin: Milwaukee Art Museum, 1981).
11. *The Clarion,* Spring/Summer 1987, Vol. 12, no. 2/3, ed. Didi Barrett (New York: The Museum of American Folk Art, 1987).
12. Printed by permission of the John Michael Kohler Arts Center, Sheboygan, Wisconsin, and excerpted from an upcoming book on Fred Smith's *Wisconsin Concrete Park.*
13. *The Decoy as Folk Sculpture,* ed. Ronald Swanson (Bloomfield Hills, Michigan: Cranbrook Academy of Art, 1986).
15. *The Clarion,* Winter 1986, Vol. 11, no. 1, ed. Didi Barrett (New York: The Museum of American Folk Art, 1986).
16. *The Ties That Bind: Folk Art in Contemporary American Culture,* ed. Dennis Barrie (Cincinnati, Ohio: The Contemporary Arts Center, 1986).

Numerous individuals should also be acknowledged for their contributions to this publication. For their considered comments in the Foreword and the Afterword, I thank Donald Kuspit and Eugene W. Metcalf. For their efforts in helping to edit various chapters of this volume, I thank Didi Barrett, Brad Collins, Estelle Friedman, Susan Waller, and Mimi Weinberg. For the assistance they provided in my research over the past years, I would like to acknowledge Kenneth Ames, Ellen Paul Denker, David Good, Julie Hall, Herbert W. Hemphill, Jr., Sharon McCarthy, Eugene W. Metcalf, J. Roderick Moore, Ronald Swanson, Robert Pincus-Witten, Robert Farris Thompson, and Mimi Weinberg. For their personal help and encouragement, I thank the following Cranbrook personnel: Judy Dyki, Diane Gunn, Lucille Harper, Margaret Hudson, Roy Slade, President of the Academy, and my nine faculty colleagues. Finally, for tireless assistance with the preparation of the many drafts of my manuscript, I extend special thanks to Roberta Stewart.

Part One

Across the Great Divide:
Art through the Stereoscope

American Sculpture on the Culture Möbius

This essay is a version of a text first presented as an illustrated lecture at Georgetown University, Washington, D.C. in 1983. Subsequently, the original text was refined and printed in its entirety in *Arts Inquiry,* an interdisciplinary arts journal published by Western Washington State University, Bellingham, Washington. Abridged and reprinted here, it introduces the central themes and arguments investigated throughout the rest of this volume.

* * *

My objective here is to provoke some thinking about the relationship between the art which has traditionally identified high culture and that which has generally been referred to as folk art. Initiating this discussion is not easy because the academic discipline of art history has primarily concerned itself with identifying and understanding the master artists and master art works of high-end culture. Once identified, these masters and masterpieces are set into a historic construct which is designated as the mainstream.

This concept promotes an elite and exclusive view of art which presumes that everything art-like found outside of the embrace of high culture is little more than a "knock off." Folk art is seen by many art historians as confused, or derivative and imitative of the mainstream. Others dismiss it entirely. Such thinking establishes folk art as either a parasitic nuisance or an irrelevant manufacture of things not worth locating in the spectrum of human creative activity.

As an artist I was trained in the mainstream. My sculpture derives from a historically clarified modernism running from Cubism and Constructivism to Minimalism and Conceptualism. As an advocate and collector of American folk art, I am endlessly beguiled and intrigued by art which originates and perpetuates itself at the grassroots level. I find myself increasingly persuaded to the reasonableness and to the curious brilliance of what curator Holger Cahill lauds as "the art of the common man"[1]—the

same art that art historian E. P. Richardson disparages as "fumbling efforts of no artistic interest."[2]

What interests me about folk art, however, is not the idiom itself but the way in which folk-made objects as art witness to the dynamic character of the thing we call culture. For me, it is the "connectedness" of culture, not the fragmentation of it, that is its greatest fascination. I sense that forces creating coherence and continuity in culture far outweigh those which create disjuncture and discontinuity. Thus, a multitude of social, historic and aesthetic factors all ultimately bind the folk and the fine artist together. My study of folk art has brought me to a recognition of culture in the aggregate as something which folk and fine artists in concert identify and interpret with the artistic signs they produce.

Mine is a concern with art as "things in the world" as much as it is with art as poetry and expression. Like others who have attempted to study art from both an aesthetic and an artifactual perspective, I find the need to demonstrate the dimensional nature of art in culture to be what George Kubler calls an "urgent requirement."[3] To reassess high and low art we need to visualize high- and low-end culture in conditions of interchange, rather than in conditions of opposition. At the same time, we need to be able to see individual artists and their work in comparative perspectives—but not necessarily those leading to conventional hierarchical gradings of things and their makers. A new and broadened survey of American art must ultimately describe the ways in which diverse art productions might reciprocate within a unified cultural context.

To demonstrate my propositions on the workings of art in culture, I find it useful to employ the common topological figure of the Möbius band as a schematic representation of culture as a historic continuum (see fig. 1). As a figure the Möbius band is a simple closed curve that has the peculiar characteristic of being continuous in two directions. Technically, it is a "one-sided surface formed by holding one end of a rectangle fixed, rotating the opposite end through 180 degrees and then applying it to the first end."[4] Many people know the band from a school demonstration in which some math teacher, taking an ordinary belt, twists it back onto itself and then asks students to explore the eccentric loop thus formed. Tracing a finger over the surface of this rudimentary Möbius band—wonder of wonders—the top becomes the bottom, the inside becomes the outside. Without removing the finger from the surface of the band, one's orientation to it is inverted.

If we envision culture as a very complex Möbius band, we can begin to formulate new understandings of folk *and* fine art. Configured in a Möbius, they twist together to form a unity. On the other hand, because a Möbius strip is formed from a plane which originally does have two

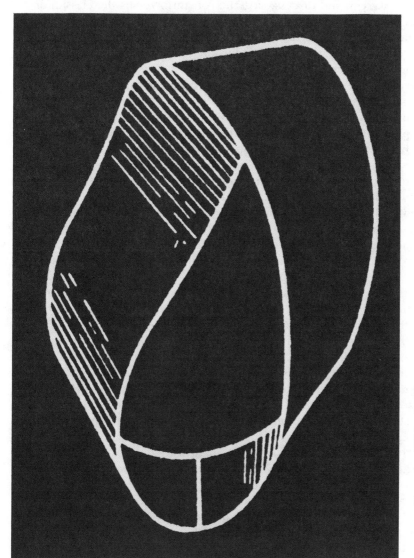

Figure 1. Möbius Band
A simple closed curve that is "one-sided" in the sense that any two points on its surface can be joined by a path that does not cross or touch its edges. The band was named for the nineteenth-century German mathematician, August F. Möbius, who first discovered it.

distinct and separate sides, a Möbius culture model can yet encompass many of our old texts—texts which differentiate things from one another in binary systems. Connecting the two ends of the conventional culture spectrum, we can still discuss, say, the romantic versus the classic, or the conceptual versus the intuitive. We can also contrast the self-taught artist and the academic artist. What is left behind, however, are certain prejudices—simplifications and exclusions implicit in the old two-dimensional high-end/low-end assumptions—factors that surely have skewed our understandings of the objects we have constituted as art and those that may still await such constitution.

A history is turning. Recently, certain writers and critics have begun to grapple with folk art's relationship to fine art. The new interest in folk art has prompted some interesting speculation on the ways in which art impulses transfer and transform themselves through the circuitry of what I recognize as the American culture Möbius. In 1975, Professor Daniel Robbins wrote about the peculiar isolation that seems to surround the study of folk art. He concludes that two factors account for this phenomenon and he identifies them as, "the continued attractiveness of the democratic notion that simple untutored folk can create work that rivals in value the self-conscious production of highly trained artists," and secondly, "the growing power of the idea that interested society can stamp its own artistic values upon almost any kind of object, that each man who approaches life as an artist will find art and will find it to the extent that he himself is creative."[5]

Robbins persuasively dismissed the idea that folk art is created in a vacuum. In so doing, he incurred the everlasting enmity of the folk art establishment. However, he opened the door to some serious study that would tie the high and the low ends of American art together. He even went so far as to suggest that the flow in American art might be demonstrated to have run uphill—from the bottom to the top in certain instances.

In 1981, critic Donald Kuspit also made a foray into the subject of folk art. He concluded that "folk art is not the higher expression of a lower folk, nor [is it] the lowest expression of high culture. Rather it is an original dialectical treatment of commonly held cultural goods—which is exactly what makes it art rather than some raw expressivity approximating to art, or some mock version of what is properly art."[6] Kuspit clings to some rather traditional elitist views of high art as an art somehow able to transcend certain of the limits he sees in folk art. However, he staunchly defends the great high modernist admiration for the basic cultural authenticity of the folk art object which he (like André Breton, Paul Gauguin and others) presumes to perpetually keep humanity in touch

with the childlike and the primal in our nature. Kuspit, like Robbins, marvels at the ability of culture to carry forward in time the images, myths, forms and symbols which it maintains as useful or meaningful to its collected purposes.

Obviously, as we begin to align and interconnect the art of the fine artist and that of his folk counterpart, it becomes apparent that the artistic sensibilities of creative people tend to be more alike than they are dissimilar. Sensibilities (like personality traits) can be identified and described. Individuals who become artists, at whatever end of the cultural spectrum, inherit their sensibilities from the same gene pool. It would be inane to suggest that any particular social, economic or ethnic group had an exclusive on any particular artistic or aesthetic sensibility.

The human propensity for order, for plastic clarity, for pattern and rigor, and even for so-called reductivity, is everywhere present in artistic endeavor. The stylistic modes in which this sensibility manifests itself vary widely, but as an artistic predilection, "orderliness" is expressed in the gridded patterns of Amish quilts as absolutely as it is in the geometric abstract paintings of Piet Mondrian. Likewise, an opposing disposition, one inclined to the obsessive, the compulsive and the additive, can be found in both high- and low-end art. Though high culture elitists sometimes view this disposition circumspectly (deeming it appropriate only to the art of visionaries, mystics and the mentally disturbed) it nonetheless conditions the mainstream art of Hieronymus Bosch and Albert Pinkham Ryder as surely as it does that of the "outsider" Simon Rodia, the builder of the *Watts Towers* [see fig. 48] in Los Angeles.

A trap now begins to form. It is easy—in fact engaging—to play a game in which one plucks two objects from art history and declares them to be equivalent (and even related) because they seem to express the same creative sensibility. American folk art has been particularly victimized in this game. Curators and collectors have endlessly identified what Jean Lipman calls "provocative parallels"—stylistic or compositional concerns that give a similar "look" or "feel" to works produced in the high-end mainstream and others from the folk milieu.[7] Presumably, the existence of these parallels confirms something about the universality of art, but this assumption seems rather naive today.

In the 1930s, this practice was employed to ratify the new high art which was generally rejected by the conservative majority of Americans viewing it. Picasso's drawings with their insistence on line and contour were compared to American silhouette weather vanes which also exhibited bold linear contours. Through this process, the radicality of Picasso's work was neutralized. His art was rendered non-threatening when it was equated with things made by simple whittlers and

blacksmiths. The same fate befell the art of other moderns. Who could hate a Matisse when, in its flatness and abstraction, it evoked the flinty primitive portraits rendered by itinerant New England limners? Reassessed, this line of argument blurs cultural perspectives and skews our understanding of deeper meanings in both modern and folk art.

Something more than the overlapping sensibilities of artists or coincidental stylistic affinities between art works must orchestrate art in its context of culture. To discover what this might be, we shift our inquiry to the social/informational nature of art. If art is a communication built on a visual framework, then an assertion or a statement that an artist might give form to would derive its meaning from the beliefs and perceptions common to the culture of which the artist is a part. Affirmations and assertions are the content of art. The colloquialisms and technical handlings which particularize a given work can be said to give it its style. Ideas and beliefs move through culture with great fluidity and are ultimately shared by the high and low end artists of any period. Thus, all artists create within, rather than outside of their culture. This fact virtually destroys the stereotype of the isolated artistic genius conjuring up forms and images from nothing. Art from idea—art from belief—art from art—yes! Art from thin air—no. The Möbius model, with its peculiar ability to render unity and disparity conterminous, clarifies the way art functions simultaneously as a receiver and a transmitter of culture.

A quick comparison of two quite different American *memento mori* dramatizes the convoluted and complex way in which ideas and images move in a cultural/artistic matrix. The theme of mortality and images intended to engender meditation on death fill the history of art. Two examples in particular draw our attention. From the high end, there is a 1891 bronze by Augustus Saint-Gaudens (see fig. 2). This untitled figure was commissioned by Henry Adams as a memorial to his wife, a suicide. Adams charged Saint-Gaudens to create a work symbolizing "the acceptance, intellectually, of the inevitable."[8] Eschewing the cliched model of the death angel typically produced by his beaux arts contemporaries, Saint-Gaudens formed a highly abstract work depicting only a gaunt seated woman wrapped in a heavy shroud. Speculation persists as to whether this work is a death angel, a mourner, or perhaps, as H. W. Janson has suggested, a *Melencolia* descended in some way from the works on this theme produced by Albrecht Dürer in the sixteenth century.[9] Saint-Gaudens never explained his riveting mysterious personage. His patron, Henry Adams (an intellectual with a particular penchant for oriental thought), perceived the memorial as a transcendent reflection on the hereafter. He had it erected in a grove of holly screens at the Rock Creek Cemetery in Washington, D.C., where it remains still, a disquieting reminder of the temporality of life.

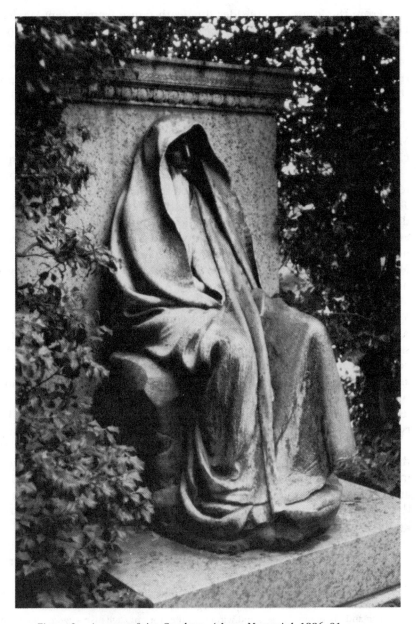

Figure 2. Augustus Saint-Gaudens, *Adams Memorial,* 1886–91
Bronze, 72".
Rock Creek Cemetery, Washington, D.C.
(Photo: George Gurney; courtesy the National Museum of
American Art, Smithsonian Institution, Washington, D.C.)

From the low end, consider the death figure from a New Mexican Penitente, *Death Cart,* contemporary with the Saint-Gaudens bronze (see fig. 3). The crude wooden *Death Cart* skeleton, wrapped in a coarse black monkish cowl, was paraded through the streets of Indian villages at Easter time by members of a secret sect of flagellants. The nocked arrow and the drawn bow poised in the hands of the skeleton are vernacular adaptations of the cutting scythe typically associated with earlier European death figures. Researchers on Penitente art have speculated that the New Mexican folk death image is very likely "patterned after the thirteenth card of the Tarot trumps which depict a skeleton or mummified corpse . . . [and that these cards in turn had] been inspired by Petrarch's fourteenth-century poem 'I Trionfi,' in which the Death Angel was female."[10] The Penitente sect did not worship death. Instead, they paraded their death angel image as a reminder to believers of the inevitability of death and of the life preparations which would create the state of grace necessary for entrance into heaven. Wrapped in her cowl, the carved New Mexican Doña Sebastiana (*La Muerte*) was as much a meditation as was her high-end bronze counterpart at the Adams Memorial.

No simple stylistic affinity links the Saint-Gaudens to the *Death Cart.* Yet, these works are connected. Their communicated content is related. As sculpture, they incorporate the same visual signs—shrouds, gaunt or skeletal visages, etc. Most importantly, both function as tools—nonverbal communication tools—created and used by two communities with associated needs for a sculptured *memento mori.* Issues of style aside, we can only marvel at the cultural connection between these two objects and attempt to identify other specific works that would bridge between them in a social and aesthetic history of great length and density.

Shifting focus from things to their makers, we find that artists themselves often can provide us with further insight into the broader meanings and histories locatable in art. The stereotype of the inarticulate artist is far from accurate. Barnett Newman, painter and high priest of the New York School, wrote the following about a series of paintings he did entitled *The Stations of the Cross.*

Lema Sabachthani—why? Why did you forsake me? Why forsake me? To what purpose? Why? . . .

The first pilgrims walked the Via Dolorosa to identify themselves with the original moment, not to reduce it to a pious legend; nor even to worship the story of one man and his agony, but to stand witness to the story of each man's agony; the agony that is single, constant, unrelenting, willed—world without end. . . .

I began these paintings eight years ago the way I begin all my paintings—by painting.

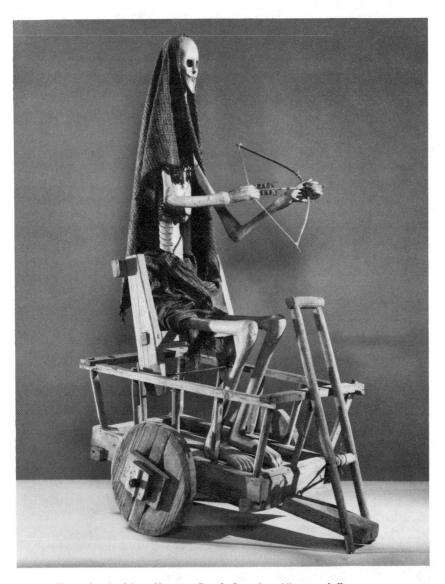

Figure 3. José Inez Herrera, *Death Cart,* Late Nineteenth Century
Gessoed and polychromed cottonwood root, pine,
metal, rawhide, horse and dog hair, 54½".
New Mexico.
(Courtesy the Denver Art Museum, Colorado)

It was while painting them that it came to me (I was on the fourth one) that I had something particular here. It was at that moment that the intensity that I felt the paintings had, made me think of them as the Stations of the Cross.[11]

Equally lucid and outspoken on the subject and source of his work, Samuel Perry Dinsmoor, self-taught sculptor, wrote this comment on the monumental concrete *Garden of Eden* which he constructed around his stone log cabin in Lucas, Kansas.

When Cain killed Abel the Lord got after him. Here is the eye and the hand looking and pointing towards Cain and wife on the next tree. These are the only things that I know of that we have to represent Deity. . . .

Do you know what the mark of Cain was? . . . [W]hen I was mixing mud putting up Cain here, I wanted the mark of Cain. I happened to look down in the Garden of Eden and think, there was the fall of man. The redemption of man is the crucifixion, so I imagined the mark of Cain, must be, a little red cross placed in his forehead; typical of the future crucifixion that was to come.[12]

Though the previous quotations differ greatly in style, they do have something important in common. They explicitly affirm that Dinsmoor, a folk artist, and Newman, a product of the academy, both understood themselves as centered in a continuous culture. In the search for meaning in art, issues of style have too often distracted us from seeing that art is primarily belief, idea and social value invested in plastic form.

Are there then really two arts in our culture? Yes and no. We will probably always differentiate the work of trained or academic artists from that of self-taught or non-academic artists. Art fused in a unifying concept (like the one illustrated by the Möbius model) does not lose its individual and plural character. It is just not easily aligned in linear hierarchical structures which suggest that vernacularisms challenge the literacy and hence the artistic worth of an object. In the final analysis, my culture Möbius suggests that all art is vernacular. On the other hand, studying and collecting, I have concluded that the only things that merit much esteem as art are those expressing literate content in a given vernacular.

Demonstrably, much of the new fascination with folk art grows from a popular belief that art from the low end offers a certain relief from the intellectual rigors of current high-end art. This is unfortunate. Folk art need not challenge modernism. Neither should it be manipulated to mystify an archetype of the untrained artist as the true and "pure" artist— the creator uncorrupted by society. The most appropriate thing, it seems to me, would be to simply let folk art take its rightful place among the several genres of creative gestures which human beings initiate to celebrate their existence.

Simply stated, an artist making something, in one way or another, is saying, "I am—here—now." For a community, this newly created affirmation functions in a system of signs reiterating the shared belief that everyone is someone existing somewhere in some time and place. Art at both the high end and the low end is cognition and context. Like ourselves, art remembers and forgets. Art is selective in its attention and in its inattention. Folk and fine art are both more interesting studied in tandem and from multiple perspectives. Viewed stereoscopically, art images become three-dimensional. In the culture Möbius, art derives its form and meaning from the understandings and experiences of its makers. Projected and focused, the images artists make express the concerns which intellectually, temperamentally and spiritually identify an age and locate a community of people on the seamless plane of history and culture.

Notes

1. Holger Cahill, *American Folk Sculpture* (Newark, New Jersey: The Newark Museum, 1931).

2. E. P. Richardson, *Painting in America* (New York: Thomas Y. Crowell Co., 1956), p. 8.

3. George Kubler, *The Shape of Time: Remarks on the History of Things* (New Haven: Yale University Press, 1962), p. 1. I feel that in describing the need for a better way to consider objects in a cultural history as an "urgent requirement," Kubler poetically addresses the major problem now facing art historians, folklorists and all those involved with what is broadly called material culture. From my perspective, this especially pertains to the study of art.

4. *Webster's Third New International Dictionary of the English Language* (Springfield, Massachusetts: G. & C. Merriam Company, 1971), p. 1450.

5. Daniel Robbins, "Folk Sculpture without Folk," in Herbert W. Hemphill, Jr., ed., *Folk Sculpture U.S.A.* (New York: The Brooklyn Museum, 1976), p. 14.

6. Donald Kuspit, "Suffer the Little Children to Come unto Me: Twentieth Century Folk Art," in Russell Bowman, ed., *American Folk Art: The Herbert W. Hemphill, Jr. Collection* (Milwaukee, Wisconsin: The Milwaukee Art Museum, 1981), p. 44.

7. Jean Lipman, *Provocative Parallels* (New York: Dutton Paperbacks, 1975).

8. Russell Lynes, *The Art-Makers of Nineteenth Century America* (New York: Atheneum, 1970), p. 339.

9. Robert Rosenblum and H. W. Janson, *19th-Century Art* (New York: Harry N. Abrams, Inc., 1984), p. 498.

10. Marta Weigle, *Brothers of Light, Brothers of Blood* (Albuquerque: University of New Mexico Press, 1976), p. 169.

11. E. A. Carmen, Jr., Elizabeth E. Rathbone and Thomas B. Hess, *American Art at Mid-Century: The Subjects of the Artist* (New Haven: Eastern Press, 1978), p. 211.

12. S. P. Dinsmoor, *The Cabin Home* (Lucas, Kansas: The Dinsmoor Estate, n.d.), p. 25.

Part Two

One-Point Perspective:
Contemporary Art/Context and Form

High Time for a Christening

Written in 1979, this essay was intended as an introduction to a book on site sculpture that was never completed. Revised and edited intermittently over the next few years, the piece was presented on several college and art school campuses as an illustrated lecture. It examines a specific contemporary art history from one artist's point of view—an artist directly involved with the studio dialogue from which a movement sprang. It is published here for the first time.

<p align="center">* * *</p>

Anyone following recent art has seen movements come and go with the seasons. Any flurry of creative activity unified by a focus on an issue of content or style or on some exploitation of media seems to qualify as a movement. Names for new movements proliferate at a bewildering rate and often seem concocted more in the interest of art marketing than in the interest of art. Certainly from the artist's point of view the notion that one's work can be neatly boxed in a movement frustrates, and even insults, the whole idea of creativity. Wayne Thiebaud and Jasper Johns both have publicly challenged whether there ever was such a thing as "Pop" art despite the fact that both of them first came to artistic prominence as card-carrying Pop artists. Don Judd similarly has expressed his discomfort over the assignation of his work to the "Minimal" movement. Peter Voulkos (a self-avowed Expressionist), when challenged about the validity of the inclusion of his work in a comprehensive retrospect of the "Funk" movement, simply shrugged his shoulders and retorted, "Hey, that's show biz."[1]

I find myself of two minds on the subject of movements and labels in art. On one hand, Voulkos seems to have told it the way it is. His quip serves as a critique of the political and economic machinations of the art world. On the other hand, his disarming disclaimer does not necessarily negate the writing and the thinking of the curators and critics who first recognized the genuine contributions of certain Bay Area artists whom

they distinguished with the Funk label. Voulkos (unfairly I think) seems to dismiss the critical condition which maintains vitality in an art scene needing to come to grips with new and evolving issues in art. Something legitimate and even necessary compels the intellectual community to follow the lead that artists so zealously command.

My best instincts tell me that in art, language, ideas and activity are inextricably tied. The task for everyone—artists and historians alike—is to keep these components in a responsible relationship. Activity should represent ideas. Language (beyond its role in the process of thinking) essentially should describe and interpret activities. By way of illustration, we would see that certain impulses (ideas) in New York at mid-century generated a production of paintings (activity) which was subsequently identified and described as the Abstract Expressionist movement (language). It would be hard to imagine discussing modern American art today without the term "Abstract Expressionist." Citing this, I suggest that by recognizing and identifying movements, we better orchestrate and illuminate our view of art, aesthetics and their history.

Thus armed (and armored) with a rationale, I would like to commence with the christening which is the subject of this essay—the christening of a highly unique and influential sculpture movement which spanned the decade of the seventies and yet somehow never found a name. From the onset, I should acknowledge that as an artist I feel somewhat awkward presuming to chronicle as a movement something which involves my own sculpture. Yet, my participation seems to give me a certain permission as a critic to build the arguments I want to set forward about the movement and the concerns of the sculptors who shaped it. In the end, I hope that the presumptive aspect of my undertaking will be offset by the clarification I can bring to a rather interesting piece of sculpture history.

The generation of sculptors who followed the earthworkers and the post-minimalists of the sixties faced the problem of reconstituting physical sculpture. To achieve this, two conditions had to be met. In the first place, the intellectual rigor which was the legacy of Conceptualism had to be somehow reintegrated into visual, dimensional forms. Secondly, to reassert itself, sculpture needed to evince new meanings—a new content derived from sources other than those of historic constructivist modernism or contemporary technology.

Thus, with a mandate but without a manifesto, a small group of sculptors across the country set themselves to this problem in the opening years of the 1970s. In New York the movement coalesced around the work of Alice Aycock, George Trakas, Mary Miss and Robert Stackhouse. In New England, Richard Fleishner almost simultaneously

began his related investigations. At the same time, in the Midwest, both Siah Armajani and I found ourselves involved with the production of works which, in their own way, addressed the issues being confronted by Trakas, Aycock, et al. in the East. By 1976, these artists, reinforced by a general awareness of each others' concerns, had established a newly realized dialectic in an essentially new form of sculpture. Initially, this work seemed to be only a part of the polyglot new wave art of the period. However, in retrospect, the coherence of this work as a discrete movement can be evidenced from a focused inspection of the projects and constructions built by these sculptors—projects and constructions which I feel now can be encompassingly cited as "suprastructions."

The word suprastruction consists of the prefix *supra* (meaning over or beyond) and the suffix *struction,* which is an amalgam of the words structure and construction. As Apollinaire appended the prefix *sur* to the word *réalisme* to describe an art concerned with a reality beyond empirical reality, I believe we can utilize the term suprastruction to describe specific works of structurally based sculpture addressed to aesthetic concerns over or beyond those found in either Cubist art or in the art of architecture. The Suprastructionists developed an essentially radical style of constructed sculpture which now needs an acknowledgment of its stylistic independence. Specifically, suprastructions need to be clearly differentiated from earthworks, fabricated neo-constructivist public art, and from various forms of post-modern architecture with which they have for too long been confused.

In formalist terms, the work examined here constitutes a mode of sculpture developed out of the traditional language of architecture. Early on, there was some effort to call these works "architectural sculpture." However, this term generated more confusion than clarification and has thankfully fallen out of usage. Nonetheless, the generic suprastruction invariably incorporates such elements as walls, decks, ramps, stairs, portals, etc., and, as a consequence, evokes some sense of the presence of architecture when one views or moves through it. The sculptors themselves seem very ready to acknowledge some relationship between architecture and their work. Armajani called his early works "bridges" and later produced projects he called "reading rooms." Miss built a series of "towers" and Aycock constructed a piece entitled *City,* while Fleishner built a number of works he refers to as "interiors." Again and again, we find this sculpture incorporating buttresses, joist systems and trusses— the very stuff of architecture. And to further emphasize the architectural character of their work, we find the artists demonstrating a decided preference for working in materials most common to the building trade— concrete, structural steel, rough-cut timber, stone block, corrugated siding

of several sorts and, of course, lath, plywood and wallboard. The scale of architecture and something of architecture's constructed structural essence is virtually a diagnostic characteristic of a suprastruction [see frontispiece]. However—and here is where the subject gets interesting—something persistently and recognizably "not architecture" is equally assertive in these works, serving to preserve their unique identity as sculpture.

Discussing an early draft of this essay with Robert Pincus-Witten in 1979, I found that I was not alone in my frustration over how to place the new sculpture in its right relationship to architecture—which is to say to both the history and the idea of architecture. In one of his characteristic flashes of insight, Pincus-Witten posited that there might be some specific model that could be found in the work of each of the artists we were discussing and that, if these models could be identified and correlated, they might reveal the common concerns of the art. Unfortunately, the rest of our conversation did not uncover satisfactory models with any clear parity.[2] It was only some time later, rethinking the problem, that I was able to set up a working reference of architectural-structural signs which reveal themselves in the work of the Suprastructionists. These signs principally indicate that something of place, space and the poetics of both (poetics long assumed to belong exclusively to architecture) might be restored to their historic role as conditions shared between sculpture and architecture. The Suprastructionists turned to architecture not to mine nuggets of style from a historic past but rather to revitalize the good faith of Constructivism. They sought to do this with a newly interpreted vocabulary of pictorial metaphor which could serve as a kind of visual acoustic system amplifying the resonance of their art as dialectic.

With this in mind, the signs which most inform and catalyze the work of each of the artists are probably worth enumerating. In Stackhouse, we sense a mix of mythical and primitive ritual structures: Northwest Coast Indian lodges, along with Viking ships and longhouses. Armajani, in contrast, pointedly refers his work to nineteenth-century American vernacular architecture: covered bridges, frontier cabins, Shaker meeting houses, etc. Fleishner's work touches to Aegean archeological sites, Roman villas, Etruscan tombs and Italian piazzas. Aycock alludes to early city complexes, medieval towns and the Egyptian City of the Dead. In Hall, we find direct reference to contemporary commercial and industrial structures: billboards, stadium bleachers and highway overpasses. Trakas's work persistently evokes a host of images peculiar to maritime culture: wharfs, docks, gantrys and causeways. Finally, in the sculpture of Mary Miss something of fortifications and stockades is evinced as we survey her

blockhouses, bunkers and watchtowers. We also sense in her work the layered labyrinthine prehistoric cliff dwellings in the American Southwest.

Suprastructions are neither a synthetic architecture nor a parody of architecture. The artists never considered these objectives to be fit concerns for their labors. The matter of their true intention may be clarified through a pictorial analogue which compares the architectural concerns of Trakas et al. to those of Nicolas Poussin (see fig. 4). Despite his use of architectural references (walls, gazebos, porticos and crumbled ruins) Poussin, in the end, does not give us any statement on architecture; he gives us painting. Perhaps this comparison goes further. Poussin's avowed Classical (tectonic) approach to art structuring, with its attendant fixation on Classical literature, myths, etc., readily predisposed him to incorporate compositionally "reliable" elements derived from architecture into his painting. In my interpretation, however, an equally important "Romantic" impulse compelled the painter to employ these elements as historic and allegorical sign systems triggering various recognitions in the minds of viewers confronting them. In a similar way, the architecture of Suprastructionism is less a content than it is a base of form and imagery uniquely suited to supporting the romantic pictorial-conceptual expression that became the Suprastructionist idiom. In the final analysis, Aycock's sculpture is no closer to the buildings of Robert Venturi or Aldo Rossi than Poussin's paintings were to the architecture of his contemporary, Francesco Borromini.

Late in the research, I reread an essay on Siah Armajani in which I found a most eloquent description of that sculptor's work (see fig. 5). I would like to quote this passage but preface doing so with the suggestion that the passage might just as easily describe Poussin's *Burial of Phocion*. Perhaps in the best way possible, this passage on Siah superimposed over the image of the Poussin painting historically ratifies the Suprastructionist tendency to incorporate architectural motifs into forms of art that are, nonetheless, emphatically not architecture.

> There is at once the personal and the objective, the objective and the functional, a present fact and historical reference, an individual determination and a social meaning. . . . Disparate things are side by side. Spaces shift. One moves from one part to another, sees elements of a familiar whole reinstated. There is a continual dichotomy between idea and object. The work is both self-contained and referential. It is complex, in a state of becoming, existing on many levels at once, not whole or singular.[3]

A second confusion which besets the understanding of Suprastructionism can be traced to the presumption that its trademark is its so-called "site-specific" character. In retrospect, this term seems relatively useless for describing anything except the most esoteric earthworks. Even here, "site

Figure 4. Nicolas Poussin, *Landscape with the Burial of Phocion*, 1648
Oil on canvas, 47 × 70½".
(The Louvre, Paris; photo courtesy Scala/Art Resource, New York City)

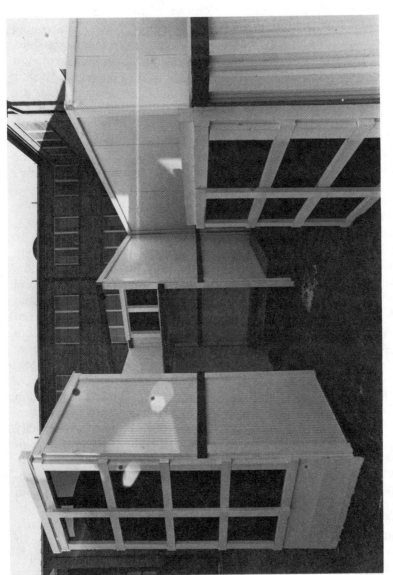

Figure 5. Siah Armajani, *School House #2*, 1979
Wood, metal, plexiglass, approx. 12 × 19 × 16'.
Installation Cranbrook Academy of Art, Bloomfield Hills, Michigan.
(Photo: Robert Zolman)

bound" might be a more accurate designation, as it would at least describe the condition of being of the *Spiral Jetty* or *Double Negative.*

Many Suprastructionist projects were implemented on site. However, the belief that a given project had no meaning outside of the environment where it originated, or that it would never have taken form without the inspirations afforded by the unique set of conditions found on its site, must be understood as more of a vanity for a project's sponsor than it would be a canon for a project's author. I feel that the popular site-specific assumption patently ignores the demonstrated fact that artists work primarily from ideas and images which they collect and carry around in their heads. It is from this stored repertoire that Suprastructionist sculpture originates. Though a sculptor might particularize some aspect of a design or an image in response to some special feature of a site, the completed work always conforms more to the dictates of the maker's imagination and will than to earth contours and topography.

This assertion will undoubtedly trouble those who need the site-specific myth and I hasten to acknowledge that of the Suprastructionists, at least one—Trakas—does hold a special reverence for sites (see fig. 6). Trakas thoroughly explores any site he is offered "with the recognition of certain attributes—geological, architectural and social—as germinators for constructions aimed at revealing the intrinsic power of a location and providing a structural accentuation of both the phenomenological and symbolic nature of the space."[4] However, in the end, I contend that even for Trakas, it is a concern with bridge and bridgeness that compels him to construct a metal or wood span across a site. Certainly it is this, more than the presumption that some impediment on the site must be bridged, that sets the sculptor to his task of bridge-building.

Looking further into the site sculpture question, I turn my attention to Stackhouse—the artist acknowledged to be the most mystical and arcadian of the Suprastructionists. In his work we also find that specificity of memory and experience, rather than of site, is the determinant shaping a sculptural production. One writer, discussing Stackhouse's early vaulted lath-covered tunnels, stressed that "these latticed entities are obdurately nonspecific" because, the author believes, they "result from an intense effort to objectify a synthesis of conscious and unconscious experiences."[5] The suprastructions which Stackhouse installed at Art Park, the Walker Art Center and at Cranbrook were all more similar, one to the other, than were the sites they occupied (see figs. 7, 8). This simple observation debunks the idea that site (per se) significantly shapes Suprastructionist work. Perhaps Aycock, writing notes in her studio far removed from the specifics of a work site, best expresses the perfected and ongoing character of a site sculptor's vision. Conjecturing on the subject of her 1976 project *The Beginnings of a Complex . . .* , she stated:

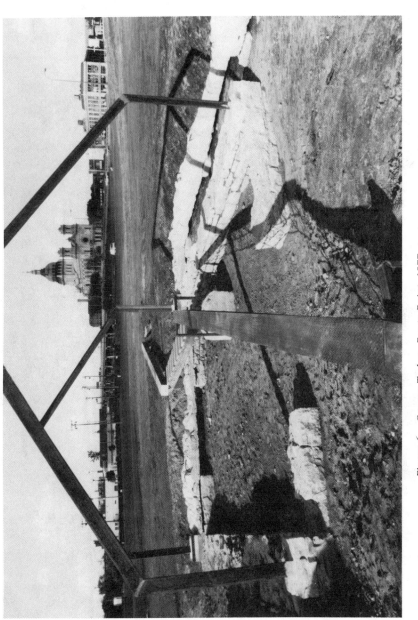

Figure 6. George Trakas, *Route Point*, 1977
Wood, steel, concrete, 10 × 32 × 160'.
Installation at the site of the Armory Gardens adjacent
to Walker Art Center, Minneapolis, Minnesota.

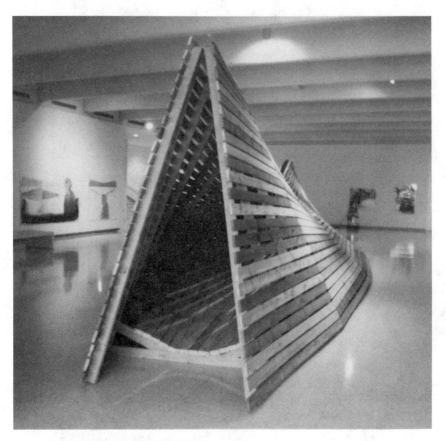

Figure 7. Robert Stackhouse, *Shiphall (A Passage Structure Borrowing Some Lines from the Oseberg Burial Ship)*, 1977
Wood, 10 × 78 × 16'.
Installation Walker Art Center, Minneapolis, Minnesota.

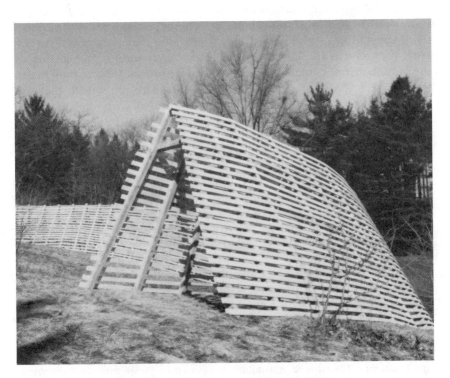

Figure 8. Robert Stackhouse, *A Dance at Cranbrook,* 1978
 Wood, approx. 10 × 124 × 57′.
 Installation Cranbrook Academy of Art, Bloomfield Hills, Michigan.
 (Photo: Robert Zolman)

It then seems possible to imagine a complex which exists in the world as a thing in itself, generating the conditions of its own becoming, and which exists apart from the world as a model for it, exposing the conditions of its own artifice. . . . [6]

Aycock declares imagination, not site, to be the primary shaping force in her work.

With this clarification, we are now free to reapproach the site sculpture issue in another way. We can examine suprastructions as open works of sculpture presumed by their makers from the onset to exist in some "right" relationship to their site. This expectation was the collective expectation of a group of artists believing that they could revoke what they saw as the hermetic (and increasingly indifferent) quality of the Minimal/Conceptual art that they found around them as they began their careers. To reopen sculpture's dialogue with the world, they addressed their work to explicit physical interfaces with sites and with viewers. At its best, this interface is both charged and poetic. A writer, describing his encounter with a Mary Miss project on the grounds of the Nassau County Art Museum, gives us a glimpse into the dynamics of this interface:

Once on the other side of the dense foliage, the viewer stands at the edge of a rolling, grassy slope, about halfway between a lower area to the left and a higher plateau on the right, both encircled almost entirely by the greenery wall. The Miss complex is multi-elemental—distinct parts interacting in, on and around the natural arena. [7]

It is precisely the open and transformational nature of suprastructions which was seminal to the new sculpture of the seventies.

An attempt to isolate the conditions which caused a particular generation of artists to seek to develop such an art at that time would occasion great sociological and psychological speculation. However, it is worth noting that all of the Suprastructionists were born within seven years of one another—the oldest, Armajani, was born in 1939, and the youngest, Aycock, was born in 1946. Predictably, I find that the most succinct and lyric encapsulation of the impulse that shaped Suprastructionism to have been penned by another artist in their generation, Ree Morton. For Morton, artistic equations were not interesting as simple formulas expressed in the first power only. Her complex understandings reduce only when the highest exponents of poetics and reason are simplified by the common denominator of experience. Working through her own aesthetic permutations, Morton left a notation that for me resolves the problem of sculpture, architecture and site:

Be
a place
do
a place
find
a place

PLACE
an image
bend
an image
delay
an image
forget
an image

imagine
a poem.[8]

Morton's lines tell us more when we note that all of her verbs are transitive. They take effect only when they have a direct object to complete their meaning. Each verb is specific and sequentially affects a place, an image and a poem. Morton's verse can be appropriated as a map of a suprastruction—a map that locates another salient aspect of new sculpture: its aspiration to theater.

Suprastructions exist as stages where viewers interact with a set of props encountered simultaneously as a place, an image and as poetics. It is important to note that all of the artists described here expected that their work would, one way or another, physically and mentally involve viewers more as actors than as spectators. Though no specific choreography was prescribed by the makers for this involvement, the sculptures were all created as real places to be confronted and investigated up close rather than as tableaus or dioramas to be viewed from a distance.

Again it is the artists who confirm this speculation. In 1979, George Trakas wrote, "Instead of making a tableau I want people who come across this [the sculpture] to have the urge to enter the piece in order to see it more fully."[9] One critic, addressing this note, observed that he (Trakas) "repeatedly used a vocabulary of paths, bridges and ponds as a way of punctuating existing geography so that an acute awareness of distance, contour, direction and time measured by bodily movement informs one's experience of space and place."[10] The author goes on to observe astutely that this expression of the interaction of time and space in Trakas evokes that which characterized formal gardens in the seventeenth and eighteenth centuries—formal gardens were specifically designed as spaces where viewers became actors in a landscape stage, orchestrated with topiary, water and parterres.[11]

The theatricality of Suprastructionism, however, should not be viewed as historicism brought to sculpture by a generation of reactionary eclectics. Rather, it is a considered response to what the artists saw as a failing of the more phenomenalist, factual art that dominated the late 1960s. It must be noted that the figure of Robert Morris can be found behind much of the argumentation that invested Suprastructionism with its concern for viewer involvement. As Edward Fry has written, "It was not until the end of the 1960s that Morris' work began to be understood and that he himself found means adequate to his longstanding intentions which, unlike those of such contemporaries as Judd, LeWitt and Andre, were not directed toward the cognitive phenomenology of elementary forms and structures but rather toward a subversion of such normative responses."[12]

Aycock, a student and friend of Morris, was aware of the implications of what Fry saw, and turned herself consciously to the production of works which have been described as being like "rough stage sets in which to act out a private theater of the absurd with their blind, narrowing passageways, stairs to the ceiling, and high, slender perches over empty spaces."[13] Aycock speaks of Hollywood stage sets, amusement parks and highway systems as paradigms for the uncertainty and ambiguity she seeks to articulate in her work—paradigms which will allow conventional forms from architecture to combine into structures which she describes as "a stage set for the world to enact itself on with all of the risks that acting in the world involves"[14] [see fig. 26].

The participatory character of a suprastruction presumes the active condition of a viewer. Sculpture aspiring to theater finds itself in need of players and a play. The role of the viewer/actor is significantly different than that of a viewer/contemplator. Roald Nasgaard discussed this distinction in an essay on structures and behavior:

> If we understand behavior not as passive perception and contemplation of an art object but as active, often physical interaction with and in the space of the art object, what is there about the structure of the work which elicits such behavior? What is the specific nature of the resultant experience? What is its meaning and its value? These are the essential questions to be asked of work which pursues formal and perceptual strategies in many ways antithetical to those of the earlier tradition of sculpture.[15]

Through their work, the Suprastructionists attempted to answer the questions Nasgaard was asking. They were motivated by the belief that viewer relationships in most other forms of sculpture were too restrictive, too unambiguous and one-way. They felt that the perception of sculpture was shackled by the assumption that aesthetic contemplation was a function of vision rather than the product of direct physical encounter. Nasgaard

saw the emergence of suprastructions and other behavioral sculpture as a sign that traditional expectations in sculpture were dissolving and that this dissolution went hand in hand "with the disintegration of 'a priori' and idealist cultural value systems."[16]

Suprastructions are intended to be used. Use here, however, extends beyond the tactile discovery use that Henry Moore stressed in his work and even beyond the cathartic usefulness afforded by the play swings so frequently incorporated by Mark di Suvero in his sculpture. The actor/viewer confronting a suprastruction must find a way to employ the sculpture as a bridge between a shared historic past and the personal experiential present. Discussing this, Julie Brown wrote, "Though certain things are given in the concept of space and time—up and down, near and far, before and after—the structure . . . through the participation of the viewer, activates these principles and makes them, in Armajani's words, 'open and available'."[17] Viewers are invited to use suprastructions as a means of questioning the disjunctions of experience and for recreating the psycho/social confrontations that actors have brought to the stage since the time of Sophocles (see fig. 9).

The achievements of the Suprastructionists are three. In the first place, the movement bequeathed a revitalized Romantic permission to the contemporary avant-garde. They insisted that "the work of art is not self-contained but depends on a larger context for its meaning. It stands in a furtherance of a cultural history, which itself does not exist in isolation."[18] Thus, in a mode that extended the neo-primitivism of earth art into the realms of legends, lessons and relational psychology, the new sculptors reintroduced the romance of metaphoric and pictorial content into American art. The formalist hegemony that had begotten Conceptualism and its several epistemological siblings was successfully challenged by the alternative aesthetic assertions of the Suprastructionists.

The new sculpture manifested its romantic permission in what Fry has called a "dialectical historicism." This tendency outcrops in the Suprastructionist celebration of both the materials and the making of sculpture. Their art was invariably work-intensive and was constructed from materials the artists esteemed as content-intensive. The sculptors, almost without exception, labored on their own projects, eschewing the depersonalized fabrications produced on contract by such shops as Lippincott, Inc. in Connecticut or Milgo Art Systems in Brooklyn. Trakas's solitary night vigils welding on-site are legendary and typify the mythic and symbolic links the Suprastructionists forged to bind their work to the romantic, heroic tradition of the Abstract Expressionists.

Politically, the Romantic disposition of the Suprastructionists aligned high art values with a work ethic stereotypically presumed to belong to

Figure 9. Mary Miss, *Field Rotation*, 1981
Wood, steel, concrete, 3.7-acre site.
Governors State University, University Park, Illinois.

tradesmen and craftsmen. The Suprastructionists were among the first serious artists to emerge from the college art programs which in the 1960s had undergone important changes, breaking down the separation of the crafts and the fine arts. As craftsmen traditionally mythologize and revere their media, so did the Suprastructionists. Stackhouse invested his mystical sense of nature in the wood he worked with; Fleishner achieved an arcane transformation of form with his use of hay bales, tufa stone, and sod. Armajani found a contemporary metaphor for his populist politics in the corrugated metal and fiberglass paneling he incorporated in his school houses and reading rooms. Materials (and the artists' handling of them) become content in the work. Discussing Armajani, Julie Brown spoke about the shared Suprastructionist romance with materials and making:

> The materials declare themselves, the method and process of building is obvious. The work is self-revealing. Understanding comes through the use of it and through the isolation of its elements, a re-examination of what they are and what they mean. The construction, or building, is both the object and the idea. . . . [19]

The second legacy of the movement was the new formal and intellectual complexity it initiated for contemporary art. The movement rejected the idea that either form or content in art need be holistic or self-referred. Instead, these things were expressed as fragmented and fragmentary. Suprastructions function most like a set of clues to be combined by viewers into sets of assumptions and presumptions. These responses in turn must be filtered through the viewer's memory, experience and bias, finally to align into active patterns of meaning. Some notes from Mary Miss's journals reveal her interest in multiplicity. Her language itself becomes part description, part implication:

> Putting several short sequences together, so that a total narrative comes thru. This avoids having to come up with a single construction/structure
>
> (As in changing stage sets) . . .
>
> Using camouflage—apparatus sort of like stage sets
>
> On its setting naturally into the environs
>
> Something slowly becoming apparent—blending in from a distance, at close range the artificial is very apparent
>
> Dispersion vs. grouping
>
> Orderly rows vs. random layout.[20]

All of the artists were involved with layering and sequencing their works. Fleishner, ostensibly the one most concerned with geometry and unity,

was equally involved with obscuring and hiding. His own photographs documenting his mazes and interiors rarely include figures. The empty photos communicate the solitude and mystery of the work. The confrontational essence of the experience of the sculpture is left open to the multi-leveled interpretations of viewers, even those studying them from photographs (see fig. 10).

Nowhere do we find greater layering than in Stackhouse, an artist preoccupied with symbolic imagery from many sources. His basic iconographic pantheon includes snakes, deer and ships, all of which fuse metaphorically in a manner penetratingly analyzed by Martin Friedman:

> These symbols are concerned with passages and metamorphoses: the snake by its movement above and below the earth, and its "rebirth" when it sheds its skin; the deer as a fleet-footed animal whose antlers are shed periodically; and the ship as a universal symbol of transition, not only in this world but as a burial vessel.[21]

The appetite for density and complexity which Stackhouse and the others brought to their work reshaped thinking in the field of sculpture. The issues of autobiography, narrative, regionalism, metaphor and political advocacy layered into so much sculpture today can be traced directly to permissions generated in the Suprastructionist decade.

The last (and perhaps most lasting) import of the movement was its curious revitalization and reification of the art of sculpture in the modernist tradition. The historic references evoked by the work and the craftsmanlike concerns acknowledged by the artists all seem at odds with modernist ideals. Yet, we need only reexamine history to find that the Suprastructionists may actually have spawned a late good faith of that most paradigmatic of modernist movements, Constructivism. For the early Constructivists, the challenge for art in the twentieth century was the challenge of co-existing with science. They believed co-existence was possible but felt that in a technological age art would always be in jeopardy. Naum Gabo was particularly clear on the problems of art and science and conceived of a balance that would put both art and science together but in very separate roles. The most famous passages from his 1937 essay entitled "The Constructive Idea in Art" are appropriate to a discussion of suprastructions and modernism:

> Science teaches, Art asserts; Science persuades, Art acts; . . . The force of Science lies in its authoritative reason. The force of Art lies in its immediate influence on human psychology and in its active contagiousness. Being a creation of Man it re-creates Man. . . . Art derives from the necessity to communicate and to announce. The stimulus of Science is the deficiency of our knowledge. The stimulus of Art is the abundance of our emotions and our latent desires. Science is the vehicle of facts—it is indifferent, or at best tolerant, to the ideas which lie behind facts. Art is the vehicle of ideas and

Figure 10. Richard Fleishner, *Tufa Maze*, 1973
Tufa stone, 4'6" × 15'4" × 17'.
Pocantico Hills, New York.
(Photo courtesy Richard Fleishner)

its attitude to facts is strictly partial. Science looks and observes, Art sees and foresees. Every great scientist has experienced a moment when the artist in him saved the scientist. "We are poets," said Pythagoras, and in the sense that a mathematician is a creator he was right.[22]

Thus, in the Constructive way, the primitivism, the theatricality, the site concerns and the ritualism in Suprastructionism were not rejections of science and technology. Rather they were signs that the artists were seeking a contemporary realignment of art and science that would give art a place where it could be itself. To a generation of sculptors coming of age in 1970, two decidedly anti-constructive forms of sculpture were evident in the art world. In the galleries, they confronted all manner of epistomological bombast that aped science in its pursuit of facts and pure measurables. In public plazas across the land, they saw an array of elephantine monuments being erected which seemed less sculpture than some form of technological necromancy. It was from all of this that the Suprastructionists turned away.

In recharting a course for sculpture, they turned not to historic revivalism but to a progressive reinvestigation of the generative spirit of Constructivism. Their work, as Gabo would have wished, was active, assertive and contagious. Its openness touched to the abundance of our emotions and experience. The historic references encoded in its forms were vehicles for ideas and its confrontational character gave it immediate touch to human psychology. As confrontational gestures, suprastructions confirm again that, as an art form, sculpture's essential uniqueness lies in its direct, rather than its empathic, relationship to its audience. Suprastructionism as a movement was an emphatic reassertion of humanism in the history of modern sculpture. Reaffirming and newly expressing humanist values in their art, the Suprastructionists wrote a small history and somewhere along the way they surely earned a name.

Notes

1. The comment cited was made by Voulkos when he spoke on a panel in April of 1967 at the University of California, Berkeley. The panel attended the opening of the exhibition "Funk" organized by Peter Selz at the University Art Museum.

2. Robert Pincus-Witten, "Entries: Cutting Edges," *Arts,* Vol. 53, no. 10, June 1979, p. 107.

3. Julie Brown, *Siah Armajani* (Yonkers, New York: The Hudson River Museum, 1981), p. 8.

4. Jessica Bradley,"Cap Trinité; Chronology of a Work in Progress," *George Trakas Montreal* (Montreal: The Montreal Museum of Fine Arts, 1979), p. 28.

5. Martin Friedman, "Robert Stackhouse," *Scale and Environment* (Minneapolis, Minnesota: The Walker Art Center, 1977), p. 26.

6. Alice Aycock, "An Essay," *Project Entitled "The Beginning of a Complex . . . ",* ed. Amy Baker (New York: Lapp Princess Press, Ltd., 1977), n.p.

7. R. J. Onorato, "Mary Miss," *Mary Miss Perimeters/Pavilions/Decoys* (Roslyn, New York: Nassau County Museum of Fine Arts, 1978), p. 5.

8. Mary Miss included this note by Morton in the catalogue for her 1978 exhibition, "Perimeters/Pavilions/Decoys."

9. From a conversation between Jessica Bradley and George Trakas in April 1979. The quotation is included in Bradley's essay in the Trakas catalogue printed by the Montreal Museum of Fine Arts in 1979.

10. Bradley, p. 23.

11. Edward F. Fry, "Beyond Phenomenalism," *Alice Aycock Projects and Proposals, 1971–1978* (Allentown, Pennsylvania: Muhlenberg College Center for the Arts, 1979), n.p.

12. April Kingsley, "Six Women at Work in the Landscape," *Arts,* April 1978, p. 108.

13. Aycock, "An Essay," n.p.

14. Roald Nasgaard, "Introduction," *Structures for Behavior* (Toronto: Art Gallery of Ontario, 1978), p. 11.

15. Ibid.

16. Brown, p. 3.

17. Ibid., p. 5.

18. Lucy R. Lippard, "Complexes: Architectural Sculpture in Nature," *Art in America,* Jan.–Feb. 1979, p. 88.

19. Brown, p. 7.

20. Onorato, pp. 7–8.

21. Friedman, p. 26.

22. Naum Gabo, "The Constructive Idea in Art (1937)," *Modern Artists on Art,* ed. Robert L. Herbert (Englewood Cliffs, New Jersey: Prentice-Hall, Inc., 1964), p. 112.

3

An Interview in Indianapolis:
Dennis Oppenheim and a Construction
Entitled *Power Passage*

In June 1979, Dennis Oppenheim was in Indianapolis constructing a work entitled *Power Passage*. At the same time, Michael Hall was also in Indianapolis on a lecture assignment. Carol Adney, Curator of the Herron School Art Gallery, asked Hall to tape-record some of his impressions of the Oppenheim project and its place in contemporary art. The resulting interview was transcribed and became part of the catalogue published at the conclusion of Oppenheim's workshop at the Herron School. It is reprinted here in its entirety.

* * *

Carol Adney What are your views on the importance of executing an Oppenheim sculpture in Indianapolis?

Michael Hall A major experimental work is being constructed in a city not generally regarded as a major art center. Artists are more mobile today than ever. Their dependence on galleries in, say, New York or Los Angeles has diminished greatly. Oppenheim is part of a new breed. He has come to Indianapolis because he was offered an opportunity to do something here and he has responded to that opportunity. I feel that it is a measure of strength that our art is becoming decentralized. It's important that major works by major artists are being developed, debuted and permanently sited in all regions of our country (see fig. 11).

CA What do you think are the values of a workshop situation for the participants and the artist?

MH There are several. I've seen workshops like this before. Each one's different of course, but they all benefit art and artists in the same general

Figure 11. Dennis Oppenheim, *Power Passage (for Indianapolis)*, 1979
Steel, plywood, electric motor, 14 × 52 × 11'.
Installation Herron School of Art Gallery, Indianapolis, Indiana.
(Photo courtesy Herron School of Art Gallery)

ways. Two come to my mind. First, a project like this generates a par-
tisanship for itself as it is being built. When local artists, art students and
professional fabricators participate in the construction of a work they
initiate a support for the work in the community. Obviously, this sup-
port is good for the initial project but in successive waves it moves out
to spark interest in other regional art activities.

Secondly (and I speak to this from personal experience), when one
builds a piece as Dennis is doing here, an artist has a rare opportunity
to tangibly realize an idea or an image in a condensed moment of total
creative activity. In their studios, artists expect to do everything
themselves. For sculptors especially, the art-making process is long and
laborious. This time-condition is both good and bad. The slow pace of
studio work is sometimes a luxury because it allows you to be very inef-
ficient. It allows you to change your mind and to be very critical, ad-
justing a piece a half an inch here or half an inch there. It also allows
you to distract yourself with all sorts of decision-making traumas which
often totally frustrate the ends of art.

Dennis, working here with 25 other people, doesn't have that lux-
ury and is not allowed that self-indulgence. The piece is going to be con-
structed in four days. He has made the sketches, he's got a model here
and is in the gallery orchestrating an activity that's moving forward at
a very accelerated pace. Viewed in simple man-hours of work, the project
is rather amazing. If 25 helpers are putting in 9 to 10 hours a day (and
that would be minimum), the project is demanding 250 man-hours a day.
Over a four-day schedule, the fabrication of *Power Passage* will have en-
tailed one thousand man-hours to complete. The same piece undertaken
by Dennis alone in some studio would require months to finish.

In a workshop, everything is condensed. An idea generates, material
is brought together, physical and mental energy are focused on the prob-
lem of the making, and presto! an image literally springs into existence
overnight. At that point, the creator can stand back and appraise the merits
of his or her ideas. Projects like this afford a totally unique opportunity
for artists to measure the real value of their concepts and inspirations.
Considerations of craftsmanship and detailing diminish. The idea emerges
first and foremost. The object or the product then stands principally as
a testimony to the strength or weakness of the vision and the commit-
ment which brought it into being.

I tend to like art that has that very up-front stance about it. I've said
before, "Win big—lose big." Dennis is living with that here and seems
to like it. He is an artist well suited to the pace of a workshop. Speaking
with him earlier today, I found him to be very excited about what he's
doing. He feels strongly about the piece and the way it is going. He's

waiting to see it completed with no real assurance that he is going to "win" in any conventional sense.

When we were talking, he alluded to the win-lose situation as he sees it. He said, "Listen—I live with 10 percent." He's acknowledging the "waste" factor in the art equation. He is realistically looking for only about 10 percent of what he does to really expand what he knows or to provide the broadened spiritual satisfaction he seeks. His "10 percent" statement is wonderful—it is filled with the kind of assertiveness and realism that grows from a pragmatic understanding of the art-making process. He goes after that 10 percent in everything he does and to get it he has to see things built—physically realized. So here in this four-day workshop he's getting his next grab at the ring.

CA There are definite benefits for the artist in a workshop situation. However, what do you think about the resultant piece? There is an inherent strength in the structure and obviously a great sense of power relayed through the blades. What else do you find with *Power Passage (for Indianapolis)?*

MH It is a complicated piece, and a very challenging piece. Like much of Dennis's new work, it's complex and layered and full of ideas and suggestions of meaning. Let me illustrate. Even as we refer to "the piece" we are actually talking about something which exists in three aspects: (1) there's the model, the rough cardboard thing, here in front of us which must really be viewed as a sketch; (2) the construction in the other room which Dennis is working on now. It measures some 50 feet in length and does grow from this sketch—but, in actuality is another form of model leading to the third aspect; (3) a large outdoor earth work and construction which Dennis sees as still another state of the *Power Passage* idea.

Examining the model and the larger construction in the gallery, I find that there is a thread of narrative which connects the various shapes and forms in the sculpture. The narrative builds upward and outward from a few basic strokes or marks which originate in Dennis's drawings. If you look closely at many of the things Dennis has done, generally you will be able to find an underlying "mark." Not a gesture (in the Expressionist sense) but some specific mark which locates the work the way connected points locate positions on a map.

This piece begins with the mark which Dennis calls the "lightning bolt"—the sort of cartoon lightning flash described by the configuration of the ramps in plan. I was speaking with Dennis earlier and he told me that the zigzag formed by the ramps substitutes for a landscape excavation he would like to cut into the earth in a larger-scale execution of this

piece. The zigzag ramps link the three main structures we see in an elevation of the piece—the chimney shape at one end, the pair of fan blades in the middle and the corridor-hallway at the other end. I told Dennis earlier that it would be nice if there were a mezzanine level in the gallery where a person could view *Power Passage* from above and thereby better perceive it in plan. He agreed but pointed out that even if the lightning-bolt mark were excavated rather than built up, it would only be part of the work and would not be intended to dominate a viewer's attention.

CA How do you see the whole piece as a narrative? What story is the artist telling?

MH Oppenheim does not feel that it is necessary to serve everything up to his audience as courses of appetizers and entrees. The piece is, nonetheless, narrative in character and goes beyond simple story telling. The narrative is an open one. The ambiguities in this work are very purposeful and restrained. The narrative I see is enmeshed in the structure.

Let's examine the corridor element in this piece. It's an architectural reference where a viewer's participation—entry—is solicited. Simultaneously, the narrowness of the corridor discourages the very entry that it seemingly welcomes. Walking up the corridor, one confronts a pair of huge whirling metal blades. Passage (both real and empathic) is now physically barred by the rotation of the ominous motorized blades. I find a very explicit element of danger here as I often have in other of Dennis's works. In my perception, the blades are intimidating. Yet I know that for others they might just as easily evoke the pleasant, benign feelings associated with old-time fans turning overhead in a country store. Here, however, I think that the wind from the blades and the roar they make as they turn force us to perceive them as an authentic hazard. They signal their own potential for violence and destruction and bar our passage through the corridor. As threatening signs, they are part of the information in this piece and part of the metaphor and narrative we are expected to discover as we explore the sculpture.

At the far end of the structure we find a most enigmatic element, the so-called chimney or furnace (see fig. 12). I associate that form with devices we use for altering the state of matter, for burning and destroying. Dennis talks about the chimney as a mechanism capable of producing smoke signals. Smoke signals, again, have multiple interpretations. They can communicate friendly messages of welcome or they can warn of danger and signal for an attack. The Plains Indians used such signals in many ways during the settlement of our West. The sequencing of images in the piece and our sequential discovery and interpretation of them

Figure 12. Dennis Oppenheim, *Power Passage (for
Indianapolis),* 1979
Steel, plywood, electric motor, 14 × 52 × 11′.
Installation Herron School of Art Gallery,
Indianapolis, Indiana.
(Photo courtesy Herron School of Art Gallery)

form what I perceive as the narrative here. *Power Passage* is something which, though formally specific, nevertheless remains open to each viewer's personal investigation.

CA How do you see Oppenheim's new work historically? He certainly can no longer be labeled a Conceptualist.

MH It might be easiest to describe Oppenheim as a latter-day Surrealist but even this label would be incorrect. The Surrealists sought to create pictures incorporating dream images and fantasies from the subconscious. The writings of André Breton, which had so much impact on the early Surrealists, explicitly envisioned the formulation of a new art which would juxtapose multiple pictorial images in irrational ways. The ideal Surrealist work (in Breton's vision) would be opaque and obscure but still compelling, precisely because it could not be "read" as a narrative or as any sort of a metaphor.

I don't think that Dennis is a Surrealist. Some of his concerns certainly have drawn on Dadaist and Surrealist sources. But another side of what he is doing now is corporeal and real in a way that Surrealist work never was. He isn't obsessed with illusions and "false realities." His work is physical and the images placed in it are real images. His forms are structured in relationships of meaning even if the full explanation of these meanings is not mapped out in simple visual or metaphoric terms.

This interpretation of *Power Passage* would be supported by the fact that Dennis hasn't used any tape-recorded sound in conjunction with this installation. Many of his other pieces for the last few years have had sound tracks—sort of "voice-overs" which complicated a reading of their form. I was talking to him about this and asked him why the Indianapolis piece didn't incorporate a tape. He said that, in his last few pieces, the sound tracks had gotten shorter and shorter—in a sense had become so condensed or perhaps so cryptic that they finally were no longer necessary. So he deleted them entirely here. I don't miss the tape at all. What has replaced it is a narration which is more of my own making—information I generate as I confront the piece. Yet I don't believe for one second that Dennis has left the script for that narration entirely open to my option. He builds the elements; I supply responses to them. He attempts to construct works from a vocabulary of imagery strong enough to channel our perceptual experience through some specific associations as we confront his construction. This piece is enigmatic. It is startling and illusive but in no way could it be called totally abstract. Yet I do not see it as coy. It's real sculpture and it doesn't play with its audience. It is not a maze or some kind of an intellectual obstacle course. *Power Passage* is best

interpreted as an artistic investigation in which Oppenheim explores possibilities in metaphorical-narrative sculpture.

Power Passage can be discovered (image-wise and form-wise) through a process of simple inspection. It is built at architectural scale. It can be appreciated artistically as an expression of a new aesthetic balanced between the structural and the pictorial. Oppenheim seems to want his work to be multi-leveled. He makes a "loaded" art. It is layered—intentionally so—and richer for it. It is not sparse or minimal but on the other hand it is not overly complex and elusive. The controlled richness of Oppenheim's particular sensibility makes his new work singular. I am watching a serious piece going up here today and I see an artist working to realize new ideas. Before the week is out I hope Dennis has found another part of the "10 percent plus" that he is always chasing after.

Weights and Measures: Public Art

Most of this article was read at a 1983 symposium on public art held in conjunction with the exhibition "Controversial Public Art: From Rodin to di Suvero" at the Milwaukee Art Museum. The symposium text was revised and expanded after the 1985 New York hearing on Richard Serra's *Tilted Arc* where Hall made a public statement on behalf of the *Arc*. The substance of that statement was incorporated into this essay. An edited version appeared in *Detroit Focus Quarterly* in 1986. The essay is printed here in its complete form.

* * *

America has been in the public art business in a big way for almost two decades. Sites have been specified, commissions have been awarded, money has been raised and spent. Controversy rages. Rhetoric about a renaissance abounds but the boom seems to be going bust. The United States may yet create a contemporary public art but to do so it will have to reconcile some of its contradictory assumptions about "public" and "art." Public in America is people—millions of them—brought up on the work ethic and Jeffersonian concepts of egalitarianism. Art in America is cult—arcane mysteries—practiced by misfits and understood only by aristocrats and the power elite. Layered with the confusions generated by this contradiction, the picture of American public art in the eighties is more than a little muddy.[1]

The story of public art is either a Cinderella adventure or a nightmare, depending on who is telling it. The gentle, socially concerned artists in the generation now over the age of fifty tell the stories I like to hear best. Theirs is often a recollection of an installation in some city park where troops of wide-eyed children from surrounding neighborhoods suddenly appear onsite to share a communication with a creator and a work. The classic version of this parable involved Tony Rosenthal and the steel cube he installed in Astor Place for the 1967 New York exhibition, "Sculpture in Environment."[2] As the story goes, the sculpture so ingratiated itself

with the community that when it came time to remove it, a ground swell of protest erupted. The neighborhood mounted a drive to purchase the piece. Quickly the artist, his dealer and the city joined in a friendly discount deal which allowed the work to stay at Astor Place. In Cinderella 1967, a popular spirit crying out for uplift found it in a work of contemporary public art. In 1985, the city occasionally scrapes off the handbills and posters irreverently pasted on the piece and, from time to time, repaints it. Despite this unfortunate postscript, the story of the cube that found a home in the heart of a neighborhood has become a legend recalled each time the faithful gather in the cause of public art.

Forty and fractious, the post-minimalists tell another tale. Theirs is a tale of woe. They recount quarrels with civic arts boards, duels with architects and rip-offs by dealers cutting themselves in on commissions—broken promises, broken contracts. The story from this side often involves Richard Serra racing from city to city in a storm of controversy. Architects emerge in Serra scenarios as meddling fools and worse. Collectors are cast either as predacious speculators or simpering groupies. The whole production ends with derelicts and graffitists ringing down the curtain on a play in which they are, at best, only bit players and extras. It is historically interesting to note that the St. Louis Serra saga involved a newspaper poll which pitted the city's 1940 Carl Milles fountain against Serra's *Twain* also sited on the Gateway Mall. The public balloted heavily for the Milles. A short civic memory forgets the brouhaha that broiled over the Milles fountain when it was installed less than fifty years ago. In their time, Milles's nudes precipitated their own outrage in St. Louis.[3]

Yet another story is told by the community art boosters who sponsor public art projects. Theirs is a view which regards each new public art project as a public birthing—midwived by the entire community. They always recount the "fantastic" support marshalled from local businesses, manufacturers and trade unions in the service of "Art the Fair." The heroes in this story are the cognoscenti who tilt against the forces of lethargy, ignorance and bad taste. These Galahads ultimately enlighten the superstitious peasants of the village who learn to love the monster of the plaza. In tribute, they emblazon its image on everything from the mayor's letterhead stationery to the side panels of the city's sanitation trucks [4] (see fig. 13).

Politicians, too, have their own fable—that of public art and the government. Properly canted, this tale sounds like a contrapuntal rendition of the Lord's Prayer. "Give us this day our daily bread" is answered, "for lo, we are increasing the council's budget this very session." From the other side of the floor the chorus intones "forgive us our debts as we forgive our debtors" and hears "yea, though we walk in the shadow

Figure 13. Logo: *La Grande Vitesse* (after Alexander Calder Stabile, 1969) City Sanitation Department, Grand Rapids, Michigan. *(Photo courtesy Paul Wittenbraker)*

of deficit spending we shall fear no one-percent program.'' Certainly legislators and "artocrats" are the power (if not the glory) forever. Amen.

All of this indicates that there is much expectation, identity and need built into any recipe for public art. In this recipe, oil and water will mix, but something very basic to the art problem almost guarantees that the blend will be far from homogenized. One of the least soluble ingredients here is the popular stereotype of the artist as the last true individual in society. This fiction can work against a public acceptance of something an artist makes. Sensing the presence of the maker in a painting or a piece of sculpture, some viewers find themselves feeling antagonistic toward the art object. Steeped in the lore of the artist/bohemian, they become resentful of the licence (self-indulgence) they believe an artist has usurped in the making of the thing before them. These individuals often find the art experience to be confrontational on a very personal level.

Inside a museum, this confrontation elicits little more than snide comments and guffaws from visitors discomforted by an encounter with an unfamiliar work of art. Frequently, however, more serious reactions are provoked when a new work of art is introduced out-of-doors in a public space. To become "socialized," the piece becomes answerable to a social system with rules and norms established to maintain a social equilibrium. The work of public art in contemporary America is at odds with itself from the onset. To achieve its highest purpose as art, it must demonstrate its uniqueness and its individuality without apology or compromise— yet it must also submit to the coercion of an audience which comes to it with an egalitarian community expectation. A work of public art in America is going to be probed, prodded, hassled, interrogated and in every way assaulted until the public is satisfied that its presence does not jeopardize the group good. In this process, the work seriously risks losing its identity as art.

The history of modern painting and sculpture has not been written in public. The breakthroughs and advances in these disciplines, like those in fields of science, have taken place in laboratories where theory becomes practice. Modern art, like modern medicine, is laboratory tested before it is popularly distributed. My reaction to much public art is that it is usually the "over-the-counter version" of something which has a great deal more potency in its prescription form. Art investigations, like scientific ones, incur prodigious waste. In science, hundreds of researchers perform the experiments which lead to a breakthrough. A practical public can appreciate trial and error in science—especially when a vaccine resulting from lengthy experimentation eradicates a disease. But a hundred sculptors fashioning a thousand figures to net one Balzac monument? The public is not ready to confront an artistic masterwork as the end product

of directed and concentrated research—especially when so much of the waste by-product of this research is made public.

The artist Robert Smithson despaired that pure artistic inquiry could ever lead to any popular usefulness. In 1972 he said, "Once the work of art is totally neutralized, ineffective, abstracted, safe and politically lobotomized, it is ready to be consumed by society."[5] Neutralized? Made safe? The language indicates that Smithson saw public art as little more than diluted ideas neatly standardized in candy shells. Yet, there must be some place where art of an experimental nature can meet a public on an even footing. There is—and Smithson constructed his *Partially Buried Woodshed* on just such a middle ground—a university campus [see fig. 22].

Lately, colleges and universities have provided homes for some of the most radical and innovative sculpture being produced. If art is investigative and if educational institutions are really involved with teaching and learning, we should *expect* the most controversial and provocative works of new art to debut on campuses. A university should expose its students to new ideas in art in the same way it exposes them to new concepts in the social sciences and in mathematics. Bridging between the laboratory and the world, the university has the opportunity to sponsor art projects answerable not to public expectations but to the tenet that there is value in inquiry for its own sake. The ambitious installations at Governors State University in Illinois, Wright State University in Ohio and at Western Washington University (to cite a few) probably would never have survived as corporate or civic commissions.

Examining another layer of our subject, we discover that much of the historic controversy over public art projects has always involved disputes over what (in the broadest sense) is real estate. Business and political interests buy, sell and commodify popular sentiment. Politicians vie for space in the voter mind and businesses compete for visibility in any number of marketplaces. Public art is often caught in the middle of campaign tugs-of-war or cross-currents of entrepreneurial scheming.

No one becomes very upset when bulldozers come in and level a few vacant shanties on the outskirts of town to prepare the way for a new shopping mall. On the other hand, no developer would expect to level a suburban residential neighborhood for the same mall. So, too, with art. Ten miles out of town, on the back forty of someone's farm, a sculptor can erect almost any type of structure conceivable. But in a city center, it is not so easy. Competition in the urban ecology forces every new life form to fight for its survival. Downtown, the physical presence and intellectual novelty of an art work guarantee that it will be challenged for its place. The demographic complexity of our urban centers guarantees confrontations for new works of art introduced there. No turf is easily surrendered in an arena of heavy political and economic activity.

If this is so, what accounts for the public apathy toward art works introduced into mall and office environments? Ironically, this work has sparked almost no comment from the art world or from the public. Mall art goes up without incident. The same citizen who would be loudly protesting the allocation of his tax dollar for a civic sculpture commission meekly acquiesces to the presence of the monumental baubles littering his local shopping center. He is oblivious to the fact that he has borne a double cost for this art. The consumer's first cost is incurred when a mall owner depreciates the purchase of an art work from his tax responsibility as a capital improvement. The cost of this savings transfers to the public in taxes. Yet a second cost is incurred when a merchant, renting frontage in an art-enhanced mall, quietly passes on to customers the "preferred space premium" in his rent through the price of the goods he sells them.

Beyond my assumption that indifferent art elicits indifference, I think that mall art is not resisted because merchants, clerks and shoppers all see themselves as guests in the places where they work and play. Conditioned by the belief that every homeowner has the right to decorate his living room in any manner he sees fit, the public views any critique of the decor in an office or a mall as an infringement of another owner's rights. Our private-public spaces might actually be more interesting if they did express some personal taste. But alas, corporations notoriously subcontract their art needs to professional "consultants" or advisory committees. Art works for malls and offices are generally chosen through a process of "selection by abdication" which is not responsible to art, artists or the public.

The commercial environment debases original art one way or another. Advisors to corporate collections, more often than not, find the imitation rather than the original; when they don't, the architects, landscapers and decorators who orchestrate the look of commercial spaces find a way to co-opt and trivialize even the most serious and innovative of works. Planted with the pachysandra in an office courtyard, even a real David Smith fades into the mirror glass around it. Actually, it is anonymously made quasi-Calders, bogus Stellas and a whole host of outscaled textural craft works which survive best in this environment. These works and the architectural settings they inhabit may constitute our most truly public art. Current assumptions in several social science disciplines would establish mall art as "material culture" and interpret it as the real expression of our period's values. We might yet find ourselves culturally identified by a generic art production which, as of yet, has no name.

The day is not far off when every office building will sport its own identifying sculpture as logo and every shopping center will have its

stainless steel fountain spewing cascades of water to soothe and calm harried consumers. I predict that this will all happen without a single department store customer ever being polled as to whether he or she enjoyed, related to, or even recognized as art that which was set into the environment as aesthetic enrichment.

Turning from business to government, what about recent federal- and state-sponsored public art projects? Maybe all of our government-funded and matched art is not so far from mall art as we might think. Maybe it is, as Robert Hughes contends, little more than a symbol of a system of power.[6] In America, power is money and money purchases the ultimate commodity—influence. The major controversies in public art may be little more than the bickering between small factions seeking influence and identity in an arena they have grossly over-inflated. The new "renaissance" in public art might all be about the willfulness of the few and the indifference of the many. The sculpture in the concrete canyon of the New York Capitol Mall in Albany and the sculpture at Art Park in the Niagara River gorge are stylistically quite different. But the works installed at both sites are imposed on a public. The governmental mechanisms which put art in the Capitol Mall and in the gorge may both be linked to systems of power and motives of social control.

In contemporary America, art power rises from, and addresses itself to, the middle class. The artists of our time are generally middle class—as are the patrons, collectors and aficionados who support government and corporate art projects. Despite the fact that current public art rhetoric is peppered with populism and pluralism, the art our taxes support does not rally radicals, reformers or striking workers. Instead, it frequently shows up in slick-cover magazines festooned with models sporting the latest designer fashions.

I am always mildly bemused by the persistent notion that there is an "educational mission" connected to the implementation of public art projects.[7] The idea that a work of new art brought into a city or town brings intellectual enlightenment and spiritual edification to a citizenry runs deep in the public art argument. This belief almost always prompts the entrepreneurs sponsoring public projects to put a commissioned artist in touch with civic groups, government committees, museum docents and school groups to orientate the populace to a proposed commission.

With few exceptions (Christo being the most obvious), artists find this activity distracting, frustrating and, in some cases, even insulting. Most artists regard this "educational chore" as a poorly disguised selling job addressed to a clientele already coerced into buying the product. I have never seen an artist, pleading a case before a planning commission, change anyone's opinion. I also think there is a difference between soften-

ing up people and educating them. The groups implementing public art projects generally know what they can and cannot do in a community and, hence, the ritual which launches artists into service club meetings as guest speakers is, by and large, a hollow exercise.[8]

The rhetoric surrounding recent public art projects bristles with educational buzzwords. It was a progressivist's dream come true the day they inaugurated the di Suvero sculpture in Grand Rapids, Michigan. On unveiling day, fired by what Robert Pincus-Witten has labeled as di Suvero's "populist attitudinizing,"[9] the Grand Rapids art community turned its entire city center into one amazing "hands on outreach program"—a "primary experience" for everyone. In simple English, the unveiling of the di Suvero was accompanied not only by great speech making, but by the spectacle of athletic teenagers scaling the sculpture as if it were some metal Matterhorn (see fig. 14). Nearby, hoards of sub-teens, in a snow fence enclosure, built their own little di Suveroesque sculptures from pipe cleaners and wood scraps donated by local businesses. The beauty of it was that the occasion was whatever anybody wanted it to be. The event seemed marked by a peculiar theatricality that di Suvero himself seemed to relish—but as I watched the event, I did not believe for a moment that the artist was totally responsible for the solipsism unleashed that day in his honor. The artist and his sculpture seemed ironically at odds with the community expectations of art as spectacle, art as people involvement and even art as education.[10] When I queried him on his place in all of this, di Suvero himself, like the tar baby, "didn't say nothin'."

One of my favorite pieces of public art is in Lucas, Kansas. Called the *Garden of Eden,* it was built in the 1920s by an isolate sculptor named Samuel Perry Dinsmoor [see fig. 47]. Working for over thirty years, Dinsmoor surrounded his home with a forest of sixty-foot-high concrete trees and large-scale figure groups depicting bible stories and historic events. The *Garden* also includes tableaus illustrating the sculptor's political views. I see this work as outrageous, preachy, tough, centered and smart. Commenting on his labors, Dinsmoor offered his own thoughts on the limits of an artists' responsibility:

> Now this side is modern civilization as I see it. If it is not right I am to blame, but if the Garden of Eden is not right, Moses is to blame. He wrote it up and I built it.[11]

Dinsmoor, by the way, never received federal or state support for his work—no foundation ever awarded him a fellowship either.

But then Lucas, Kansas is not New York. The 1985 government-funded installation of Richard Serra's *Tilted Arc* in lower Manhattan

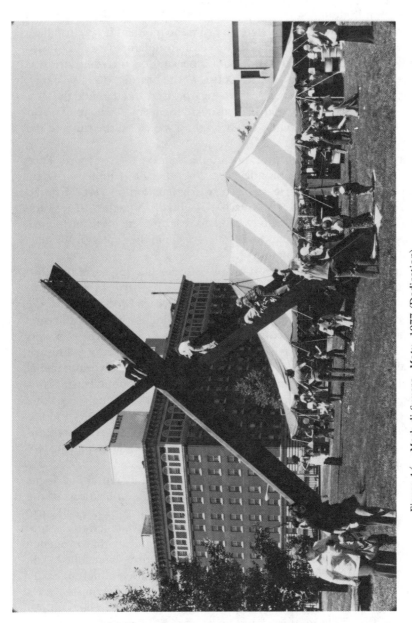

Figure 14. Mark di Suvero, *Motu*, 1977 (Dedication)
Cor-ten steel and rubber tire, 35′.
Gerald R. Ford Federal Building and U.S. Courthouse, Calder Plaza,
Vandenberg Center, Grand Rapids, Michigan.
(Photo: Michael Hall)

precipitated complications Dinsmoor never dreamed of. Commissioned by the General Services Administration and placed in front of the Jacob Javits Federal Building, Serra's twelve-foot-high, 112-foot-long steel wall was born and baptized in controversy. From the moment it was installed, the wall became the focus of a tidal wave of complaint. The din of protest finally became so great that a public hearing on the sculpture was convened in a United States District Court. At the hearing, office workers, as well as high art connoisseurs, alternately praised and damned the *Arc*. Outside the courtroom, the graffitists also had their say. Their spray marks on the *Arc* seemed to become "the strangling weeds on the ruins of the idea of public art."[12]

Fortunately, neither hearings nor hooligans have the last word. They do remind us that art in the broadest sense is a social phenomenon marking and locating its time. No less a masterwork than Rodin's *Thinker* found itself booted around the streets of Paris—essentially homeless—for years. Ultimately, of course, *The Thinker* came to rest on a site more auspicious than any plot of urban Parisian real estate—a site in the center of Western cultural imagination and memory.

Remembering this, I weary a bit of episodes like the Serra flap, but I recognize them as inevitable and perhaps as necessary. In addition to my professional interest in the *Arc*, social concerns brought me to the witness stand at the hearing. New and distressing issues have emerged from the Serra commission controversy. For the first time, the concepts of referendum and recall have been extended to the subject of public art. Politically interpreted, the Serra proceedings suggest that a work of public art, like a public official, can be guilty of betraying a public trust. If this interpretation prevails, then, logically, a guilty work, through some due process, can be dismissed from public service. The Serra inquiry did not really (as it purported) probe the possible violations of contract committed by the principals in the *Arc* project. Rather, the inquiry put the *Arc* itself on trial.

My second concern grows from the first. With its emotional focus directed at the *Arc*, the hearing did little to assess the obligations of the public agencies which initiate and institute public arts projects. They *are* charged with a public trust. Perhaps it is they who have failed to execute a mandate. The furor around the *Arc* may actually indicate that an agency and an idea, rather than an artist and a sculptured form, have failed. The proceeding I witnessed in New York was problematic enough to easily qualify as a mistrial. Assuming this, the *Arc* should be acquitted on a technicality and set free to pursue its own search for a site in our cultural mindscape.[13] Left alone, this would be its goal as a work of art anyway.

One final problem for contemporary public art develops long after

the controversy attending a piece's installation has been silenced. Ten years later, does anyone care? Ten years after a dedication, who is going to sandblast and repaint a plaza stabile or freshen up a wall mural? The maintenance of contemporary public art will ultimately cost far more than its fabrication and installation. The marvels placed by the National Endowment for the Arts yesterday are looking rather unloved today. This poses a serious question. Who is responsible for the upkeep of public art? What an irony that today's controversial new arrivals might die in thirty years of nothing more malignant than neglect—the neglect of both the private and the governmental suasions which gave them life in the first place.

Do I think there can be public art today? Yes, I think so. But I believe that it will incubate in private. I feel that artists should go ahead with their studio work. I believe collectors should patronize artists and that museums should archive, exhibit and conserve the things artists make. Critics should look, think and write and government should expect to be involved with public art. Most important, I believe people should actively engage the art of their time. Culture is communication and, because art speaks, it is inherently a part of any cultural conversation. Out of the studio, all art inevitably becomes public. This, more than anything else, puts the problem before us in perspective. Transcending politics, economics and mythologies, the poet Paul Rickenbacker penned his vision of public art in a few lines of verse about sculptors and their calling. For me, his words seem to put art, artists and the public into an essential and right relationship.

> I leave behind
> A mound of chaff,
> Forsaken
> At the feet of one slim golden shaft:
> Born in me,
> Of metal and myself,
> To feed the world.[14]

Notes

1. Gerald Nordland, *Controversial Public Art; From Rodin to di Suvero* (Milwaukee, Wisconsin: The Milwaukee Art Museum, 1983).

2. *Sculpture in Environment* (New York: Cultural Affairs Foundation, 1967), n.p.

3. From a file of newspaper clippings on the St. Louis Serra project made available to me by Beej Niergarten-Smith, Ed.D., Director: Laumeier Sculpture Park, St. Louis, Missouri.

4. Donald W. Thalacker, *The Place of Art in the World of Architecture* (New York: Chelsea House Publishers, 1980), p. 48.

5. Robert Smithson, "Cultural Confinement," *Artforum,* Vol. XI, no. 2, October 1972, p. 39.

6. For a relevant discussion of politics, power, and art, see Robert Hughes, *The Shock of the New* (New York: Alfred A. Knopf, 1981), pp. 99–108.

7. This idea has clearly evolved from contemporary museum practice which increasingly seeks new ways to educate viewers. See Mark Lilla, "Art and Anxiety: The Writing on the Museum Wall," *The Public Interest,* Vol. 66, Winter 1982, pp. 37–54.

8. These impressions were gathered between 1975 and 1985 when I was both a candidate for public commissions and a panelist nominating artists for various proposed projects. Guidelines for bringing artists and communities together vary somewhat from one sponsoring agency to another, but they always presume an educational value in some requisite artist/community interface.

9. Robert Pincus-Witten, *Eye to Eye: Twenty Years of Art Criticism* (Ann Arbor, Michigan: UMI Research Press, 1984), p. 112.

10. For the official government account of the di Suvero Grand Rapids project, see Thalacker, pp. 48–53.

11. Samuel Perry Dinsmoor, *The Cabin Home* (Lucas, Kansas: [n. pub., n.d.]), n.p.

12. Robert Hughes, "The Trials of Tilted Arc," *Time,* June 3, 1985, p. 78.

13. Michael Hall, "The Serra *Arc.*" Testimony at the Federal Court hearing on the *Tilted Arc,* New York, March 7, 1985, 11:00 a.m.

14. Paul Rickenbacker, "Know Thyself," *University of Washington Annual* (Seattle, Washington: University of Washington Press, 1964), p. 122.

5

Modernism, Machoism, Midwesternism: Sculpture in America

First presented in the annual "Faculty Lecture Series" at the Cranbrook Academy of Art in 1985, this piece was subsequently read for several art school audiences—most notably at Arizona State University. At each of its presentations, the lecture proved controversial for it raised issues sensitive to various factions of the contemporary art world. Expanded and reworked in 1986, the lecture became an essay. The essay as printed here was re-drafted and finalized in 1987.

* * *

It was some years ago that an interviewer from the Archives of American Art came to my Detroit studio to ask me for some comments on my life as an artist in the Midwest. I reflected briefly on the changes my work had undergone since my transplantation from the West Coast and then for the first time I found myself speaking as a midwestern artist. My response to this realization was mixed. Though my work had flourished since my arrival in Michigan, I had also lately become aware of the skepticism with which the American art community views the art and artists in its heartland.

Today, after almost twenty years in the Midwest, I am even more aware of this skepticism and the numerous and problematic stereotypes which constantly fuel it. Because stereotypes are generally a blend of fact and fiction, we know that they can always be refuted. For example; there is the old cliché that depicts midwesterners as traditional and conservative in their outlook. Yet, when one peruses the biographies of America's most innovative painters and sculptors, one discovers that a fair number of them grew up in the Midwest and formed their artistic ideas and styles there.

But what about the facts that support the fictions? On the subject of Midwest art, I think they warrant an explication. All too often, I find myself confronting the stereotype which typifies the midwestern sculptor

who works at large scale as a macho Neanderthal or a provincial cowboy welder with no real place in the art world. In an equally offhand way, the art these sculptors make is frequently typed as retrograde and summarily discounted. Predictably, I recoil from all of this. Such stereotyping hardly describes the sculptors I have known in the Midwest—nor does it appropriately portray their work.

Still, the Midwest macho modernist lives. I believe, however, that he lives not on the periphery of American art but very close to its center. He exists as a product of a social and aesthetic history comprised of both facts and fictions. He survives and evolves in step with the history in which he is rooted. As to the tradition of monumental sculpture in the Midwest, it, too, lives. But once again I suggest that it is far from retrograde and peripheral. I believe it is possible to establish the genre of contemporary large-scale midwestern sculpture as a high Mannerist style of an originally European Constructivism. My speculation is that this genre can be set into a romantic American art tradition which, in one form or another, has reflected the agrarian and primitivist yearnings of Americans through two centuries.

To understand these yearnings, (and hence the cowboy welder) we must examine the history of America's enduring love affair with the frontier and its frontiersmen. The same sentiment that would put Andrew Jackson, Teddy Roosevelt and Ronald Reagan in the White House would put Gary Cooper and John Wayne in a Hollywood galaxy of stars. Images from the frontier seem to penetrate all levels of American popular and high culture. Americans (and the artists among them) seem endlessly beguiled by literary and pictorial allusions to the simplicity and rigor of life on the land (agrarianism) and to the intuitive nature and self-reliant spirit of the pioneers and settlers living that life (primitivism).[1] Unfortunately, however, all this has not been necessarily good for twentieth-century artists.

According to tradition, as Americans moved into their West they imposed on themselves a gender-based separation of work assignments. Men advanced into the wilderness, skirmished with Indians, felled trees and established settlements. Women followed, stabilizing and refining the settlements the men founded. Americans have mythologized their explorers, surveyors, trappers, cattlemen and pioneer farmers as no-frills, no-nonsense individuals and have come to view the tasks they performed on the frontier as "men's" work.

Demonstrably, this perception gave rise to the popular literary model of the self-sufficient male frontier hero—a hero who needed to neither read nor write—only to act. For these heroes, reason is the controversion of intuition and reflex. Cooper's Leatherstocking survives because

he has the instinct and cunning of a savage. Likewise, all the western movie heroes (and anti-heroes) portrayed by Clint Eastwood shoot first and ask questions later. Popularly, Americans seem to perceive action and decisiveness as masculine. Deliberation and reflection, by implication, are thus associated with things not masculine. This brings us to the dilemma in which art, because it is contemplative in nature, is frequently perceived in modern America as a non-male concern. Associating art with things polite and with things self-expressive and introspective, Americans enamored of the frontier have difficulty justifying art-making as legitimate man's work.

We ask, then, how might men gain respectability as artists in a contemporary culture hostile to or, at best, indifferent to art? We also ask, how could Americans reconcile the schism that separated them from the world model in which men defined the frontiers of painting, sculpture and architecture? Yankee ingenuity solved these problems. From their old beliefs, Americans conjured up a cultural symbol suitable to become a hero for a new century: the artist/frontiersman. The avant-garde became a frontier and the artists at its cutting edge could find acceptability if they conformed to frontier models. The frontiersman/artist joined Teddy Roosevelt and John Wayne in the spotlight on the American stage.

For reasons that still remain matters of conjecture, the concept of the frontiersman/artist took root early and well in the Midwest. The soil there, as we will see, was already liberally sown with the seeds of agrarianism and primitivism. Perhaps this encouraged the midwestern flowering of a species of American artist determined to assert its art as witness to the frontier spirit. There is a durable lineage of midwestern artists who have viewed their work as testimony to personal identity and heroic individuality.

As a region, the Midwest is a kind of microcosm of America. It is centered temperamentally and historically as much as it is geographically. Those who settled the Midwest brought with them an American dream of land which was tempered with a sober understanding of what the land would offer them as opportunity. They farmed, they laid railroad track and built cities. They opened shops, erected factories and established schools. They elected presidents, fought in foreign wars and roller-skated on Saturday nights. They planted and raised the pioneer spirit as surely as they planted and raised corn.

To establish that agrarian and primitivist values appeared early in midwestern art, I would like to explore a rather curious piece of folk art in Valton, Wisconsin—a fraternal meeting hall known as *The Painted Forest*. In 1897, the Valton brotherhood of the Modern Woodmen of America commissioned a mural painting for the interior of their meeting

hall. One Ernest Huppenden, an itinerant German-American scene painter, received the commission. The lodge building assigned to Huppenden was situated in a north/south orientation with its entry facing to the southeast. Inside this building, a long wall facing east and a long wall facing west provided the bulk of the surface upon which his mural was to be executed.

On the east wall, the painter created a representation of a city. The image here is gridded, stark, geometric and painted primarily in grays and browns. The cityscape is filled with references to commerce and trade—signs of civilization and evocations of urban European life. On the north wall, Huppenden depicted a bearded prophet in long robes making a summoning gesture with his arms (see fig. 15). He is directing lodge initiates to leave the bustling city and to go West. On the west wall, we find a lush scene of green mountains and virgin forests. In the foreground of this scene, Huppenden painted clearings filled with tent encampments and woodsmen busily felling trees. Over the whole western wall, the golden rays of a setting sun bathe the world with a warm glow.[2]

In the overt didacticism of Huppenden's mural, we can decipher a number of social values that, I sense, still inform American art. Huppenden was commissioned to paint a propagandistic work which would instruct its viewers to spurn urban life and European traditions and to seek, instead, a spiritual union with nature in the American wilderness paradise. In the West, Huppenden's settlers find fulfillment in a bucolic life of work and communalism where natural man is reunited with the simple, the primitive and the authentic in his spirit.

The ideas and associated values that dictated the imagery in the mural at Valton were community values shared by people all across the United States. These concepts are still shared by Americans in this century. Fleeing their urban work places, they seek personal revitalization vacationing in the countryside and they find spiritual regeneration camping in remote wilderness retreats. In their art tastes, Americans show a decided preference for landscape over other subjects in paintings and photographs. One could even go so far as to speculate that the acclaim conferred on the Earth Works movement of the 1960s reflects a popular taste. Of all the conceptual art produced in that period, it was earth art that best expressed American agrarian and primitivist ideals. Critics and the public alike, conditioned by the myths of the frontier, identified with the earth artists and embraced their expression.

With this in mind, it is not surprising that so many midwestern artists today have a vision of art that springs directly from the sentiments we read in the Valton murals. St. Louis sculptor Jim Sterritt has long maintained that midwesterners are, by birth, close to the land and that their sculpture always refers back to the land. For Sterritt, and other artists

Figure 15. Ernest Huppenden, *The Painted Forest* (Detail North Wall), 1897 Paint on plaster, 14 × 30 × 60′ (building): 14 × 30′ (north wall). Wood Hall, Modern Woodmen of America, Camp #6190, Valton, Wisconsin. Restored in 1982 by the Kohler Foundation, Inc., Kohler, Wisconsin and donated to Sauk County, Wisconsin.

like him, the array of machine parts, tools and farm implements welded into David Smith's *Agricola* sculptures form a coherent and aesthetic sign system (see fig. 16). These same artists relate to the ''block and tackle'' way in which Smith constructed his work directly at the forge or on a welding table. Sterritt believes that sculptors must work with their hands and that only people comfortable with hard work should become sculptors.

Over the many years that I have known Jim Sterritt, his perspective on sculpture and his support of midwestern art have remained constant. He identifies with sculptors who are more comfortable welding than reading a book and he readily seeks out the company of artists who would rather repair a truck than debate the Futurist Manifesto. Sterritt has been making sculpture and teaching art in the Midwest for thirty years. He knows much about his region and its art. His advocacies and his prejudices suggest that frontier impulses stubbornly sustain themselves in the spectrum of artistic temperament in America.[3]

To confirm this further, we need only look at other midwestern sculptors. They share a belief in much of what Sterritt endorses. The signs that confirm their beliefs are curious. Behind their studios, we find the ubiquitous pick-up truck. Ostensibly these vehicles are necessary to the sculptor's trade. As a sign, however, the truck is a witness to the sculptor's stoicism and embrace of the work ethic. In an agrarian ideal, a pick-up truck (and its close cousin, the small flatbed or stake truck) is the yeoman's work animal. Meeting the artists in their studios, we note their footwear. For sculptors, footwear means boots of two varieties. The first variety is the steel-toed work boot—the footwear of the foundryman and the factory worker. The second boot is the cowboy boot—the footwear of Remington's trail riders and Zane Grey's rugged saddle tramps. Moving out to the bars and restaurants where the artists congregate, we observe that the sculptors frequently affect the distinctive swaggering posture associated with males in certain tribal groups. High on this list are bikers, truckers and Indians—clans and societies mythologized in a primitivist ideal for their transiency, aggressiveness and independence. Trucks, boots and bravado all merge in what appears to be only a parodistic vestige of the frontiersman/artist idea. We ask ourselves, how did pick-up trucks become so bizarrely collaged into the pastoral of Huppenden's Wisconsin murals?

A possible answer—and perhaps a justification—can be traced to the conflicts and confusions first generated over fifty years ago when artist/frontiersmen were forced to face the challenge of modernism. Consider the problem of American artists discovering an art rooted in sources alien and antithetical to frontier egalitarianism. Arriving on American shores

Figure 16. David Smith, *Agricola VIII*, 1952
 Steel and bronze, painted brown, 31¾ × 18¾ × 21¼″.
 Collection Candida and Rebecca Smith.
 (Photo copyright 1987 Candida and Rebecca
 Smith; photo courtesy the National Gallery of Art,
 Washington, D.C.)

in the early twentieth century, modernism had several strikes against it. It was European and it was intellectual. Its masterworks were witness to analytical processes and theoretical refinements. The movement was articulated in arenas of aesthetic inquiry initiated by cosmopolitan individuals who had no need to think of themselves as frontiersmen.

Finding the prototype for today's cowboy artist only requires reading the biographies of two luminary American modernists—the painter Jackson Pollock, and the sculptor David Smith. Timing and events, it seems, set these two midwestern American artists to the task of grafting European modernism to a native American sapling. By midcentury, they would harvest the first fruits of the hybrid which would become modern American abstract art.

A sketch of Jackson Pollock's life and a perusal of the writings of his biographers give us overload doses of agrarianism and machoism. Pollock was born in Cody, Wyoming in 1912. His father was raised in Iowa. His mother was also a midwesterner from Iowa. Pollock's father farmed in Cody for the first few years of Jackson's life and then moved his family to California where he continued to farm. Once out of high school, Jackson worked for awhile as a member of a team surveying parts of the Grand Canyon. Determined to become an artist, he left the West to find his place on the frontier of American art in New York.[4]

Privately, the artist fought a continuous battle with alcoholism and with the violence in his nature. He was drawn to confrontations. "When he was drunk and unhappy, and involved in trivial bar squabbles, weapons were sometimes thrust into his hand by avid onlookers."[5] He died in an automobile crash in 1956. The frontier violence, drama and heroism in his life, his art and his death instantly established him as a symbol for an American age.[6]

Analyzing Pollock, Elizabeth Frank locates the painter and his work in the center of the endemic sexual conflict in American art. Invoking Melville in her critique of a late Pollock entitled *The Deep,* she writes:

> *The Deep,* with its uncharacteristically opaque and unbroken blanket of milky paint that splits over a deep black fissure . . . recalls a passage in *Moby Dick* that seems to summarize the continuous presence of conflict and the crucial role of emotional and structural oppositions in Pollock's work: "Hither, and thither, on high, glided the snow-white wings of small, unspeckled birds; these were the gentle thoughts of the feminine air; but to and fro in the deeps, far down in the bottomless blue, rushed mighty leviathans, sword-fish, and sharks; and these were the strong, troubled, murderous thinkings of the masculine sea."[7]

Pollock himself revealed much of the frontier bias in his artistic vision with his own statements. He demonstrated his personal identification with

the American myth of the land and its arcadian primitive inhabitants when he said:

> My painting does not come from the easel. . . . I prefer to tack the unstretched canvas to the hard wall or the floor. I need the resistance of a hard surface. On the floor I am more at ease. I feel nearer, more a part of the painting, since this way I can walk around it and work from the four sides and literally be in the painting. This is akin to the Indian sand painters of the West.[8]

In this frequently cited comment, the painter displays his frontier temper and betrays his agrarian expectation to legitimize art-making as man's work. Painting on the floor, he wrests productivity from a reluctant soil.

Pollock's sculptor counterpart, David Smith, was born in Decatur, Indiana in 1906. Like Pollock, he had parents who were both midwesterners. In 1921, Smith moved to Ohio with his family and four years later returned to Indiana to work as a welder and riveter in the South Bend Studebaker plant. Only in 1926, after deciding to become a professional artist, did he leave the Midwest and move to New York City.[9]

Initially fascinated, and in some ways seduced, by New York, Smith ultimately rejected urban living and moved to a farm near Lake George where the rustic side of his temperament was more at home. In building a studio and a house on his own land, he reenacted his pioneer birthright. The art critic Hilton Kramer recognized Smith's yeoman-like spirit and identified it as the shaping force in the sculptor's creative endeavors. In 1960, he wrote:

> Smith's workshop in the mountains . . . brings together two old-fashioned ideas of American life: the proud individualism and keen workmanship of the man who lives on his own land. Both are ideals of freedom out of the American past, derived from the ethos of a harder but simpler life than most Americans find possible to live now. . . . We might say that everything about Smith's work is up-to-date but the style of life which makes it possible for him to create it.[10]

From some source (perhaps his midwestern upbringing), Smith had an uncanny sense of American values. He worked from an emphatically American vision. His notes and journals are filled with pithy affirmations of his self-consciously proletarian view of work and freedom. His writings also ring with a defiance that is blatantly macho and frontierlike in its tone. Some samples:

> By choice I identify myself with workingmen and still belong to Local 2054 United Steelworkers of America.[11]

> Culture and the ideal perfection is the refinement which belongs to gentle men—art is the raw stuff which comes from the vitality, labor of aggressiveness by men who got that way fighting for survival.[12]
>
> I feel raw freedom and my own identity. I feel a belligerence to museums, critics, art historians, aesthetes and the so called cultural forces in a commercial order.[13]

Like Pollock, Smith died in a vehicle crash. Driving his pick-up truck, he somehow careened off the highway and into a tree. The year was 1965 and the artist was in the midst of constructing the most ambitious and heroic works of his career. He left behind a field of forged and welded totems which would become his immortality. He also left a fragile poem that might well be the perfect epitaph for an aging midwestern modernist:

Highway 60 Illinois

A weathered hawk setting in a tree
feeling old and slow
feathers gone from the wing
one broken in the tail
watching the 70 mile traffic roar below
through fields of cotton brush and corn stubble.[14]

The sagas of Smith and Pollock are not unique. The clash of frontierism and modernism also affected many of their contemporaries and created a legacy which endures. Many American artists still grapple intensely with the conflicting imperatives of belief and experience, finding themselves unduly preoccupied with what Freud noted as a general tendency for all people to attach to unspoiled landscape and primitive conditions their yearnings to enjoy "freedom from the grip of the external world."[15]

The frontier model has posed problems for women in the arts as well as for men. The factors that conspire to make farmers and cowboys of American artists run wide and deep. We might well ask how much of that which female artists in America envision for themselves is predicated on an acceptance of the Pollock-Smith agrarian macho model; and how much on a rejection of it? Contemporary women artists working in the medium of fiber seem to have pursued both options. Intent on finding a more assertive expression for themselves, some of them constructing monumental fiber works have entered the arena of public art as sculptors. They want a parity with men in a traditionally male-dominated field and they have earned it. Other women, however, have turned their sensibilities inward and have sought to reunite contemporary fiber art with its decorative and utilitarian history.

Ironically, in shifting their art away from a heroic model, women

may still find that their expression is trapped on the frontier. The primitivist impulse, revivifying the creative expectations of American women, could well occasion an art addressed to the historic frontier female concerns of domesticity and communalism. We have seen this even in the political and ideological art of the feminist movement. In 1974, Mary Beth Edelson created a performance work called *Ritual with My Daughter.* More recently, sculptor Judy Chicago joined with a number of other women to produce a stitched, crocheted and quilted collaborative entitled *The Birth Project.*

Gender issues aside, we recognize that American modernism after Smith and Pollock became a vernacular. It was thoroughly adapted to the regional interpretations of its many practitioners. This has been especially evident in the Midwest. As a host of "isms" proliferated after Abstract Expressionism, midwestern artists tried their hand at all of them. But for many midwestern sculptors, the most compelling "ism" of all continued to be the old standby, Constructivism. They were naturally partial to its technical concerns and its part-to-part formal structure. Also, they found that at monumental scale, Constructivist compositions met the conditions of both a public and a private art. Over the past three decades, sculptors in the Midwest have built acres of monumental fabricated sculpture which has become the most visible public art of the region. Though this work acknowledges the cosmopolitan legacy of Malevich, Gabo and the other early European Constructivists, it is, nevertheless, regional and decidedly frontier. Indeed, this work may have departed sufficiently from its antecedents as to have earned its own stylistic identification. For my purposes here, no label seems more appropriate to this art than the term Agromonumentalism.

The sheer size of some of the works produced by the Agromonumentalists of the Midwest is overwhelming. Out of his Kansas City studio, Dale Eldred designed and built a sculpture for the city of Mankato, Minnesota. Installed in 1970, the piece filled Mankato's town square. Its gigantic girders projected out over the trucks and cars on the streets surrounding its site. In a Chicago studio in 1976, John Henry fabricated a work titled *Illinois Landscape No. 5.* He sited it south of the city on the campus of Governors State University. Henry's piece sprawls across the landscape for the length of half a football field. Its arms reach forty feet into the air (see fig. 17).

Also in Illinois, Chicago sculptors Jerry Peart, Barry Tinsley, and Maryrose Carroll have completed impressive sculpture projects in numerous plazas, parks and office centers. Similarly in Ohio, both David Black and Carl Floyd have erected their own monumental works on various public sites. Recently, Floyd has undertaken the construction of

Figure 17. John Henry, *Illinois Landscape No. 5,* 1976
Painted steel, 36 × 24 × 134′.
Collection Governors State University, University Park, Illinois.

a sculpture park outside of Cleveland. This work traverses several acres and extends fabricated causeways and walls into the waters of Lake Erie. Elsewhere in the region, other large-scale works have been built and sited; notably by Mel Leiserowitz, John Piet and Hanna Stiebel in Michigan, Julius Schmidt in Iowa, Rudy Autio in Montana, Jerald Jacquard and John Mooney in Indiana and Rolf Westphal in Wisconsin.

The sculpture built by all of these artists has much in common. It is big, assertive and always well made. Its scale and boldness speaks to the concerns of makers challenging the enormity of the midwestern landscape with their gestures. The craft employed in the making of these structures is that of workers proud of their ability to use tools and machinery— the virtuosity of artists who have mastered the skills of professional tradesmen. Conceptually, Agromonumentalism tends to be straightforward and not intellectually over-demanding. The abstraction in this art is not that which Picasso and Braque wrested from their critique of representational art. Instead, it is a conceit. It is a pure choreography of shapes, colors and materials orchestrated into images. The Agromonumentalists create arrangements of forms which become the abstract content of their art. Constructivist sculpture in the Midwest today is emphatically plain modernism. In art historical terms, this art may legitimately be the Mannerist form of the modernism we recognize as classic in the time of Picasso and perhaps as baroque in the period of Smith and Pollock.

Above all else, the sculpture of the Agromonumentalists continues to reinterpret and reaffirm the frontier tradition of American art. But this alone is not the main point of my discussion here. Probing the stereotype of the Midwest macho modernist, I hope to have provoked some wider conversation on a set of factors which I believe directly affect art and artists in worlds seemingly far removed from the world of Dale Eldred, John Henry and Jim Sterritt. In a dozen guises, I find the Midwest sculptor alive and well in New York, Boston, Los Angeles and even San Francisco. Pollock's cowboy boots live in the minds of artists all across America— even those in Soho, stylishly attired in running shoes. Furthermore, having worked outward from a narrow but loaded stereotype, we should better understand why it is that, in one form or another, it is the frontiersman/artist who is so frequently invited to carry the American flag abroad to international art exhibitions. The world has come to see the frontiersman as *the* American artist. Europeans especially, it seems, are forever fascinated with the American Wild West. Buffalo Bill lives on as the urban cowboy sculptor. He stars today in the American pavilions at Kassel's Documenta or the Venice Biennale just as he did in the courts of the monarchs a hundred years ago.

It is perhaps time for critics and historians to put aside pejorative views of midwestern art. It seems that as the art critical community looks at American art, it wants to see anything but what can be seen in the Midwest. However, whether we like it or not, authentic art is being fashioned every day in studios from Ohio to Colorado. I do not know if the great sculpture masterpiece of the eighties is being welded together today in some Des Moines warehouse, but I do know that if Americans want to take their art seriously, sculpture being produced in Des Moines and Buffalo and Lexington and Missoula should not be discounted.

Reassessed, the art made in the American Midwest should enhance understandings of American aesthetic and social values. In regional art, one might find the true ratification of all that purports to be mainstream. Through a revisionist eye, we might find that the plain modernism described here brings continuity and context to an art history cohering outside distracting "isms." In such a reassessment midwestern artists will find their beliefs and their work vindicated by the elusive frontier touchstones that Americans always suspend between a place of fact and a place of fiction.

Notes

1. In this essay, I extend the term "primitivism" somewhat beyond its traditional usages. In most art critical writing, "primitivism" refers to the interest that early modern artists (Picasso foremost among them) focused on the arts of various tribal cultures. Frequently, the term is broadened by historians to describe the belief held by certain artists (or groups of artists) in the superiority of the natural (the native or naive) over the artificial (the rational and civilized). Thus, it was a primitivist desire for a return to nature that would prompt Paul Gauguin to leave Paris and take up residence among the natives of Tahiti. I have intentionally used the term "primitivism" colloquially in this essay. My usage specifically addresses the tendency of Americans to fixate their primitivist longings on the pioneer frontier life of their own westward movement.

2. Personal field work, Valton, Wisconsin, May 2, 1981. At that time, I toured the lodge known as M.W.A. Camp #6190 (*The Painted Forest*). I am indebted to Don Howlett for the historical information on the lodge and the artist Ernest Huppenden, which I have presented here. The lodge hall itself was restored in 1982 under the auspices of the Kohler Foundation, Inc., Kohler, Wisconsin. The Foundation subsequently deeded the monument to Sauk County, the county within which it is located.

3. Jim Sterritt, personal communications, 1975–1980. Sterritt has been an active member of the College Art Association of America for many years. At numerous meetings of that organization, he has voiced his views on sculpture and art in the Midwest. Through my long personal and professional association with Sterritt, I have come to know and respect his regional and artistic advocacies.

4. There are several well-researched books which document the life and work of Jackson Pollock. The brief biographical account here was compiled from two sources: Bryan Robertson, *Jackson Pollock* (New York: Harry N. Abrams, Inc., 1960); Elizabeth Frank, *Jackson Pollock* (New York: Abbeville Press, 1983).

5. Bryan Robertson, *Jackson Pollock* (New York: Harry N. Abrams, Inc., 1960), p. 18.

6. It is interesting to note in a discussion of the frontier temperament of Jackson Pollock that the painter's disposition was, in some ways, similar to that of the frontiersman/president, Andrew Jackson. Tracing Andrew Jackson's rise to power in the U.S. Senate during 1823, historian Frederick Jackson Turner describes Senator Jackson in terms that would also describe the painter for whom the Senator might well have been a namesake:

 > This six-foot backwoodsman, with blue eyes that could blaze on occasion, this choleric, impetuous, self-willed Scotch-Irish leader of men, this expert duelist, and ready fighter, this embodiment of the tenacious, vehement personal west, was in politics to stay.

 Frederick Jackson Turner, *The Frontier in American History* (New York: Holt, Rinehart and Winston, 1962), p. 253.

7. Elizabeth Frank, *Jackson Pollock,* pp. 97, 102.

8. Robertson, p. 193.

9. The biographical information presented here on David Smith was taken from a short chronology of the events in the artist's life prepared by Edward F. Fry. Edward F. Fry, *David Smith* (New York: The Solomon R. Guggenheim Museum, 1969).

10. Cleve Gray, ed., *David Smith by David Smith* (New York: Holt, Rinehart and Winston, 1968), p. 13.

11. Ibid., p. 61.

12. Ibid., p. 130.

13. Ibid., p. 133.

14. Ibid., p. 153.

15. Leo Marx, *The Machine in the Garden: Technology and the Pastoral Ideal in America* (New York: Oxford University Press, 1964), p. 8.

Bolton and Beyond:
Sculptors and Heroes and Such

The following entry evolved from an illustrated talk at the Cleveland Art Museum in 1982. Originally titled *My Heroes Have Always Been Sculptors,* the talk was recorded by the Museum's Curator of Education, John Moore. His tape was transcribed in 1984 and edited at that time. It is printed here in a format frequently used for exhibition catalogues. The citings and descriptions interspersed throughout the text are intended as catalogue entries and are printed as such.

*　　*　　*

One of the indelible lessons that formed my earliest understandings of American sculpture came from the pages of *Life* magazine. In the early sixties, the magazine ran a photo essay on David Smith. The piece, as I recall, was entitled *David's Steel Goliaths.* The image that stays with me from that essay was a two-page spread showing Smith surveying the field of sculpture to the south of his Bolton Landing studio (see fig. 18). I was transfixed by the welded totems in the field. I was equally moved by my realization that these objects had been willed and worked into being by the solitary creator who gazed out over them. I later found out that the photographer who took the picture was a long-time friend of Smith's. Through his camera lens, I first glimpsed something I would grow to understand as the heroic in modern American sculpture.

Since my encounter with the Smith photo, I have built a large part of my life around sculpture. I have met and known a lot of sculptors. And from time to time I have seen contemporary works of sculpture that, like the totems at Bolton, fill the fields of my imagination—works that in their own ways testify to the fact that the heroic is an enduring Romantic concept in American art. On these occasions, the curator and the collector in me comes out. My thoughts drift to the formulation of an exhibition that would celebrate the heroic as a theme and a spirit, rather than as a style, persisting in American sculpture.

Figure 18. David Smith Overlooking the Field South of His Bolton Landing Studio, 1962–63
(Photo: Dan Budnik; photo courtesy Woodfin Camp and Associates)

From Smith's own statements and journals, it is obvious that he identified himself within a heroic tradition. It is less obvious, however, what has happened to that tradition as it has reformulated itself in the thinking of other sculptors in the third quarter of our century. A discussion of heroic sculpture is something that one approaches with caution. Too often the vainglorious, the grandiose and the masculine are confused with the heroic. The term, as I interpret it, refers to the courageous, the risky, the noble, the perfected and the larger-than-life. My contention is that we have today—and probably always will have—heroic sculpture.

The word sculpture itself evokes an array of stone, wood and iron objects wrested from unyielding nature. The aspiration to make sculpture is, thus, implicitly heroic, for it anticipates confrontation and presumes a sculptor's will to prevail. What I would like to do here is to create a conceptual exhibition with myself as curator. I would like to gather and reconstruct a selection of objects and install them in the mind's eye. The justification for this exhibition would be its potential usefulness as critical inquiry and historic speculation. The question is posited: Whatever happened to the heroic in American sculpture after the death of David Smith? I suggest that the concept remained alive and well through the third quarter of the twentieth century, but that it splintered and transformed as it took hold in the thinking of various sculptors—and took shape in their hands. I offer here an exhibition not encumbered with practical considerations, or by the accommodations typically occasioned by boards, directors, funding and logistics. Here, we find only a curator sifting and sorting and finally (as curators will) exhibiting a bias proferred as scholarship and aesthetic persuasion.

Hence a fantasy show addressed to the subject of the heroic in late twentieth-century American sculpture. The exhibition presents twenty works by ten artists—works suggesting that the heroic runs wide and deep in contemporary American art. The exhibition limits itself to works produced between 1960 and 1980. I feel that this is a period that can be put in some perspective today. Without a grant and without a gallery, an exhibition coalesces. Appropriately, it is entitled "Bolton and Beyond."

* * *

David Smith (1906–1965)

The sculpture of David Smith is an obvious anchor for the exhibition. Smith was the first American to assimilate fully the lessons of European modernism and to translate them into a domestic abstract style of fabricated sculpture. He was born in the twentieth century and devoted

his career to a search for an identity for himself and for his work that would be both modern and American. Smith saw his search for the identity of the American sculptor as a heroic quest. His understanding of the heroic grew from his literal embrace of the whole concept of sculpture as confrontation.

To Smith, the ideal artist was a rugged frontier individual—self-reliant and always ready to put work "on the line." He frequently described the making of sculpture as a contest between makers and materials. He came from Indiana and had worked as a factory laborer in his youth. For the rest of his life, he identified himself with working people and with the land. He believed that there was something raw and untamed in America from which an assertive, bold new art could be made—an art that would stand up to all that he saw as effete, polite and non-heroic in European art.

Smith built his identity around a vision that wedded the European concept of the bohemian and the American concept of the frontiersman. It is not by chance that Smith and his painter peers are referred to as the "heroic generation." Smith, Kline, Pollock, de Kooning, Newman and Rothko amalgamated high European modernism with the psychoanalytic theories of Freud. Lacing this amalgam with a solid dash of Jeffersonian politic, they built a heroic domestic art—individualistic and idealistic. In the same spirit of inventiveness and innovation that advanced American technology at mid-century these artists broke traditions and pioneered in their field. Smith lived by an American model. Each new piece he brought out of the studio was his personal challenge to the art of the past and the art of the future.

Voltri XVI, 1962
Steel.
44 × 40 × 38".
(Estate of the artist)

Voltri XVI is one of several works Smith built on the theme of a welder's work table. The steel legs of the table are real work table legs, braced with angle iron and steel gussets. The table's surface supports clusters of various metal shapes that seem both randomly placed and carefully composed.

Some of the small steel boxes in this aggregation are stacked in ways that anticipate the configurations of boxes in the Cubi pieces which Smith would begin constructing a year after *Voltri XVI* was completed. A twisted steel coil at the far end of the table seems to acknowledge Smith's constructivist admiration of Vladimir Tatlin's *Monument to the Third International. Voltri XVI* is best described as eccentric, com-

plex, original, somewhat surreal and highly autobiographical. Overall it is a revealing insight into Smith's heroic sense of work, art history and the steel he welded.

Primo Piano I, 1962 [fig. 19]
Steel, painted white.
102½ × 145 × 22".
(Private collection)

This is the first of three related pieces Smith constructed between 1962 and 1963. Its basic structure involves a pair of short posts connected by a horizontal length of heavy angle iron about twelve feet long. Two vertical steel slabs have been affixed to this horizontal bar. These, in turn, are welded to two large flat steel circles, which then seem to float in the space above the steel lintel. Three other flat geometric shapes configurate around the circles at either end of the structure.

Though Smith was in the habit of composing many of his works as silhouettes, he generally shifted planes within his compositions so that they would move forward and backward in space. This practice tied much of his planar work directly to Cubism. The forms of *Primo Piano I* move only in the plane of the horizontal bar to which they are attached. The piece is emphatically a structure to view frontally. More than any other of Smith's late, large scale works, this piece contends that sculpture need not be "in the round"—it need only exist in space. Flat and dematerialized by the white paint that covers its surface, this sculpture has a mystical rather than a physical presence. It stands out as one of Smith's most daring attempts to make new sculpture.

Peter Voulkos (b. 1924)

Much of the Cubist/Expressionist legacy left by Smith was ironically inherited and perpetuated by a sculptor trained as a potter. Peter Voulkos reinterpreted Smith's vision of the heroic in a medium more ancient and basic than iron—clay. His energy, his irreverence and what has been called his technique-of-non-technique have markedly redrawn the lines separating fine art from the crafts. The work from his hands synthesized the lessons of New York painting and the history of monumental oriental ceramics. The result was an enormous production of radically original sculptural/vessel objects.

Voulkos understood clay as a material that could be both built up and marked upon. He knew that bricks and cuneiform tablets were all made from clay. He took the potter's art back to its latency in geology and clay. Then he brought this discovery forward into the present with

Figure 19. David Smith, *Primo Piano I*, 1962
Steel, painted white, 102½ × 145 × 22″.
Private collection.

a prodigious output of vessels that bear archeological witness to his libidinous artistic encounter with the world.

In clay, Voulkos found a way to create sculpture with the same immediacy and spontaneity that Pollock and Kline had imparted to painting. Clay, in his hand, was something that could be quickly formed and then pinched, prodded, gashed, marked and colored in response to whatever enactment he might initiate. Tools, time and process were virtually eliminated—the hand and the mind could syncretize and the record of this syncretism could be made permanent. Intuition and energy directed Voulkos as he worked. His confrontations with materials were physical and disciplined. His mastery of the skills necessary to the shaping and firing of clay was the liberation of his expression.

Gallas Rock, 1961
Stoneware.
96".
(Collection: The University of California at Los Angeles)

Gallas Rock is the most monumental clay sculpture that Voulkos every successfully built and fired. Over one hundred wheel-thrown and slab-formed elements are combined into the piece. More than anything else, the sculpture resembles a stack of handmade boulders. Piled one on top of another, the elements of the assemblage compress yet lift and inflate. It is in *Gallas Rock* that Voulkos reveals his heroic sense of the Montana landscape that surrounded him as he grew up. The sculpture celebrates clay as earth and earth as living strata.

Despite its sculptural presence, *Gallas Rock* remains an assembly of vessel forms. From a shape vocabulary derived from jars, jugs and churns, Voulkos constructed a monumental clay column suggestive of a kiln load of ware that had suddenly fused into one enormous vitreous mass. *Gallas Rock* is a true potter's totem, encoding the kinship of process and history in an homage to all that is inscrutable and timeless in the potter's art.

Plate, 1963 [fig. 20]
Stoneware and porcelain with sgraffito and slip decoration.
16" diameter.
(Private collection)

Though Voulkos has produced many plates, some of the earliest and most radically Expressionist ones manifest the physicality and idiosyncrasy that became identified as the "Voulkos style." The plate here is one of these. It is formed from slabs cut from wheel-thrown cylinders. This plate must be seen less as a platter than as a surface for artistic

Figure 20. Peter Voulkos, *Plate*, 1963
Stoneware and porcelain with sgraffito and slip decoration, 16″ diameter.
Private collection.

mark-making. The plate derives its form from an abstraction of a pottery motif; its surface decoration of impressed ideograms derives from an abstraction of drawing and writing.

The center of the plate has been sliced with lines forming a tic-tac-toe grid. The brilliance of Voulkos's deployment of this sign as "decoration" is that in the context of "plate as art" the tic-tac-toe sign makes Expressionist marking, doodling and graffiti all related gestures. A mark that at first seems impudent and juvenile becomes (on reexamination) provocative and sophisticated. The creative actions Voulkos compressed in the wet clay and scrawled across its soft surface were temporal. In the fire of his kiln he vitrified them for all time, along with a sly comment on Kilroy as Franz Kline.

Robert Irwin (b. 1928)

In the 1960s, Robert Irwin stopped painting and renounced his identity as a painter. By 1970, he was systematically dismantling his studio, divesting himself of all the props that typically establish one as an artist. He replaced his studio with an open field in his mind where he could play what could be called "an inquiring game." This activity, by 1972, would completely restructure the operative definitions and assumptions that would allow him to "be" an artist and "make" (speculate on?) art.

He rejected Expressionism's heavy emphasis on maker and mark and its celebration of the maker/self. He offered as an alternative pristine site installations of string, cloth and paneling from which the hand of the maker/creator would be completely expunged. I do not pretend to understand entirely Irwin's complex theoretical and philosophical art argumentation. However, I am persuaded that his restructured understanding of art have allowed him to create some of the clearest (and insofar as clear can connote beauty), most beautiful aesthetic assertions that can be embraced by the term "sculpture."

Irwin's walls and scrim environments are neither pure rationality nor pure metaphysics. Though his work has its roots in Western science and philosophy, it is heavily laced with Eastern mysticism. As reason, intuition and self-indulgence, Irwin's work simply asserts that art must be an act of curiosity and that aesthetic perception is the ultimate (and only proper) subject of art.

Untitled Disc, 1969
Cast acrylic with acrylic paint.
60″ in diameter.
(Collection: The Detroit Institute of Arts)

The disc pieces date from the early progressive phase of Irwin's work. In this period, Irwin began exploring light and its capacity both to describe and distort form. Central to this investigation was a simple convex disc made from clear acrylic. On its reverse side, the disc was subtly spray-painted white with a narrow silver stripe built up across its center. Suspended in a flood of projected illumination, the disc would diffuse into an ambiance of light, shadow and cast reflections.

In a given installation, Irwin would mount his disc on a tubular column that would project it a foot or more out from a wall. Training lights on the disc from specific points, he could create a physical/optical situation in which the disc as object seemed to lose its fixed relationship to its surroundings. A cloverleaf pattern of ghost discs became a halo around the acrylic original. The relationship between the disc (thing), the wall (place) and the room (space) became dynamic rather than static. The dynamic condition Irwin found he could create with his lighted discs encouraged him to search further for ways in which space and light could interact to extend normative perceptions.

Two Story—Flat Floating Plane, 1974 [fig. 21]
Plasterboard over wooden frame painted white.
22′ × 19′2″ × 5″; gallery 25 × 44 × 34′.
*(Installation: Wright State University [piece
destroyed at conclusion of exhibition])*

In 1974, Irwin was invited to Wright State and asked to consider a site work in the university gallery. The room presented to him was a tall, open cubical space, belted midway up by a catwalk mezzanine gallery. A metal guardrail encircled the four inner sides of the mezzanine walkway, which were open to the floor below. From the parquet surface of the ground floor, a column of space rose uninterrupted past the mezzanine to the gallery ceiling twenty-five feet above. It was across this opening that Irwin constructed a floating white vertical wall. His panel was affixed with hidden brackets to the beams which cantilevered the second level deck. Its bottom edge hovered some two feet above the lower floor; its top edge stopped about the same distance from the ceiling. To a viewer approaching it frontally, the wall/screen presented over 400 square feet of white expanse. From the side, the wall dematerialized, becoming only a narrow strip slicing across the room.

The wall identified and explored the unique properties of the gallery as an interior architectural space. The grand but inaccessible cubic void rising from the floor was both described and challenged by the white

Figure 21. Robert Irwin, *Two Story—Flat Floating Plane*, 1974
Plasterboard over wooden frame painted white, 22' × 19'2" × 5";
gallery 25 × 44 × 34'.
Installation Wright State University (piece destroyed at conclusion of exhibition).
(Photo courtesy the Art Gallery, Wright State University, Dayton, Ohio)

screen levitated within it. The wall became a present non-presence in the room—something both imposing and serene. Less an object than a condition, Irwin's installation was both active and contemplative in its environment. It converted a largely neglected and vague space into a sculptural argument postulated in a spirit of pure aesthetic speculation.

Robert Smithson (1938–1973)

No one today disputes the notion that Robert Smithson's cosmological view of art was anything but heroic. For his impact on the shape of modern art, Smithson is appropriately enshrined in the legion of modern Center Prometheans that also includes Malevich and Rothko. But it is specifically the sculptor Smithson that I consider here—the sculptor Smithson who admired the physicality of iron as an earth element as much as David Smith ever admired it as cast billets on flatcars in Pittsburgh. My exhibition focuses on the Smithson who would shape earth with bulldozers as adroitly as Voulkos would shape it with his hands.

Ever the intellectual, the poet and the theoretician, Smithson must not be overlooked as a sculptor. Earth matter (geology) fascinated him. The creation and dissolution of forms in nature (entropy) unified his sculptural/philosophical inquiries. And, finally, primitive ritual marks, sanctifying sites in the land (archeology), provided both the real and mythic base for his work.

It fell to Robert Smithson to wed lore and natural law effectively into a variegated but conceptually coherent new vision of sculpture for the late twentieth century. By arguing that the factual and the mythical were co-conditions in any work of art, Smithson challenged the binary system of oppositions that had historically divided art into two camps—the Classic and the Romantic. Further, by asserting that art and art products were not the same, he led his peers to the belief that imagination and understanding are the only tools a sculptor needs to reshape the world.

Asphalt Rundown, 1969
Asphalt.
Approximate length of spill, 80–100'.
(Site work: Rome)

A site work known almost exclusively from photographs, this project brought a dump truck loaded with hot asphalt up to the edge of an eroded earth bank. There the truck spilled tar and rock down the face of the bank. The classic photo documenting the piece is shot from the bottom of the bluff. At the top of the hill, the truck with its dump bed poised in the raised position disgorges its load of asphalt onto the black slide cascading down the precipice.

Asphalt Rundown was a study/illustration. Smithson believed that those who expected art to exist independently of nature were denying the temporality of the world. As a work of art, the *Asphalt Rundown* was meant to acknowledge and participate in the physical natural world. On the eroded bluff (site) Smithson imposed a mark (tar). Though this mark was initiated by the artist (act of dumping), it ultimately was shaped and controlled by nature (gravity pulling—tar cooling). Smithson expected his mark to disappear (erode) through a process (entropy) that would, in time, erase the mark, the marker and the marked alike. His belief was that entropy inevitably was itself beautiful and could be perceived and interpreted artistically in the physical/sculptural world. *Asphalt Rundown* ringingly affirmed this belief.

Partially Buried Wood Shed, 1970 [fig. 22]
Wood, earth.
Shed 10'2" × 45' × 18'6".
*(Installation: Kent State University [piece
now destroyed])*

The *Buried Wood Shed* grew from Smithson's interest in geology and archeology. Conceptually, the project revolved around a small storage shed that Smithson found standing on a plot of land at the edge of the Kent State campus. Smithson requested and was granted permission to use the shed in his project. He then employed workers with bulldozers to pile dirt around and on top of the shed until the central beam supporting its roof cracked. At that point, he abandoned the site—leaving further changes in the work to follow a natural (entropic) course.

Some have interpreted this piece as violent and destructive. Others have viewed it as a pessimistic comment on man's place in nature. The reverse seems to be true. The shed (man) persevered. Water and wind (nature) moved mud and earth around and through the shed. Over time, weeds and wild flowers sprouted on the site and sapling trees took root. Fourteen years after Smithson left Kent, the cracked center beam of the shed failed and the buried structure collapsed. As the artist had wished, his piece had accumulated its own history, and a condition of prophecy that he had instigated realized and fulfilled itself.

Claes Oldenburg (b. 1929)

The heroicism in the sculpture of Claes Oldenburg is all too often overlooked. The whimsical, the comic and the satirical aspects of his art are much easier to discern and describe. Oldenburg deploys the antic and the comic in his art much as Shakespeare did in his plays. In Oldenburg's art/world view, the hero and the anti-hero (fool) are paired and tied. They are inseparable in the anti-world he creates with his sculpture. Olden-

Figure 22. Robert Smithson, *Partially Buried Wood Shed*, 1970
Wood, earth, 10'2" × 45' × 18'6" (shed).
Installation Kent State University, Kent, Ohio. Photo shows shed partially
burned and collapsed, ca. 1975.
(Photo courtesy Brinsley Tyrrell)

burg pokes fun at the foibles of contemporary society with a serious (and sometimes cynical) finger.

The theatricality in Oldenburg's work is important and intentional. Shifts in scale heighten the dramatic impact of many of the works. Over and over, he deployed his "Pop" objects as props in a social play acted out in public spaces as well as in galleries. The grand and the overblown in Oldenburg's work, as in an opera, emphasize the tragic and the heroic in an almost didactic manner. Oldenburg assaults his audience operatically with his aggrandized clothespins and catsup bottles.

I perceive Oldenburg, the artist, as a classic anomaly. He inverts the world so that we can see it differently. Such a presumption reasserts the belief that an artist creating meaningful images can redirect the values and aspirations of a society. Oldenburg's sculpture is intentionally confrontational. As argumentation and suasion rather than as Pop parody, Oldenburg's art becomes heroic.

Giant Soft Drum Set, 1967
Vinyl and canvas, stuffed—on wood base covered
with formica.
84 × 72 × 48".
(Private collection)

Collapsed and disheveled, the *Giant Soft Drum Set* nonetheless retains its essential recognizability as a grouping of components from a percussion ensemble. Sticks, drums, foot-pedals and cymbals metamorphose into a landscape of plateaus, bluffs, peaks and rifts. Viewed at a more intimate scale, the stuffed shapes suggest a group of figures in repose.

The *Drum Set* is elevated and isolated on an enormous formica-covered wooden box. This pretentious (ludicrous?) pedestal transforms the sculpture into a serious icon. The pedestal is yet another of the polymorphisms that characterize Oldenburg's art. The deflated (disarmed?) drums are exalted by their presentation on the phony riser. Interpreted symbolically, the drum set is an ideal. It is an homage to the perfected state of community that Oldenburg envisions in a utopia somewhere beyond the rigid, aggressive world that his soft sculpture undermines and lampoons.

**Lipstick Ascending on Caterpillar Tracks [The
Lipstick Monument],** 1969, reworked 1974 [fig. 23]
Painted fiberglass tip, aluminum tube and
steel body.
H. 24".
*(Installation: Yale University [original
piece destroyed])*

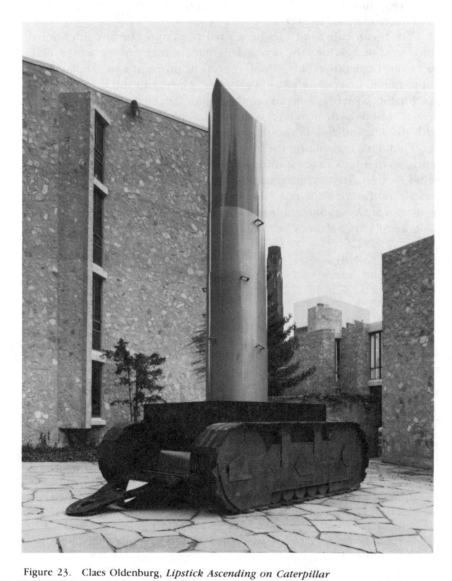

Figure 23. Claes Oldenburg, *Lipstick Ascending on Caterpillar
Tracks [The Lipstick Monument]*, 1969, reworked 1974.
Painted fiberglass tip, aluminum tube and steel body, 24'.
Photo of 1974 version.
*(Yale University Art Gallery, gift of the Colossal Keepsake Corporation;
photo courtesy Yale University Art Gallery, New Haven, Connecticut)*

The *Lipstick Monument* was an incongruity on the Yale campus in 1969 and remains so even resurrected for this exhibition. More strident than even most other Oldenburg works, the *Lipstick Monument* was obviously expected both to flatter and assault the illustrious academic community for which it was created. Sited in a plaza near one of the Yale libraries, the sculpture explicitly depicted a caterpillar-mounted, erect lipstick tube-cum-phallus.

The *Monument* juxtaposed two quintessentially American images—war tanks and designer cosmetic products. As an image, it was incongruously imbued with co-evocations of the masculine/feminine and the aggressive/seductive. The sculpture critiqued both the mechanization and the vanity that its maker believed had brought America to a crisis in the world (it was erected in the midst of the Vietnam War and the protests against it). The *Monument* was unavoidably confrontational, and its presence elicited repeated physical assaults. Ultimately, it was so severely vandalized that it had to be removed from the campus. It retreated into memory as a heroic veteran of a most unusual war. (A replacement version of the *Monument* was re-sited at Yale in 1974.)

Eva Hesse (1936–1970)

Eva Hesse is included in the exhibition for the pioneering way in which she committed herself to an exploration of the emotive and evocative properties of non-traditional sculpture materials. She sought an art without artifice and found it in forms made from latex, fiberglass, cloth and vinyl. She favored these materials because they could be slumped, dripped, poured and built up. Most important, she found them obdurately unrefined and ahistoric.

Hesse engaged her materials directly. She worked them with her hands and coaxed to their surfaces the sense that things fragile and isolated could somehow endure in a world that is abrasive and often overwhelming. Despite the quasi-serial (systematic) approach Hesse employed in the formulation of this work, she must be understood as an Expressionist by temperament. What at first seems in Hesse to be an aberrant Minimalism comes full circle to reveal itself as a "mystical-intellectual" expressive abstraction in which substances and processes meld into a single ephemeral vision of the sublime.

The other issue that seems to permeate Hesse's art addresses the connections that individuals may or may not have to one another in a community. Some of her latex slabs hang in rows like coats in a closet. Others are pinned uniformly along a wall with disconnected cords (umbilicals?) protruding from their centers. Despite its purity as an inquiry into materiality, the art of Eva Hesse must also be interpreted as figurative and humanistic. Her sense of materials recalls much of what Oldenburg

discovered in pliable (giving), informal (non-draftsmanly) media. Though her work could be expansive and grand, it essentially compels speculation on the small differences that distinguish beings from one another in an Emersonian (transcendental) understanding of existence.

Sans II, 1968 [fig. 24]
Fiberglass.
5 units each 38 × 86 × 6".
(Units now dispersed to various collections)

Superficially, *Sans II* is easy to describe. It is an arrangement of cast fiberglass box units approximately eighteen inches square and six inches deep. These boxes are stacked in two tiers that run horizontally across a wall at eye level for some twenty-two feet. Confronted, however, the piece becomes much more complex.

Each handmade tray in each unit on the wall differs slightly from its neighbor. Each shimmers with its own light pulse. The fiberglass material in *Sans II* traps and radiates light. The character of this light varies, depending on the thickness of the resin used in its construction. In addition, the color of each box modulates in a tonal range from clear to amber, depending on the discoloration which was occasioned when a chemical catalyst converted liquid resin into a solid. In concert, the *Sans II* trays and panels become the antithesis of all that is serial, hard-edged and predictable in minimal art.

Untitled, 1970
Fiberglass over polyethylene over wire.
7 units each 7'2"–9'3" in length;
10–16" in diameter.
(Private collection)

Built two years after *Sans II,* this untitled piece extends Hesse's statement on the ordered and the disordered from a wall surface into free space. This work also concretizes the anthropomorphism suggested in Hesse's earlier latex pieces. The seven bent tubes in this piece are suspended from a ceiling. They seem to wander, like disembodied legs, through an invisible confining circle on the floor. Standing and suspended, free-formed and yet wrapped, each of the tubes becomes a personage. In this configuration, the optimistic condition of community that the artist depicted in her more serial works is absent. It seems replaced by a statement on the isolation of individuals who seek to survive as unique entities in the world. This late piece, however, is not entirely pessimistic. Formally, it is reflexive; this reflexivity suggests that there are both real and ideal states in the world which are wedded through a poetic understanding of the self in an ebb and flow of life.

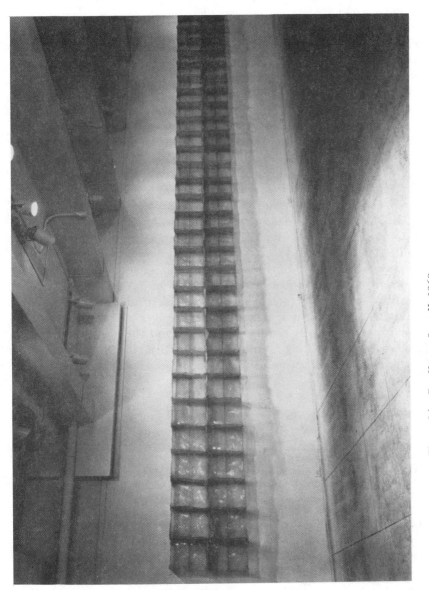

Figure 24. Eva Hesse, *Sans II*, 1968
Five fiberglass units each 38 × 86 × 6″.
Units now dispersed to various collections.
(Photo courtesy Xavier Fourcade, Inc., New York)

Tony Smith (1912–1980)

Since Tony Smith's work first became well known in the early 1960s, critics and artists have disputed its meaning and its place in the history of sculpture. Early on, it was branded Minimalist. On close inspection, however, this sculpture rejects such an assignation. Though Smith may have shared with certain Minimalists the expectation that sculpture should occupy real rather than pictorial space, there is much in his aesthetic that is indifferent to the canons of Minimalism.

For me, it was Tony Smith who best articulated the notion that physical sculpture formulated on tectonic principles (rather than on ideas of drawing or modeling) could heroically interpret the figural and the gestural in art. From plane and solid geometry, he reconstructs nature. His rigid forms, in the end, are anthropomorphic. Without the explicit figural references that transform many of David Smith's works into "personages," Tony Smith's sculpture nonetheless seems imbued with a life force. The structural essentiality of the work allows it to be read as both figure and landscape.

Smith the architect and Smith the sculptor were one. His early training in the language of building seems to have uniquely disciplined and broadened his sculptural understanding. Perhaps only as science uncovers more of that which links molecular and crystalline structures to living cells and DNA, will we understand empirically what Tony Smith the sculptor intuited—namely that the geometric and the organic are not mutually exclusive. Smith's gift was to heroically assert (in a contemporary vision) that science and art could unify in a tenacious architectural form of sculpture.

Smoke, 1967
Painted plywood.
22 × 45 × 33'.
(Installation: Corcoran Gallery of Art,
Washington, D.C. [piece destroyed at conclusion
of exhibition])

As a structure, *Smoke* was an exercise in elegance. Its columns and lintels bellowed into the Corcoran space like clouds. They enveloped and dwarfed the spectators moving through it. All that was grand and Beaux Arts in the gallery was trivialized by *Smoke*'s sculptural challenge to it.

At first glance, *Smoke* seemed to be only an eccentric space frame. Probed further, it revealed itself as a theoretical assertion that architecture and furniture, like human bodies and stellar constellations, have structural essences. Further, it suggested that, in the end, these essences

are irreducible. In its dark, planar austerity, *Smoke* extended contemporary aesthetic understandings of the structure of nature and of the structure that is both vital and immutable in visionary abstract art.

Moses, 1967–68 (Model Executed), 1969 (Piece
Fabricated) [fig. 25]
Painted steel.
15′ × 11′6″.
*(Collection: The Art Museum, Princeton University.
The John B. Putnam, Jr. Memorial Collection)*

Like some half-built ziggurat run amock, *Moses* presents a disquieting sculptural image. Its form alternately suggests and then obscures the tetrahedral geometry from which it grows. The lower mass of the piece is sliced, pierced and truncated. This mass rises to terminate in a matched pair of vertical columns or ''chimneys.''

The piece is asymmetrical and eccentric in appearance. Still, it is physically and formally refined. Its presence evokes the image of Michelangelo's horned *Moses*—defiant and combative and very much of this world. The refinement of idea that Smith could infuse to sculpture of such evocative and formal power was not matched by any of his peers. *Moses* stands as an important revivification of the modernist belief that rigorous geometric structural art can yet be startlingly original and expressive.

Alice Aycock (b. 1943)

The sculpture of Alice Aycock exemplifies the romantic/structural/pictorial tendencies of the generation of artists exploring architectural sculpture through the 1970s. I have identified these artists as Suprastructionists and have attempted elsewhere [see chap. 2] to describe the architectural/metaphoric idiom they created. It is possible, however, to focus on Aycock alone and to find in her work the full-blown heroic vision of a movement.

Aycock's art attempts to amalgamate specific historic information and imagery in constructed works that are initially inspired by personal fantasies and phobias. Aycock's sculpture is theatrical, narrative, participatory and enigmatic. The conscious architectural historicisms in Aycock pieces seem (at first) to be at odds with the narrative episodes of dream and memory that are freely woven through them. Intentionally, Aycock confronts viewers with sculpture that must be experienced as architecture but understood pictorially and metaphorically.

Aycock talks of movie sets, ghost towns and of the Egyptian City of the Dead as sources and inspirations for her work. These references

Figure 25. Tony Smith, *Moses*, 1967–68 (Model Executed), 1969 (Piece Fabricated)
Painted steel, 15' × 11'6".
The Art Museum, Princeton University, New Jersey. The John B.
Putnam, Jr. Memorial Collection.
(Photo courtesy the Art Museum, Princeton University, New Jersey)

touch to common themes of occupancy and habitation. Pictorially, her sculpture suggests that it is inhabited by mythic and imaginary beings. Yet as architecture, it invites a real occupancy from the viewers entering it. Such sculpture could easily become entertainment of the "fun house" sort. Presuming and risking much, Aycock's sculpture heroically walks an aesthetic tightrope.

The True and the False Project Entitled "The World Is So Full of a Number of Things," 1977
Wood and sheetrock.
Approx. 15 × 20 × 24'.
(Installation: Weber Gallery in New York [piece dismantled at the conclusion of the exhibition])

The True and the False Project was constructed of rough cut wood enclosed with plasterboard in a method typical of the construction of contemporary homes. As a structure, the piece was a maze-like configuration of walls, rooms, stairways and window bays. Crawl spaces and ladders connected its various chambers and terraces. Blind portals and niches pierced its facade.

The work became a surreal stage suited to both impromptu performances and ritual pageants. Though the self-revealing ordinariness of its construction rendered it familiar, the overall impact of the piece was disorienting and disquieting. Aycock intentionally left the piece open to multileveled interpretations, but she clearly expected that such interpretations would grow from a viewer's physical confrontation and exploration of the project.

Large Scale Dis/Integration of Microelectronic Memories (A New Revised Shanty Town), 1980 [fig. 26]
Wood.
Ramp unit 14 × 75 × 105'; adjacent carousel unit 14 × 15 × 30'.
(Installation: Battery Park Landfill, New York [piece now destroyed])

Shanty Town was never actually completed. It was designed as a complex of elevated boardwalks enclosing a maze of walls, which, in turn, were to be pierced by fifty-two doors. From a distance, the structure resembled a causeway or the timber frameworks ship-builders refer to as "ways." Closer up, the piece was a symmetrical, two-story labyrinth opening to the west, where it faced the Hudson River and the New Jersey shoreline beyond.

Aycock fictionalized the piece as an old woman's search for her life's history—each door representing a year of time. Aycock intended for

Figure 26. Alice Aycock, *Large Scale Dis/Integration of Microelectronic Memories (A New Revised Shanty Town)*, 1980
Wood, ramp unit 14 × 75 × 105'; adjacent carousel unit 14 × 15 × 30'.
Battery Park City Landfill, New York.

viewers to experience confusion, confinement and solitude as they explored the maze or walked down its ramps. She projected these emotions as mirrors of the emotions of the sculpture's mythical maker—and perhaps those of anyone reflecting on the events of a life.

As it neared completion, *Shanty Town* came under siege. Its doors and wall panels began to be stripped away at night to surface in the morning as loft improvements throughout lower Manhattan. Time and funds for the project ran out. In the end, Aycock stoically accepted the fact that her own fable had indeed become fact, but had become so in a maze of narrative much more complex than the one she had first envisioned on the beach in Battery Park.

Mark di Suvero (b. 1933)

To mix audacity and ambition is to conjure the art and the person of Mark di Suvero. Born in China and raised in San Francisco, di Suvero originally aspired to be a poet. He studied philosophy in college before discovering his calling to sculpture. Something of the poetic wit and irony of Marianne Moore as well as the iconoclasm of the Bay Area "Beats" continues to shade di Suvero's art as well as his political dispositions. His idiosyncratic pictorial assembled sculpture is slightly Whitmanesque and thoroughly American. It fell to di Suvero to ennoble the term "junk." It also fell to him to fuse Freud and Ginsburg in a revitalization of the primitivism that Picasso had bequeathed to David Smith—a legacy that seemingly had lost its potency in the hands of Smith's self-appointed east coast and British heirs.

It is the sledgehammer directness of di Suvero's work that gives it its heroic edge. His work is often seen as the three-dimensional counterpart of Franz Kline's painterly Expressionism. Though formally this may be so, conceptually and spiritually di Suvero is more interestingly compared to Calder. Where Calder played, di Suvero romps. Where Calder was suggestive, di Suvero is explicit. Most important, where Calder was considered and refined, di Suvero is brash, blunt and incisive. Di Suvero has created a populist American genre art from the Constructivism and Surrealism that remained essentially French in the sculpture of Calder.

In the end, it is raw physicality that most distinguishes di Suvero's art. His is a sculpture in which I-beams clash and cables restrain suspended ship prows and floating tanks. Tires and telephone poles thrust and parry. Di Suvero's sculpture is classically modern. It is abstract and intelligent. It is self-absorbed, but not at the expense of social awareness. Its expressive power and personality reflect the decidedly American ingenuity and assertive temper of its maker.

Pre-Columbian, 1965
Wood, steel and rubber.
98″ × 14′3″ × 110½″.
(Collection: Storm King Art Center)

This sculpture is one of di Suvero's earliest works to incorporate the
motion of a "roundabout" or carousel. It consists of a horizontal stack
of wooden poles, steel extrusions, chain sections and driftwood all
capped at one end by a rubber tire. Balanced over a metal shaft fitted
onto a low tree stump base, this entire assemblage (like some Brob-
dingnagian weather vane) pivots and turns.

The subjective and the experiential in art all fuse in the powerful
iconography of this work. Its disjunctive form defies polite analysis and
demands instead to be understood as coming from the realms of play
and fantasy where the art called *brut* originates and has meaning.

For Lady Day, 1968 [fig. 27]
Painted steel.
40 × 54 × 35′.
*(Collection: Governors State University, University
Park, Illinois)*

Lady Day consists of a linear I-beam structure supporting two gigantic
steel drums. These drums are formed from a railroad tank car tank which
di Suvero sliced open at one end. The small section salvaged from this
cutting is mounted on a boom connected to a tall steel mast that rises
vertically from the sculpture. The large tank section is suspended in
the archway under one of the outrigger legs supporting the mast.

Like much of di Suvero's sculpture, this piece is both an abstract three-
dimensional drawing and a kinetic found-object collage. The beams of
the structure from an anthology of Expressionist gestures in space. The
tank drums provide a counterpoint of mass within this composition.
The horizontal boom with its small drum dips and rotates in the wind.
The large tank swings ponderously in its harness when viewers step
into its yawning mouth.

With *Lady Day,* di Suvero established the scale concerns that would
typify and identify his work after 1968. Despite di Suvero's non-
objective intentions, the scale and imagery in this piece evocatively refer
to ships and locomotives. Alluding to the grand and to the mythical,
di Suvero reveals his ambition to monumentally reinterpret American
Constructivism and the whole idiom of welded steel assemblage.

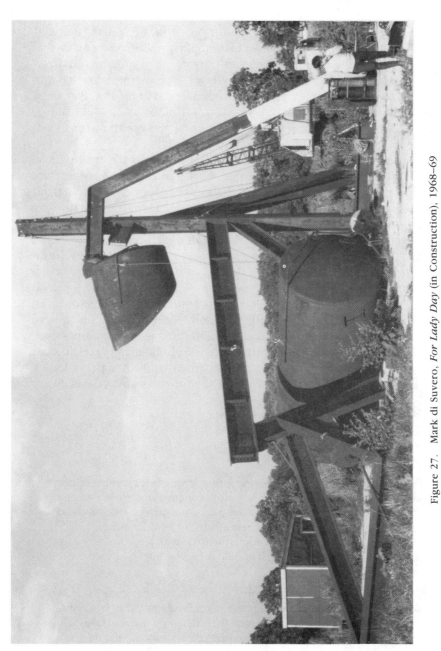

Figure 27. Mark di Suvero, *For Lady Day* (in Construction), 1968–69
Painted steel, 40 × 54 × 35'.
Governors State University, University Park, Illinois.
(Photo: Michael Hall)

Richard Serra (b. 1939)

My exhibition checklist rounds out with the work of Richard Serra. It was Serra who identified the physical essentiality in di Suvero's manipulations of weight, mass and balance and translated it into a material and process-based conceptual art. Layer by layer, Serra stripped style from sculpture to expose the bare physical structural facts at its core. For Serra, steel and wood are not materials to bend, form and assemble. Instead, he expresses them for themselves in their most unprocessed (and unstyled) states—as plates, bars, blocks, logs and planks.

For Serra, forms that are in the plane of the earth are prone, those perpendicular to the earth are standing. Forms in any tilted attitude are either propping another form or are themselves propped. Ordering and locating, stacking and scattering his elements, Serra inquires into the way in which gravity, time, weight and materials become the alphabet of image-facts from which sculpture historically has been made.

The demonstrations in Serra's early pieces escape the trap of illustration primarily because they are so devoid of nuance. They must be accepted as the physical/sculptural revelations that they are. Only the prop piece that best demonstrates "propness" survives. Having reduced sculpture to the elements of "sculpturalness," Serra now seems to have embarked on the making of works in which these elements compound. Some of this work has entered the arena of public art. There, it must somehow retain its heroic elementariness in an ambiance pervaded by the very complexities which Serra as a sculptor has always eschewed.

One Ton Prop [House of Cards], 1969 [fig. 28]
Lead.
48 × 55 × 55".
(Private collection)

One Ton Prop is an open box shape formed from four identical square lead plates. The base edges of each plate are aligned along the perimeter of a square drawn on the floor. The plates are then raised and tilted toward each other until their corners meet. The box stands because the plates are configured in an offset system in which each plate props the corner of the plate to its left and, in turn, is propped by the corner of its neighbor to the right.

Like a card house (the reference in its second title), the sculpture stands. The gravitational tug that would have it fall is offset by the buttressing inherent in its configuration as a structure. In lead (a material traditionally understood as among the most inert of substances), the dynamic nature of the sculpture as a system is emphasized. Poetically, a basic sculptural affirmation is expressed in the most base of metals.

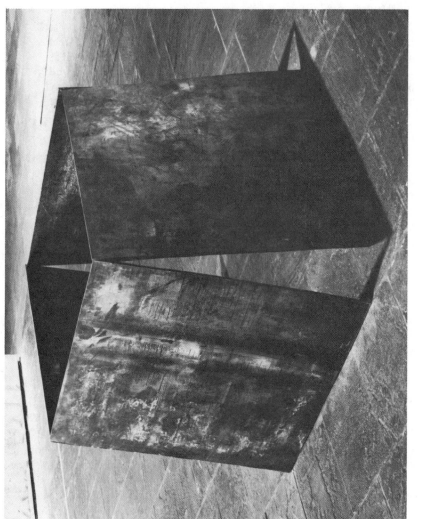

Figure 28. Richard Serra, *One Ton Prop [House of Cards],* 1969
Lead, 48 × 55 × 55".
Private collection.
(Photo: Jerry L. Thompson; photo courtesy Leo Castelli Gallery)

Delineator, 1974–76
Steel.
Each plate 10 × 26'.
*(Installation: Ace Gallery, California [piece
dismantled at the conclusion of the exhibition];
collection of Richard Serra and Ace
Contemporary Exhibitions)*

Delineator opposed two identical massive rectangular plates of steel
in the open space of a gallery. One plate on the floor was centered as
a rectangle within the larger rectangular plan of the room. A second
plate, suspended from the gallery ceiling, was centered transversely
across the room with its mid-point exactly plumb over that of the plate
on the floor.

In *Delineator,* Serra abandoned the pure structural and process-based
concerns that were the primary focuses of his earlier work. In this in-
stallation, the elaborate support system necessary to "levitate" the ceil-
ing plate was disguised—made invisible. The weight and mass of the
floor plate seemed denied by the illusion of its floating counterpart de-
fying gravity. *Delineator* was both physical and meditative. Viewers
aware of the crushing weight over their heads were nonetheless drawn
physically and empathetically into the centering locus of points
resonating between the plates of Serra's dark steel cross.

* * *

The artists discussed here, each in their own way, bring something heroic
to contemporary American art. Obviously, the history of heroic sculpture
must be separated from the Romantic history that fictionalizes artists
themselves as heroes. This popular image of the artist as Promethean out-
sider traces back to the biographical writings of Giorgio Vasari. His
sixteenth-century volumes on the lives of Michelangelo, Leonardo, etc.,
spawned the twentieth-century cult of the Left Bank bohemian. Revised
and augmented by Romanticism, Vasari's concept of the divinely inspired
artist/hero became a secular stereotype of the artist/self as heroic creative
deity.

Vasari, no doubt, would have understood and venerated Van Gogh
as an immortal. It is even probable that he would have placed David Smith
in his hall of heroes. The lives and artistic expectations of both Van Gogh
and Smith conformed to the models propounded in Vasari's biographies.
Beyond Smith, however, Vasari would probably have found himself con-
fused and conflicted in an attempt to "type" American heroic art and
artists. Vasari lived in a world described by a linear, and generally one-
point, perspective. The artists discussed here assume that American art

(like American politics) would come into its own somewhere beyond the vanishing point that limited and circumscribed what Vasari, as a European, could know and see.

It falls to Americans to understand a plural heroic in their art. No single measuring stick will assess the heroic in work as different as Aycock's is from, say, that of Irwin. One concept of the heroic informs the pictorial/gestural art of David Smith and Peter Voulkos; another, the theoretical/perceptual art of Smithson and Irwin. We look in yet another place to find the heroic in the structural/metaphoric art of Tony Smith and Alice Aycock, and we reassess our understandings again to grasp the heroic in the political/ideational art of Oldenburg and Eva Hesse. Finally, only by formulating still another definition can we divine the heroic in the constructive/deconstructive sculpture of di Suvero and Serra.

A different breed of artist is creating the sculpture for our time. Theirs is a demanding and vigorous art asserting itself into spaces historically accorded to architecture, philosophy, psychology, theology and even painting. Despite its complexity, sculpture persists as an art with a history and an identity. It formulates itself in imagination and it concretizes itself in materials. It questions and it answers—it posits and it rejoins. Most important, it aspires. The new heroic sculpture engages the history of culture in fields of perception and dialectic which, from the tree-lined horizon at Bolton Landing, now reach into a far beyond.

Part Three

Selective Attention:
Collector Artists/Collections as Criticism

A Sorting Process: The Artist as Collector

Published here is an edited and abridged version of a lengthy 1976 conversation on folk art between Sarah Faunce, Curator of Paintings and Sculpture at the Brooklyn Museum, and Michael Hall. The taped and transcribed conversation between Faunce and Hall became part of a catalogue accompanying the Brooklyn Museum's bicentennial exhibition, "Folk Sculpture U.S.A." Faunce interviewing Hall sought a statement on folk art from a contemporary artist/collector. Hall's responses to Faunce's questions reflect the shifting perspectives of a new generation of American folk art enthusiasts.

* * *

Sarah Faunce What I want to start with is really what interests me most and has since I saw the pictures of your collection and knew who you were—the fact that you are a contemporary, sophisticated sculptor coming to your maturity in the sixties, and at the same time you are a connoisseur of this naive tradition. I am interested in how you got involved with folk sculpture.

Michael Hall That seems to be the first question that everybody comes up with. Where does it all tie in? I think all too often they want a simple correlation, one-to-one.

SF Which is impossible.

MH Probably, but there are certainly connections even though they may seem obscure. Folk art is meaningful to me and has affected my work. However, my affection for it really has more to do with an attitude and an outlook than it has to do with forms.

For thirty-five or forty years now we have seen contemporary sculptors trying to build a contemporary aesthetic connected to this material. Nadelman and Laurent were probably the first and the history

moves right on up to William King, Red Grooms, Marisol, Lester Van Winkle and others in our time. They all found inspiration in folk art forms. We see this manifested in their work. We see the influence on these artists go directly into a look. Not so in my work.

SF That's why the question. You know, with Marisol, for instance, you can almost feel . . . see . . . a one-to-one connection.

MH Let's back up and come at this another way. I was born in California. I'm a product of the post-war period. My family moved West as many people did after the war and I was born into a world where history was the last five minutes. It was quite an eye-opener for me when I left the Coast. I moved to Colorado, then to Kentucky, where I taught at universities. I first saw folk art in the mid-sixties. Suddenly, some kind of a history—a cultural connection—began to fascinate me.

Discovering folk art, I had the great sense that I could simply declare my cultural roots. I did not need to have New England forebears to claim a particular Connecticut portrait as my birthright. I could just say, "This is my birthright" and build a family history of my own choosing. As an artist, I think that the same kind of arbitrary, free approach to finding a family tree began to carry over into what I thought about my own work. My childhood was without art in every sense, so when I came to art I could pick my parentage, as it were. If David Smith's work made sense to me, then David Smith could be grafted onto my ancestral tree. If Mark di Suvero influenced me, I could adopt him too.

I have been in the American Midwest for almost nine years. Maybe all those cliches about the heartland have gotten to me. But, somehow, I have begun to put the things I'm collecting into a particular perspective of identity. Folk art is tied to the land. It is tied to a sense of self. It is tied to regions. These connections have become interesting to me. The value of folk art may be its affirmation of its maker's identity *in* a specific context; the self in a community, in a region or perhaps in an ethnic group and of course in a nation. Folk art has made me curious about what Americans are.

I remember sitting in my house one evening talking to a young artist from California. After a few gin and tonics, he looked over at one of the Tolson carvings in the collection and said, "Michael, I have got to tell you, that's the most limited thing I've ever seen." I had a small revelation! He was *absolutely* right. The carving was so terribly limited that it had true individuality. It was Edgar Tolson's unique limitations that gave the piece its existence and its specific qualities as a work of art. The piece stood for Tolson and Tolson stood for it—and neither could be

removed. Our culture, identified as a people in a place in a time, would be the poorer without it.

After that evening I understood that what excited me in the folk art material I collected was what I call the "one man, one pocket knife" statement it makes. I'm not interested in cigar store Indians or factory decoys or assembly-line produced carousel horses. I'm attracted to the kind of material that the Brooklyn Museum show is about—works in which you find some maker's affirmation of self—"I am," reiterated again and again. That's my definition of art's place in culture. Collectively, it compiles and confirms our identity as creative, self-aware beings.

SF Someone like Tolson makes these things because he is Tolson and he has to make them.

MH And that he did make them matters. His existence on this earth somehow is validated right there. In a sense, we need him to know who we are. We need that *he is* to believe that we are.

And this brings us down to the question of the definition of art. The definition that I'm using really has to do with the declaration of self or the recognition of self in time and place. Perhaps we became human when we painted our first cave ceiling. We recorded our tribe in the midst of a bison hunt. We recalled an afternoon or a particular event. Or maybe our depiction was votive—an offering in a season when we needed a good hunt. The particular purpose of the cave painting doesn't matter so much here. What matters is the fact that the cave painting itself confirms that man recognized that he existed and that he existed within a context— his tribe, the seasons, the environment. Depicting his interaction with a herd of bison, he recorded his awareness of himself. Perhaps this act of cognition made him man.

The folk artist does that. I think all artists do that for us as a people or as humankind. That's why there will always be art. Every generation has to have its artists. They affirm our existence for us, though we don't always accept their art. Confusions arise, of course, as we debate art and art history, art and art criticism, art and style, art and taste, art and acceptance and art and alienation. But *Art* goes on.

In the high-art world, artists are bound together by a recognition of their cultural worth. The dealer/collector system and the museums also join in to support the arts and all together this is the so-called art community. The folk artist works outside this community. That is really the only difference. The folk artist hasn't been brought into this embrace.

Who is to know how long that situation will continue? Many contemporary folk artists are now being clutched to our cultural breast prac-

tically to the point of suffocation, almost from the day they're discovered. Better this, though, than neglect, I guess, because they are important to our culture. Tolson is a good example. What he does for himself, for his family, for the people of his town, for the people of eastern Kentucky, for the people of the South, and for the people of the nation, in its own small way, matters. I don't think I'm overextending this. He is one among many. He happens to be very good, and when artists get that good, they matter more and more.

SF I had a number of questions about how you relate to this kind of unsophisticated material as a sophisticated artist. I was looking at some pictures of your work—big, structural statements that retain a very country feeling. I wondered if that was a feeling at all connected with the folk sculpture.

MH Well, no. I think that quality of something country or countrified in my work is

SF By country, I don't mean quaint. I mean something that is built out of the ground, that relates to the ground.

MH Well, that's true. My pieces are for landscape. They are conceived for the out-of-doors—for spaces which are definitely not urban spaces. Not simply rural space, but the outdoor space I know around me—a specific skyline and a different kind of source—Michigan or Kentucky—where I have worked.
 So my work relates to folk art indirectly, through my empathy for the fact that the folk artist always works out of his limits. He never questions that what he does might be otherwise. His expression is vernacular, personal, and specific. That's what gives his work its character. For too long we have felt condescending about this. It's seemed somehow provincial—a damning label to set on any work of art, because provincial suggests

SF . . . That it's not aware of the whole tradition of art.

MH Right. One starts to believe that the art world begins and ends in Soho or uptown—in lofts or in the galleries—and it's not so. Soho itself is a province. It's quite possible that the work that comes out of Soho reflects primarily local values. When these values are hyped as the values of the whole art world, it becomes another issue altogether. But I think it's perfectly reasonable that somebody working in New York would be

involved with New York values, with images that come out of a New York environment and from the contacts and stimulations which generate a New York view.

I live in the midst of a houseful of folk art which buffers me artistically. I'm trying to be an artist in a pluralist art world and still be clear about what I know and see and value independently. Folk sculpture, in my dark moments, is a certain solace to me. My collection is a monitor or check on what I do in the studio. I have to walk through the collection to get to the studio and that walk becomes a gauntlet. The folk objects stand there and tell me what my mission really is. To come back from work, I have to pass through their scrutiny again. The ideas that I've just set forth, the images I've just created, and the values that I've just made manifest—whatever it is that I've just formulated in the studio—has to stand a comparative test. I try not to live with inferior things. The better they are, the harder they are on me. I like the discipline, I like the challenge.

I could walk through a room with three or four David Smiths, a Mark di Suvero and a Peter Voulkos and feel the same thing. I wouldn't separate it. If I could own the Smiths, I would have them too. I find the identity and value in Smith's work fantastic. I can sense a "one man, one pocket knife" quality running through his things, even though he worked in welded metal. Mentally lets place the black figures I found in southern Ohio next to a David Smith. They're not the same in appearance, but as to what they confirm about art, they are similar—for me.

SF Tolson's *Fall of Man* series is somehow irresistible.

MH I'm drawn to its clarity. I have lived with it long enough to have the feeling that in the eight tableaus of the *Fall of Man* series, Tolson has really given us something profound in its art content and something very reductive, very essential in terms of its sculptural form. It's really a self-portrait—Tolson's own comment on the personal isolation of the individual in this life. The *Fall* narrative begins with a blissful depiction of the conviviality of the Garden of Eden [see fig. 42]. Progressively, it moves on to become a statement on man's isolation and alienation. The Cain figure standing in the last tableau staring off into nowhere has survived birth and death—alone. The sorrowful Eve figure bent over the fallen Abel has also survived a profound life experience and grieves alone (see fig. 29). Tolson depicts life as a passage in *The Fall*. He also acknowledges the indomitable quality of man—and hence of himself. As much as I admire Tolson's tableaus I think his most important statement is in the single figures he carves. I've seen dozens of them and they always

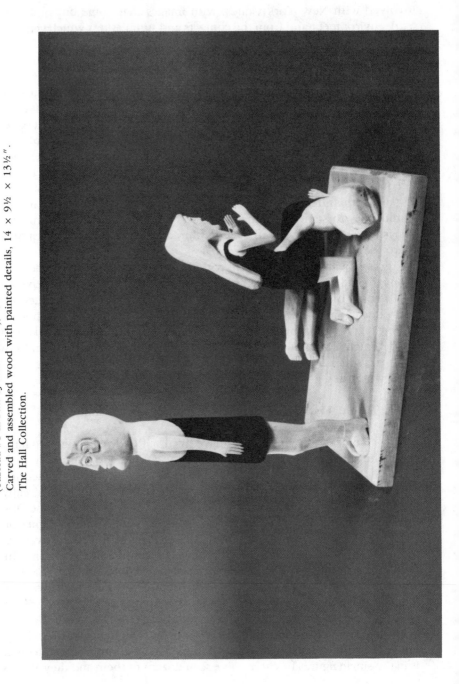

Figure 29. Edgar Tolson, *Cain Going into the World*
(Tableau #8 in *Fall of Man* Series), 1970
Carved and assembled wood with painted details, 14 × 9½ × 13½".
The Hall Collection.

have a certain frozen frontality that's so in-turned that it's almost Gothic. Each figure is reserved and enigmatic. And yet, each is profoundly under control, stoic. All of his single figures—the Appalachians call them dolls—are autobiographical. They look straight ahead and their arms (90 percent of the time) are held right at their sides. They have a visage which you don't penetrate, you can't see beyond the mask of their faces. The person inside is closed to you—as most Appalachians are closed to outsiders—as they are closed even to their own families.

SF Really not communicative.

MH It's a subcultural view. It's the thing that everyone always stereotypes: the suspicious, reactionary, southern Appalachian who would just as soon shoot you as look at you. We've heard all those cliches. But those characteristics grow out of the isolation of people living in pocket settlements up in the hills. They face a world where they are essentially outcasts—as are Eskimos and so many other marginal subcultural groups. I see Tolson as being very aware of this because he lives it every day. He has lived it for seventy years and has become its poet laureate. He can say it and he can say it so well in his art. The figures in Tolson's tableaus, Adam, Eve, Cain—they are all Tolson to me. The Cain figure in the last piece of the *Fall* series stands alone—he is the single figure Tolson has always built his statement around. The space between the Cain figure and the weeping Eve in this set-up is significant. It is a very modern space filled with psychological meaning. Merce Cunningham can't choreograph figures in space any more intensely. The question of what is sophisticated and what is not gets to be a moot point.

I hope viewers can feel and understand Edgar's use of space and feel the psychological relationships between his dolls. Only then can they understand how Tolson really sees life. I could talk about each piece in the group, but that's not important. We need to know that the series begins "perfect"—in harmony with itself. It ends up discordant—or "real" (depending on your view)—out of phase with itself. The series ends with actualities rather than with ideals. Mountain people live a very actual life and Tolson is telling us about that. *The Fall* is directly out of his own experience. My sense of the symbolism in Tolson's *Fall of Man* will be challenged by a lot of people. They won't want to see it. They'll think I'm off the mark, trying to read too much into the series. They'll think I'm

SF . . . Projecting into it.

MH Yes, attributing a great deal to a source they believe is not capable of such insight or capable of rendering such complex notions of content in a work of folk art. Go ahead. Let them look at the piece.

SF But you're not out to proselytize about it.

MH I'm not, no. I think that American folk art in its best moments is terribly important, but any art is terribly important at its best moment, for reasons that I've already clarified. It's just that, in my opinion, American folk art is an art idiom that has not yet been critically understood. One of the reasons for this is that the vocabulary of folk art is so disparate.

SF You can't make easy attributions.

MH Right, You can't say that a certain piece worked into such and such a ritual and was probably made by such and such a carver from such and such a period and is the third best example known.

SF Nice museum criteria.

MH Nice, close, curatorial, compact categorizations. Right? What can I say? You're not going to be able to do that with folk art and especially not with the work in this show.

SF No, that's right. There's a tremendous range.

MH And that's what's so American about it. Now I can wax a little chauvinistic. If the melting pot theory has any substance at all, it should be absolutely manifested in our folk art production. In my opinion, it is. And if our political value or our collective national psyche has a plural character, it might be reflected in an art that is really independent, frontier, inventive, ingenious—all those cliches out of our high school history books. Why shouldn't we find these qualities in our indigenous art production? We do. But having found them, we have difficulty living with them. It would be easier if folk art all looked alike, if it all grew out of a common value, a common vision. If we could box it all up and package it, we'd have it made. But we can't. The debate on folk art is only beginning.

This exhibition will only be as good as the idea behind it and the objects brought to it. Not to be able to borrow three or four critical pieces is to weaken the show's statement. It's curious that when things finally

matter, they matter so much. It's like dealing with the Renaissance and not fitting

SF . . . The monuments and the masterworks, yes.

MH To miss the Sistine ceiling and the *Last Judgment* fresco is to miss key statements that confirm and validate a time, a view and a history. I like the idea of this show. I like what I think is being loaned. If the critics and the public can appreciate the exhibition as a bringing together of a significant 60 percent of the best works in an idiom, I will live happily with that.

This project brings to mind the last folk sculpture show I worked on, "American Folk Sculpture: The Personal and the Eccentric" (Cranbrook Academy of Arts Gallery, 1971). It seemed so easy then. As co-curators of that show, Bert Hemphill and I sat down and built an exhibition around a great want-list; it was one of those games you play in your mind late at night—the Super Show. If we could put together sixty items, what would they be? With no consideration of what was or wasn't available, no consideration of size, scale, rarity, value—none of that. We just listed sixty items, and secured the loan of forty of them for the exhibition. It was marvelous—but it won't happen again.

SF It's like every other thing.

MH Yes, the things we were borrowing then are treasures now. In those days, they were just curiosities. It wasn't really that long ago, but a lot has changed. New interest is building and everyone is competing for folk art now. In the Bicentennial period, everybody is trying to exploit American things. However, I don't think folk art is well understood. It's still looked on as a curiosity. I think Brooklyn is to be congratulated on the quality of what it is exhibiting here. "Folk Sculpture U.S.A." is about something. I hope it starts a new conversation on American art.

SF Yes, that's what I hope too. That people will penetrate through to the serious level of the objects and not see them just as charming or quaint.

MH I've never seen them that way. If that's what they were to me, I wouldn't collect.

SF You never even went through that stage?

MH Never. I don't know why. It seems like such an easy place to start.

SF You first saw folk art in Kentucky?

MH I first saw it right here in New York—by accident—ten years ago at the Museum of American Folk Art. Bert Hemphill had curated the exhibition on view and it included some important things brought together from collections in the city. My wife Julie and I just walked up the stairs to the museum gallery and fell into folk art. It spoke and we listened. The more we listened, the more we could comprehend. Conversions are sometimes very slow, and sometimes very sudden and intense. Our conversion to folk art was—Wham! We saw something at work, something we really didn't know about in any historical sense. That chance meeting also launched the whole interaction between Bert and us; he had the history, we had an outside perspective that made us

SF Fresh to the whole thing.

MH Yes. We'd never heard of the limner, John Brewster. We had never heard about Wilhelm Shimmel traveling around Pennsylvania trading his carvings for food and lodging—and we didn't need to know about those things at that point. Bert fascinated us with his insights and with the experience he had with folk material. We fascinated him with our naive enthusiasm. He felt it gave him fresh insight. Up until that time, I guess he had never run into anyone who was able to come to folk art so freely—an audience who hadn't been brought up with folk art as antiques and heirlooms. As art people schooled in modernism, we knew something about African art, about Oceanic things and pre-Columbian artifacts, but folk art was new to us. Today, our understanding of folk art has been complemented by the history and experience that we've built viewing collections and reading books. Greater understanding helps us discriminate as we collect. We draw clearer lines now but we still get intensely subjective when we make those late-night lists.

SF That's a wonderful collector's game.

MH It is *the* collector's game.

SF The collection without walls.

MH Yes! It exists as idea. Criteria tighten and focus within a panorama that is always expanding as new objects come to light—things you didn't

know existed. As your horizon expands you develop a narrowing or focused insight. Collecting becomes structured. For me, collecting is more engaging now than it was in the beginning. There is always something to learn from a new discovery. Take the *Boy Riding a Bicycle* that the Brooklyn Museum just acquired (see fig. 30). It was under all of our noses in New York for ten years. Then it was "discovered" and came on the market. The first time I saw it, I already knew that the Museum had a "hold" on it. That's collecting. Every collector has a story about the one that got away. Of course they also have the stories about the ones they landed. Sometimes it comes down to timing, circumstance and luck. *The Newsboy* is one we recently landed [see fig. 31].

SF That's very recent, isn't it?

MH Yes, and it is acquisitions like *The Newsboy* that keep a collector going. If we didn't believe that something like that figure was still out there somewhere to find, we probably wouldn't still collect. That's what keeps dealers alive and collectors hungry. It's almost unbelievable that after forty-five or fifty years of an intense combing of barns, attics and basements, that something like *The Newsboy* would just appear. I'm still amazed that an untouched figure of that much originality, power, expression and interest was still out there for the picking.

Every collection is built a piece at a time. I think the public never fully understands that. Museums sometimes don't understand it. Ninety percent of the time, I don't believe that curators really know what they ask for when they ask for a loan. I'm sorry, but I think it's true. Even a museum collection is built a piece at a time. Every museum gift went through a birth agony with the private collector who donated it. Or perhaps, a curator in a museum takes a position and starts to buy and build. Then he or she moves to another institution and a new curator inherits the collection but *not* the history that built it. To a new eye things once highly esteemed and desired are suddenly just "stuff."

Every piece in every collection has a story. If a collection is a statement—it's constantly creative. A collector saying, "I will own this, I won't own that," is exercising a creative prerogative. Examining a collection as a sum of parts, we find the collector expressed.

SF It doesn't come to an end, does it. It never comes to the point where you say, "Well, I've had enough now. I'll stop."

MH Historically, that doesn't seem to be true. We find that collections close. After a certain period of building, learning and acquiring, a

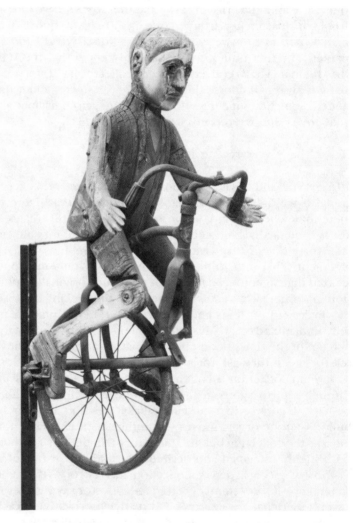

Figure 30. Lewis Simon, *Boy Riding a Bicycle* (Sign), ca. 1950
Painted wood and metal, 40½".
Collection the Brooklyn Museum, New York.
H. Randolph Lever and Dick S. Ramsay Funds.
(Photo courtesy the Brooklyn Museum)

collector has shaped the core of a collection. The collection closes—which doesn't mean that a piece or two isn't added here and there. But as a statement, it is done. Often when a collection starts to close the collector sends it to auction. It's split up again and its parts then filter out and fall into new alignments with other things in other ownerships. I think this is very healthy. Sometimes, of course, a collection transfers in its entirety to an institution like a museum. That's reasonable too—providing, of course, that the receiving institution *cares*. There is nothing sadder than an unloved collection.

SF Yes, better for it to be in the hands of people who can care for it than to be tucked away and neglected.

MH Witness the recent dispersion of the Mackey decoy collection. That great collection is now a part of the life of hundreds of other collections. It starts again. Think of it as an ecological system. Collecting sustains itself. I can't overestimate the value of private collectors.

SF Your pieces in this show were among the first that I saw and [were] one of the reasons for my instant excitement with the show. Are any of your earliest acquisitions in this show, or are they mostly later things?

MH The show includes a cross-section of the whole period of our collecting. The *Man with Pony* [see fig. 43] came in the first year. The *Sport World* came within the first year and a-half. The *Miss Liberty* figure within the first two years. We had very good luck.

SF You certainly did.

MH We found some great things when a lot of people weren't looking at eccentric folk art. Certainly more conventional material—factory weather vanes and cigar store Indians—had been avidly collected for years. But the more personal, one-of-a-kind, eccentric folk art was still out there. Some of the earlier collectors had understood it and had shown an appreciation for it. But even those collectors acquired offbeat things mostly to complement more mainstream objects—material that could best be called "Index of American Design" Americana. A lot of what Brooklyn has included in this exhibition certainly never would have made it into the "Index." It is a little too offbeat. As I said, a few people had looked at this material early on. Bert Hemphill and Adele Earnest always responded to these things. But it takes a wide interest to make a collecting area—to make museums take note or to make the general public, the art

community or the critical community create space for a new art form. It takes even more to assert that new material might even displace traditionally accepted material and restructure traditional values. In the late sixties, there were only a handful of people competing for offbeat folk art. There are hundreds of people looking for it now.

SF In that short space of time?

MH Yes, in that short space of time. It is viable now. It has found a market. Profit reinforcement also produces second- and third-wave collectors who get involved for reasons that may not be as personal as those that moved the first wave.

SF The followers.

MH Yes, following a taste. But remember, when a new or changed taste emerges in collecting, all sorts of objects and ideas are thrown into the pot to be boiled down. If another piece of folk art similar to the *Boy Riding a Bicycle* comes along, the original *Boy Riding a Bicycle* will have to survive inevitable comparisons to it. To me, that's how it should be. Artworks should be compared to be assessed. Particular collectors can be designated as visionary and put their stamp on a collecting taste or even on certain objects but they can't completely dictate taste or prescribe understanding. Something peculiarly democratic forms taste and art values.

SF It's a sifting process.

MH It's a sifting and sorting, evaluating and comparing. The process that debates art is not static. Tolson's work poses a challenge which still hasn't been answered. A lot of people have reservations about Tolson. They think Edgar is a simple country craftsman whose images are repetitive and whose skills are only manual. Based on their inspection of his work, he's only the best of the mountain whittlers. Of course, I feel otherwise, but time will judge.
 The *Boy Riding a Bicycle* is another discovery that has emerged as a challenge to accepted values and understandings in folk art. For me, this object is one of the great, mysterious, raw, inventive images in the trade store figure idiom. Now a host of other rude, crude twentieth-century shop figures will be compared to it. Are they the same? Put them side by side and you'll find out. I believe the *Boy Riding a Bicycle* will emerge as a critical standard. I had that feeling the day I first saw it. I'm

not possessed of any great powers of divination but I've looked seriously at a lot of "new" folk art. The *Boy Riding a Bicycle* just seems that good to me. It asserted itself into my consciousness and it has stayed with me. Sifted out, I think that art with the originality and impact of that figure is what collectors are always looking for.

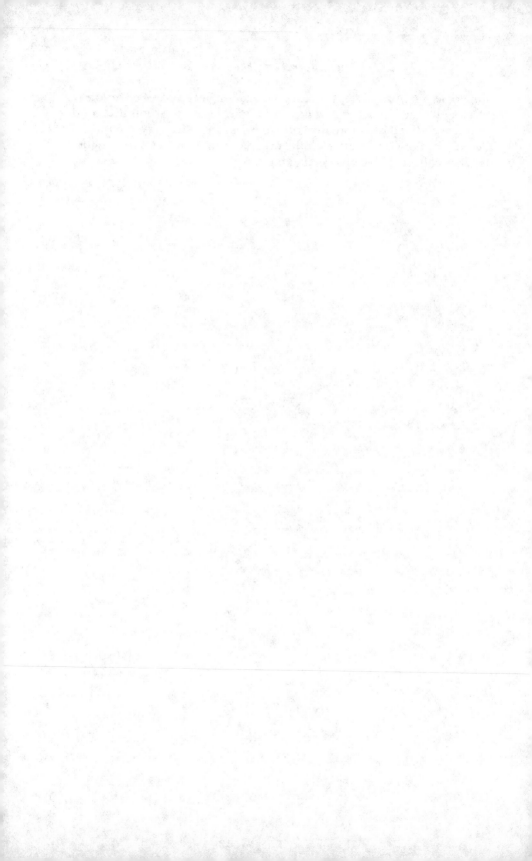

Through a Collector's Eye:
A Changing View of American Folk Sculpture

This essay was originally written for the 1976 Brooklyn Museum exhibition catalogue *Folk Sculpture U.S.A.* In final edit, the Faunce-Hall interview (preceding chapter) replaced this essay in that catalogue. A 1977 version of "Through a Collector's Eye" was read at a three-day national conference on American folk art held at the Henry Francis du Pont Winterthur Museum. Regarded by many at the conference as an unorthodox history, the statement today is recognized as one of the first efforts to connect early twentieth-century collecting of traditional folk art to contemporary collector concerns for eccentric folk-made objects and the folk art of the late twentieth century.

* * *

The history of the collecting of American folk art is a social history as much as it is an art history. In this history, private collectors, gathering and conserving objects, have had an important impact on the understanding of folk sculpture. The history that has brought us to our present perspective on this subject in a large measure is a record of the growth and change of the tastes and advocacies of collectors. Briefly recapping this history, we find that in the collecting community there have often been conflicting views of what folk art is and even on what a collection of folk sculpture should properly include.

It is my intention here to discuss the history of the collecting of folk sculpture in a simplified structure that addresses three primary concerns. In the first place, we must briefly review the high points of the evolving and ongoing interactions between collectors, dealers and museums that have built the folk sculpture world. These interactions have never been the subject of a comprehensive study, for they are numerous and complex and have spanned a period of fifty years. Concurrently, we must inspect some of the ways in which art values and art language spawned in art arguments inside and outside the folk art field have sustained and

changed the collector conversation on folk sculpture. Finally, we would also have to identify some of the key figures who shaped thinking on the subject of folk sculpture. Many of them, interestingly, wore more than one hat. Collector/curators and collector/dealers arrived early on the folk art scene. Their dual perspectives gave them enormous leverage in the field. Artist/collectors had an even more seminal impact on collecting, and they continue to reshape the history being traced here. Hopefully, in combination, these discussions will create a sketch of the history of folk sculpture collecting as it could be drawn from a collector's perspective.

Folk sculpture was not sought or studied seriously until after World War I. Reactions to the war's sobering illustration that the great era of mechanization had its dark side prompted many Americans to reconsider their pre-industrial heritage—and that included their native folk art. In this process, two very different camps shared in the initial discovery of folk art. Each was drawn to the idiom as a reaction to their broad perceptions of modern times and American life. On the objects they agreed. Folk art is easy to admire. Who could spurn figures and fragments, tools and furniture, nostalgia and charm, bits of history and lots of crackled paint— preferably red, white and blue? They also agreed on the criticality of folk art as the art of the common man. Folk art tangibly reinforced their beliefs in American democracy, equality and individuality. But on their art understandings the two collector groups were sharply divided. Each side saw art through a different social and intellectual value system.

One camp, somewhat overwhelmed by the complexity of modern life, began to look backward with great longing to what they idealized as a more perfect and simple past. For them, a certain innocence seemed to have been surrendered even as the Allies achieved victory in the War. Distanced by the encroaching present, these collectors began to survey their past. Two important institutions affecting the collecting of folk art emerged in this ambiance. In 1922, the magazine *Antiques* was founded, and in 1927, the restoration of Colonial Williamsburg commenced.[1] Thus, one of the major critical journals that would address itself to folk art criticism and one of the major institutions that would ultimately display and archive an influential folk art collection were both established early to celebrate the historical past.

Reflecting this nostalgic impulse, many of the more conservative early collectors of folk sculpture were less art collectors than they were antique collectors. Skeptical of the pretentions of art collecting, they embraced folk art as but one part of the early American craft tradition. They believed it to have social value for its comment on the sensibilities of the honest folk who had settled the great frontier. Authors and critics

of the period enthusiastically described folk art as quaint, simple, charming and practical.[2]

The second camp was more progressive in its views. For them, the War had generated a mood of heady pride and a confidence that America would ultimately lead the world into its modern destiny. For these collectors, the present was a challenge. They were cosmopolitan in their outlook and much taken with the new modern art evolving in Europe—particularly in Paris. They imported modernism to America and patronized American artists who began to work in the modern style. They were attracted to folk art because in its simplicity and directness it manifested many of the stylistic traits they admired in the art of the high modernists. Much of their advocacy for folk art reflected their belief that the discovery of a native, democratic source of artistic energy grounded and authenticated anti-academic modernist art in America and "was therefore a Good Thing."[3] The collectors in this group tended to value those art objects that most nearly resembled high art. They gathered things that fit well into the traditional categories of painting and sculpture—leaving tools and craft objects to the antiquers.

In the idiom of sculpture, the modern art collectors were especially attracted to trade store figures, abstract decoys and bold sheet-iron weather vanes (see fig. 31). The antique collector camp tended to seek out old tools with pleasing sculptural form, cast and forged iron works, and a host of utilitarian objects such as butter molds, toys and pottery. The most unique (and often the best-preserved) things gathered by both groups soon became established as folk sculpture classics.

The first artist/collectors of folk art felt an artistic kinship with the folk objects they gathered. The Ogunquit school's encounter with folk art is the genesis text on folk art collecting.[4] The salient fact from this account is that as Marsden Hartley, Yasuo Kuniyoshi, Robert Laurent and other artists of the teens and twenties worked to develop an American style of non-academic high art, they felt a creative empathy for the stylized abstract folk pieces they bought in shops near their summer studios at Ogunquit, Maine. Their interest brought folk art its first important certification as art.

In New York, the sculptor Elie Nadelman, following Laurent's lead, began collecting folk sculpture himself with great intensity in the 1920s. His huge collection was sold during the Depression, but various parts of it found their way into public collections. Nadelman drew inspiration from folk sculpture and styled many of his later works in a manner that incorporated simplifications of form reminiscent of those observable in the folk carvings he owned.

It was artist/collectors who in many ways first connected folk art

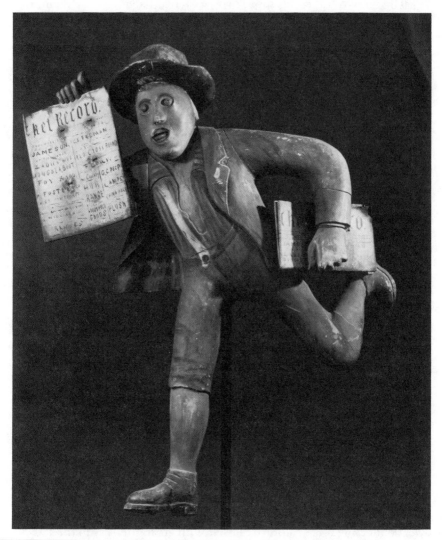

Figure 31. Anonymous, *The Newsboy* (Trade Sign for *The Pawtucket Record,* Rhode Island), 1879
Carved and assembled wood; painted. Tin details, 42".
Private collection.
(Photo: Thomas B. Wedell)

to a larger art world. It was in Ogunquit (and in Nadelman's studio) that art dealer Edith Halpert and museum director Holger Cahill first discovered folk art. Cahill's subsequent activities brought folk art into several major museums, and Halpert's enthusiasm prompted Abby Aldrich Rockefeller to begin assembling her collection of folk art—a collection that would soon be recognized as one of the most important early statements on folk art.[5]

Even in Ogunquit, much of the early conversation on folk art revolved around the subject of design and the way in which a "natural" sense of good design seemed to inform hand-made folk objects. The artistic worth of an axe or a weather vane was regarded by many collectors as something to be found in its formal refinement as a piece of utilitarian design. The antique collectors and many of the modernists were united in this belief. They found their beliefs ratified in two historic exhibitions of folk sculpture—the first at the Newark Museum in 1931 and the second at the Museum of Modern Art in 1932. These exhibitions were organized by curator/collector Holger Cahill and reflected the interest in folk art he had acquired during his visits to Ogunquit. Cahill's inclination to a formal design-based understanding of art is revealed in the catalogue statements he wrote to accompany his exhibitions. He saw the best folk objects as worthy of presentation because they possessed something he vaguely described as "genuine sculptural quality."[6] He specifically stated that, "the story of American folk sculpture would make one of the most fascinating chapters in the history of the arts of design in the United States."[7]

Much of the early collector taste for formal and chauvinistic folk sculpture became canonized by a Federal Art Project, which created the Index of American Design in 1935. Already recognized for his expertise in Americana, Holger Cahill was tapped to head the Index project in New York. In the years between its founding and the onset of World War II, the Index project employed professional artists to render watercolor illustrations of thousands of American-made artifacts. Federally funded and coordinated, the Index in actuality was a state-by-state survey of American decorative and domestic arts compiled by regional administrators cataloguing objects across the country.

Though the Index renderings were not published in book form until 1950, the objects in the archive were well known to early collectors.[8] Index objects were basically what Americana enthusiasts had already singled out as being classically American. They fit neatly into broad categories related to their form and function. Renderings of whirligigs and shop figures were filed alongside those of forged iron door hinges

and decorated blanket chests. For the design-conscious thirties, the Index was right on target. It certified a national taste for folk art addressed to the design and craft merit of objects possessing controlled lines, clear contours and simple surface patterns. These characteristics were locatable in a host of folk-made objects ranging from toleware to weather vanes and toys. The Index also suited the expectations of most collectors, for it did not differentiate between things that could be described variously as fine art, craft or decorative art.

With the Index as a model, collectors seemingly reigned in their curiosity about folk art. The two original collector groups merged as their tastes (and the objects they collected) all came together in one encompassing reference source. A rigid (and frequently anti-intellectual) academy arose around an idiom first admired for its non-academic quality. Emphasizing design over expression, the early advocates of folk art esteemed many sculptural objects that later collectors would disregard as nothing more than artifacts. By valuing antiquity over aesthetics, they blinded themselves to the folk art of the twentieth century.

In the early 1940s, collector/dealer Sidney Janis began to exhibit the work of several then contemporary folk painters in his New York gallery. His roster of what he called "self-taught" artists included Morris Hirshfield, Patrick Sullivan and Horace Pippin.[9] Though all of these artists are luminous in today's pantheon of folk art greats, their exhibitions at the Janis Gallery were largely ignored by the folk art world.[10] The Hirshfields that Janis sold ended up in private collections of fine art—or at the Museum of Modern Art.

Without a real home in the art world, most of the folk sculpture on view for Americans before the middle of the twentieth century was housed in historical museums. Historical museums tend to emphasize the "folk" over their "art." This would create problems for collectors who would presume that the word "art" significantly differentiated some things from others in the world of objects. On the other hand, these same collectors were typically skeptical of art critics and issues of aesthetics. By default rather than by intent they left the academic study of folk art a void.

There is little doubt that folk art collectors contributed in a major way to the creation of the schisms that estrange folk art from various disciplines of scholarship. The collector conversation on folk art became largely hermetic in the 1940s. Collectors went their own way, embracing design and patriotism as the qualities they most admired in the folk-made objects they deemed collectible. When pressed with questions about what they were doing, they all too often seemed content to respond with little more than recitations of homey cliches about folks and the art of the land.[11]

This condition, fortunately, did not last forever. The post-World War II avant-garde art world generated an indirect but clear challenge to the Index approach to folk art appreciation. Against the backdrop of an expanded global political view, American fine art collectors began to complement their collections of modern art with sub-collections of "primitive" art. Their curiosity about African, Oceanic and Eskimo artifacts was triggered by the fact that so many early modern artists had surrounded themselves with exotic primitive works.

Braque and Picasso had their African masks and fetish carvings. Max Ernst had his collection of Indian and Eskimo artifacts. Henry Moore had gathered pre-Columbian figures and had specifically cited these works as sources and inspirations in his own creative quest. As artist/collectors, these individuals all saw much in primitive art. They shared their excitement with their fellow artists and frequently with their dealers who, in turn, brought primitive art to the attention of a wider collecting community.

The ripple response to all of this occasioned the founding of the Museum of Primitive Art in New York in 1954.[12] This Museum came into being through the joint efforts of Rene d'Harnoncourt and Nelson Rockefeller. After its opening in 1957, the Museum was steered on its course for sixteen years by its first director, Robert Goldwater. Goldwater became an enormously influential figure in American art at mid-century. He devoted his life to the understanding of modern and primitive art and was uniquely suited to rebut those who persistently deplored what Bernard Berenson called the "confusion of aesthetics and historicism which had introduced 'artifacts' into the universe of art."[13] Goldwater's austere and dramatic exhibitions of African, Oceanic and pre-Columbian art had tremendous impact on the perceptions of Americans as they examined the question of primitive art's importance in modern life.

Goldwater himself best argued the arguments that would focus the attention of American collectors on tribal arts. His was wholly an art advocacy, and he summed it up when he wrote, "Much more important than any ideal denotation of the word 'primitive' are the affective connotations it has come to have when coupled with the word 'art'."[14] Encouraged by the intellectual and aesthetic permission evolving in the conversation on the primitive, American fine art collectors at mid-century began to acquire examples of tribal art. Most of them pointedly bypassed folk art. American folk art was not being discussed in the high modern debate on "the primitive."

Throughout the 1950s, New Guinea houseposts and African masks found their way into American homes as primitive sculpture. They were appreciated for their artistic value rather than for their ethnographic interest. Collectors mounted masks and fetish figures on simple clean stands,

bathed them in accents of light and left them to "speak for themselves." Adjectives like powerful, spiritual and votive came into common usage in the critical appraisal of tribal works.[15] Collectors discussed the "impact" of African carvings and experienced the "presence" of Northwest coast totems. Somehow, time and distance (coupled with the allure of the exotic) conferred a special aesthetic credibility on the folk arts and crafts of foreign lands. As primitive sculpture, these objects were endorsed for their strength of expression and were critiqued with a vocabulary that was not tied to the rhetoric of nostalgia, patriotism and design which was smothering the discourse on American folk sculpture.

The mid-century challenge to American folk sculpture was whether its forms were powerful and monumental enough to stand on their own in an expanded field of collector expectation. The museum world emphatically thought not. Most museum presentations of folk art addressed folk objects in the context of early American life. Typical installations featured weather vanes perched atop pine dry sinks and decoys nestled next to pottery crocks on the worn shelves of painted cupboards.

Even the few museums exclusively dedicated to the celebration of Americana habitually took a "good old days" approach to presentations of folk art. The Shelburne Museum, founded in 1947, was built initially around a carriage collection.[16] The Henry Ford Museum exhibited "a multitude of materials, ranging from superbly fashioned whimsies to ponderous traction and steam engines."[17] Even the Abby Aldrich Rockefeller Folk Art Collection at Williamsburg was displayed in rooms brought together from various historic houses. Complete with stenciled walls and floors, the museum's rooms provided "period" settings for folk art that were quite different in feeling from the stark presentations Goldwater gave to the Rockefeller primitive art collection in New York.

Some collectors and dealers, however, did respond to the challenges leveled at folk art from the outside art world. A second generation began to compare indigenous American sculpture with primitive objects from other cultures that had attained the status of "certified art." They pointed out that some primitive American carved dolls had the same abstraction of bold frontal symmetry that was so aesthetically compelling in early Cycladic figures. Others likened the expressive stylizations in the visages of American face jugs to those of African masks. They also argued that American decoys were often decorated with "clear stylized patterns that have the elegance of Oriental brushwork."[18]

By finding links that would connect folk-made objects to the look and feel of other primitive arts (and thus to the sources of modernism) these collectors rejuvenated and greatly refined the consciousness of folk art. Most important, in seeking to compare certain works of folk sculpture

to other forms of primitive and modern art, second-generation collector/authors like Jean Lipman signaled their expectation that folk art could be accountable as art. As editor of *Art in America* from 1941 until 1971, Lipman frequently took her views on folk art into print. Though she insisted that folk art had died by 1900, she persistently asserted that the activities of America's early folk artists were "a central contribution to the mainstream of American culture in the formative years of our democracy."[19]

The 1960s saw folk art finally establish a real beachhead in the art world. A museum exclusively for folk art was founded in New York in 1962.[20] At about the same time, collector/dealer Adele Earnest initiated a series of folk sculpture exhibitions at the Willard Gallery in New York. The Willard Gallery was known for its modern and contemporary art. Hence, it introduced folk sculpture in the context of fine art—not in the context of antiques. Earnest recognized the expressive strength and formal abstraction in the twentieth-century stone carvings of Wil Edmondson, and concentrated one of her Willard Gallery shows on them. Though Edmondson's works had been exhibited earlier in New York, the times finally favored their acceptance.[21] Impressive in their own right and also easy to compare favorably to the carvings of Modigliani, Edmondson's sculptures took their place in an enlarged list of folk sculpture classics soon after the Willard Gallery exhibition.

It was also in the sixties that Herbert Hemphill, Jr. began to restructure his perspective on folk art. Hemphill, a collector who served as curator for the Museum of American Folk Art in its early years, began to collect forms of folk sculpture that bore virtually no resemblance to works embraced by the Index categories. Hemphill and a circle of artist/collectors that gathered around him began to collect objects that they felt had strength of form but, more important, had power of expression.[22] Hemphill moved away from collecting early folk art and began searching out works of twentieth-century origin. His concerns addressed the offbeat, the expressive and that which in Europe is called the *brut*—the raw.[23] The language necessary to describe the sculpture Hemphill sought derived from the lexicon of Abstract Expressionism rather than from that of design.

Despite all of this growth, American folk sculpture still seemed something like an awkward adolescent in the family of art as it matured into the seventies. Folk art (like education, foreign policy and the institution of marriage) was still to take new knocks. The new knocks to folk art came from contemporary American fine art. All through the sixties, styles of art from Pop to Minimal rose to challenge each other for a moment of sun in the aesthetic arena. Each arrival came complete with its

own value system and critical vocabulary. New York painting was gutsy; significant sculpture was tough; Bay Area art was funky. Labels became the thing—devotees of the avant-garde nullified all "untough" art with epithets such as slick, designy and easy. By 1970, even Edmondson carvings were "up against the wall" and looked pretty much like the establishment to the generation of artists and critics creating and extolling earth works [see fig. 22].

Again, it was artist/collectors who gathered some new objects and reconsidered some old ones to find an ongoing relevance for folk art. Their search coincided with the advent of the Bicentennial and was fired in part by the broad-based Bicentennial fascination with all things American. Rummaging through antique shops and flea markets, they rediscovered folk art—but in forms that addressed the art issues of the contemporary art world. In search of American models for themselves as artists, they patronized many living folk artists—outsiders with whom they identified. Jim Nutt, Whitney Halstead, Roger Brown and others in Chicago found Joseph Yoakum. Boris Gruenwald and Mike Sweeney discovered Elijah Pierce in Ohio. Bennett Bean met James Crane in Maine, and John Tuska and I encountered Edgar Tolson in Kentucky.[24] In Virginia, Miles Carpenter's work was found in 1971 by two young artists named Chris Sublett and Lester Van Winkle (see fig. 32). They responded to the whimsey and spontaneity of Carpenter's sculpture. They recognized the gaudy painted figures he built and dressed as genuinely "funky." They shared their discovery of the artist and his work with other collectors, and Carpenter quickly began to cast a shadow that could be seen in the contemporary galleries of New York.

All of this discovery was exhilarating for the artist/collectors involved, but it also entailed its share of headaches. As they became involved with the personal lives of various folk carvers and painters, the discoverers often found themselves functioning as biographers, curators and business managers. Through it all, however, they remained collectors and artists gathering and sorting visual information and images—finding a relevance for them creatively.

Artists, because they make things, seek a particular resonance from the engagements in their lives. They find this resonance in ideas, in interactions with people and, of course, in direct encounters with works of art. I believe that the condition that separates the artist/collector from other collectors is the way the artist/collector puts collecting into the service of the specific act of art making. Folk art has continued to be nurtured by artist/collectors because artists have continually challenged our conventional ways of seeing all forms of art. From the earliest period to the present, a host of folk-made objects which might well have remained

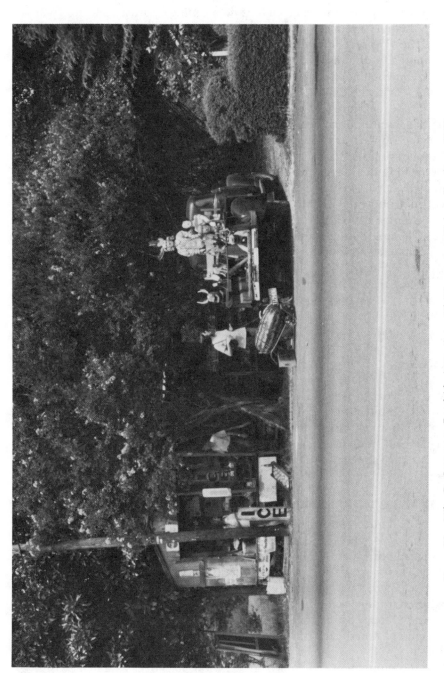

Figure 32. Miles B. Carpenter, Roadside Attraction with Figures in a Pick-up Truck, ca. 1972
Wood, paint, metal, cloth, string, feathers.
Carpenter Home, Waverly, Virginia.

despised or ignored were given life and meaning by artist/collectors who gave them a "second look."[25]

The most recent transformation of thought on folk sculpture has been prompted by the discovery and documentation of what are called folk environments. Looking at huge folk-made structures like Simon Rodia's towers in Watts, California [see fig. 48], collectors were forced to confront folk sculpture that could not be collected—at least not in the conventional sense. Nonetheless, collectors had to acknowledge that the spirit which produced such environments was the same vigorous, independent creative spirit they had always believed to be the generative force behind the making the making of the sculpture they did collect. Again, it was an artist, a painter named Gregg Blasdel, who first found a way to collect environments. He did it with a camera, systematically recording site works across the country. His 1968 photo essay in *Art in America* focused national attention on a newly found species of folk sculpture and precipitated a survey photo exhibition of folk environments at the Walker Art Center in 1972.[26]

The care and maintenance of environments poses new problems for everyone. The works themselves are often fragile. Because they are rooted on the site where they stand, they cannot be moved and housed safely in some collector's home or in a museum. Curators and collectors have had to extend themselves to folk environments. Having done so, they have begun to take an active interest in their conservation and preservation. A group pledged to save the *Watts Towers* is working with the State of California to perpetuate Simon Rodia's work as a public trust. The Kohler Foundation, Inc., under the direction of collector/curator Ruth Kohler, is attempting to salvage Fred Smith's *Wisconsin Concrete Park* [see fig. 46] from the ravages of a storm that severely damaged it in 1977.[27] Artists have already been consulted for recommendations on how to best preserve and restore both of these important monuments.

Environments have further broadened a critical vocabulary in the field of folk sculpture. As the word "monumental" seems appropriate to the *Watts Towers,* the term "visionary" has almost become synonymous with the Hampton *Throne* (see fig. 33). Discovered in a garage in northwest Washington, D.C. in 1964, the *Throne* was an enormous assemblage of discarded furniture parts, light bulbs and other found objects covered with tinfoil. It was built by a reclusive black artist named James Hampton, who labored patiently over his creation for years. Preserved today by the Smithsonian Institution and housed at the National Museum of American Art, Hampton's *Throne* is a cultural folk sculpture treasure.[28] No one calls it slick or designy. Like the *Towers* in Watts, it is a true monument. As an artistic creation, it evokes as much passion

Figure 33. James Hampton, *The Throne of the Third Heaven of the*
Nations' Millennium General Assembly, ca. 1950–64
Gold and silver foil and paper over wooden fur-
niture and cardboard, 177 pieces of various sizes.
Hampton photographed standing in front of *The*
Throne which he constructed in a rented garage in
northwest Washington, D.C.
Collection National Museum of American Art,
Smithsonian Institution. Gift of anonymous donor.
(Photo courtesy The Washington Post)

and mystery as the most avant-garde contemporary art collector could hope to find in the paintings of Mark Rothko or in the sculpture of Lucas Samaras.

Looking ahead, folk art collectors face the challenge of working with scholars, critics, historians and social scientists to better understand the social and aesthetic worth of the things they collect. A new audience, curious about folk art's importance in America's cultural past and cultural future, has begun to ask provocative questions which beg answers. Some signs are encouraging. Folk art exhibitions are being reviewed in high-art journals. Works by living folk artists have recently been included in survey exhibitions of avant-garde American art.

Despite this, the art critical community remains skeptical about folk art. Critic Amy Golden articulated this skepticism when she wrote, "Because folk art is neither completely accepted nor rejected as art, it has an equivocal relationship to normally accredited art."[29] Yet Golden offers some hope for a reconciliation of this situation when she writes, "Folk art challenges the process of legitimization itself. In the days of the Academy, avant-garde art carried the same challenge."[30] Golden's critical musings have by and large been ignored by the folk art world. There is still much for collectors to do in behalf of the larger acceptance of folk sculpture as art.

Three generations of collectors have discovered and preserved literally thousands of objects loosely labeled American folk sculpture. For most collectors, the basic fiber of folk art is still homespun. They build their collections around honest objects lifted from the handcraft traditions. Nonetheless a fifty-year search for words and ideas, objects and art has brought the collecting field to some new realizations. The powerful "primitive" works introduced during the period of the mid-century secularization of modernism have found their place. Likewise, the newly identified funky eccentric objects introduced in the sixties have been accommodated. Today, monumental and visionary environments are further extending the visual vocabulary of folk art, but the process of folk art discovery is not necessarily an ever-expanding one.

Today, collectors must initiate an introspective investigation of folk art which digests and derives sustenance from all that has already been gathered. It falls on contemporary collectors to become truly critical and to separate the authentically expressive visceral works produced in the folk milieu from those that at first glance seem bold, but that are actually only inept. In a similar vein, collectors must begin to sort out fully authoritative refined works from their many glib look-alikes. It is time to reinspect the best of the old Index objects and perhaps to find that simple classic forms may also have their monumental and expressive

aspects. In a like fashion, it is time to strip away the pejorative connotations that have accrued to terms like 'fresh' and 'honest' and to acknowledge that something eloquently fresh and profoundly honest pulses in the mysterious *Hampton Throne.*

Determinations such as these are not made simply, nor are they made only once. Any conversation on art is ongoing. As we have seen, much of the dialogue on folk sculpture has transpired between collectors. As folk art collecting grows, a history is continually being revised—and reassessed. Because collectors have earned a rightful place in this history, they can fully expect to affect its next period of growth and change—for the dialogue on folk sculpture is far from closed.

Notes

1. Holger Cahill, "Introduction," *The Index of American Design,* ed. Erwin O. Christensen (Washington, D.C.: National Gallery of Art, 1950).

2. Holger Cahill, *American Folk Sculpture* (Newark, New Jersey: The Newark Museum, 1931), pp. 13–18.

3. Amy Golden, "Problems in Folk Art," *Artforum,* June 1976, p. 52.

4. Tom Armstrong, "The Innocent Eye," *200 Years of American Sculpture* (New York: The Whitney Museum of American Art, 1976), p. 76.

5. Ibid., p. 86.

6. Cahill, *American Folk Sculpture,* p. 18.

7. Ibid.

8. Clarence P. Hornung, "Author's Note," *Treasury of American Design* (New York: Harry N. Abrams, Inc., 1976), p. xiv.

9. See Sidney Janis, *They Taught Themselves: American Primitive Painters in the Twentieth Century* (New York: The Dial Press, 1942).

10. Sidney Janis, personal communication, Spring 1975.

11. For a typical discussion, see Frances Lichten, *Folk Art of Rural Pennsylvania* (New York: Charles Scribner's Sons, 1946), pp. 1–7.

12. Douglas Newton, "Tribute to Robert Goldwater," *Robert Goldwater: A Memorial Exhibition* (New York: The Museum of Primitive Art, 1973), p. 8.

13. Ibid.

14. Jacqueline Delange, "Robert Goldwater and the African Object," *Robert Goldwater: A Memorial Exhibition* (New York: The Museum of Primitive Art, 1973), p. 18.

15. For a historic and useful discussion, see Ladislas Segy, *African Sculpture Speaks* (New York: Lawrence Hill & Co., 1952), esp. pp. 117–37.

16. Electra H. Webb, "Foreword," *The Story of the Shelburne Museum* (Shelburne, Vermont: The Shelburne Museum, 1960), n.p.

17. Robert G. Wheeler, "Foreword," *Folk Art and The Street of Shops* (Dearborn, Michigan: The Edison Institute, 1971), p. 1.

18. Jean Lipman and Alice Winchester, *The Flowering of American Folk Art, 1776–1876* (New York: the Viking Press, 1974), p. 166.

19. Ibid., p. 7.

20. Robert Bishop, "Introduction," *American Folk Sculpture* (New York: E. P. Dutton & Co., Inc., 1974), p. 12.

21. Edmondson's carvings had actually been introduced to New Yorkers as early as 1937. His longtime supporter, Alfred Starr, of Nashville, Tennessee, arranged a one-person exhibition of his work at the Museum of Modern Art in that year.

22. Herbert W. Hemphill, Jr., personal communication, Summer 1974. These communications formed the base for my introduction to the catalogue: *American Folk Art: The Herbert Waide Hemphill, Jr. Collection* (Sandwich, Massachusetts: The Heritage Plantation of Sandwich, 1974), pp. 12–13.

23. The term *brut* (raw) was first used by the artist Jean Dubuffet in reference to the art of prisoners and psychotics. He collected such art and ultimately housed his collection in a museum of his own called the Museé d'Art Brut which he opened in Paris in 1948. The museum is now located in Lausanne.

24. The story of the involvement of late-twentieth-century fine artists with their folk counterparts has yet to be written. The encounters cited here are known to me through my personal association with the individuals discussed.

25. The discovery of the art of the "outsider" Martin Ramirez is a perfect case in point. The drawings of Ramirez were first gathered and preserved by a psychologist who had known Ramirez in the DeWitt State hospital in Auburn, California. The doctor used them as visual aids in a course he taught on abnormal psychology. Nutt, recognizing the artistic worth of the drawings persuaded the doctor to sell them to Chicago art dealer Phyllis Kind. Kind introduced the work in her gallery in 1971. Collector response to the exhibition fully supported Nutt's contention that the drawings were more important as art than as clinical information on the mentally ill.

26. Gregg N. Blasdel, "The Grass-Roots Artist," *Art in America,* September 1968, pp. 24–41.

27. Don Howlett, personal communications, Summer 1977.

28. Lynda Roscoe, "James Hampton's *Throne,*" *Naives and Visionaries* (New York: E. P. Dutton & Co., Inc., 1974), pp. 13–19.

29. Golden, p. 49.

30. Ibid.

Instruction Drawings: Silverman Collection

The following was printed in a 1981 catalogue accompanying the Cranbrook Academy of Art Museum exhibition of the Gilbert and Lila Silverman Collection of contemporary art. Fascinated with the avant-garde, Gilbert Silverman has assembled one of the most comprehensive groups of works produced by the artists of the "Fluxus" movement. In addition, he has gathered an impressive body of works he identifies as "instruction drawings." Cranbrook exhibited these drawings as a separate part of its larger presentation of the complete Silverman Collection. Hall's remarks on these works became the text for the catalogue introducing the instruction drawings to Cranbrook's museum audience.

* * *

Gilbert Silverman has distinguished himself as one of the most adventurous collectors of contemporary art in the Midwest. His tastes are broad and he has filled his Southfield, Michigan home with objects ranging from paintings by Brenda Goodman to the Fluxus "finger boxes" of Ay-O. Within his large collection, he identifies a sub-group of things that have a special significance for him and increasingly to the art world at large. He calls this collection the "Instruction Drawings." Silverman gathers the critical musings of artists—the documentations of the formative thinking that anticipates the making of an art work. He sees them as accumulated bits of what he believes are the most creative conversations of artists—their plans, proposals, diary notes, memos to helpers and the like. This collection within the Silverman Collection emerges as a very important and virtually unique perspective on new art.

Gilbert's involvement with instruction drawings began in 1973. It was then that he purchased a set of detailed notes which Sol LeWitt had sent to Tokyo to enable Japanese museum workers to construct a work for the Tokyo Biennale which LeWitt himself could not be present to install (see figs. 34, 35). The LeWitt instructions sent Silverman in search of other such works which exist somehow outside of traditional categories

Figure 34. Sol LeWitt, *Instructions for Tokyo Biennale*, 1970
Ink on paper, 8 × 10″ (two sheets).
Collection Gilbert and Lila Silverman.

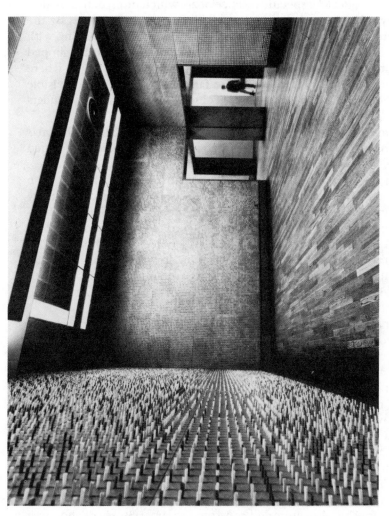

Figure 35. Sol LeWitt, *Between Man and Matter* (Installation at Tokyo Biennale), 1970
Paper cut into 4 cm. squares inserted into holes in wall. Colors placed at random and evenly distributed.
Tokyo, Japan.
(Photo courtesy John Weber Gallery)

as either objects or as documentations. Silverman's commitment has always been to follow where artists move and grow; the instruction drawings allow him to do just that.

Gilbert's involvement with the instruction drawings, from a collector's point of view, is a curious "run around end." Gathering these works, he is able to "collect" a specific essence of art which often defies ownership in any other form due to its huge scale or temporal nature. By the early seventies, Silverman's home and office were already bulging with hundreds of art objects. Once he obtained LeWitt's notes, he slipped quietly out of the world of painting and sculpture into a world where his imagination could be transported to far realms of ideas made visible in simple notes and scrawled diagrams. These he keeps in ordinary binders or behind glass in unassuming frames.

In some ways, the rationale behind gathering the instructions has a historic base. Scholars and museums have always sought and esteemed the drawings and studies which form a part of most artists' oeuvres. Michelangelo's sketches and Seurat's charcoals are beautiful in their own right and also provide valuable insights into the workings of two very complex and creative minds. The historic model for what Gilbert Silverman collects, however, must be found in Leonardo's notes for the construction of machines and fortifications rather than in traditional "old master" drawings. Collectively, the instruction drawings form an intimate and revealing aggregation that intentionally does not lend itself to aestheticizing. Instead, it is a collection of worlds of thought and aspiration trapped in a jumble of plans and ideographs.

The instruction drawings are a microcosm of contemporary art. The Calder piece is a simple sketch for a proposed mobile complete with notations (in French) for the colors to be applied to the shapes suspended from the mobile's armature wires. The drawing by Jackie Ferrara is a precise set of calculations (on graph paper) which designate the elaborate system of measurements needed to construct one of her incrementally stepped towers. Vito Acconci's notes for *Broad Jump* outline the conditions for a performance work. They ponder the implications of a piece in which variables introduced into a performance scenario would definitely alter and affect its form. Silverman is not rigid in his definitions. He is as interested in the musings of artists making formative notes to themselves as he is in the detailed architectural plans and elevations they might draft for the fabricators and construction supervisors collaborating with them in the making of huge site-based sculptures.

Silverman broadly adheres to the modern Webster's dictionary definition of an instruction as "an instructing . . . knowledge, information, etc. given or taught." Because so much recent art has been preoccupied with

information rather than with form, the instruction drawings collectively penetrate the labyrinthine matrix of contemporary art concerns in a manner that is wholly compatible with the nature of contemporary art itself. A Jean Tinguely sketch with its notations on the size and movement of a proposed machine sculpture and a Smithson drawing for the *Broken Circle* earth project both cut to a critical sense of information as it manifests itself in the creative speculations of two very different artists.

The diversity in this collection also reveals something about the art perspective of the collector who brought it together. The instruction drawings are not aligned or biased in any particular way nor are they concerned with art as style or fashion. Rather, they are confirmations of Silverman's belief that the creativity of any artist is an elevated and worthy thing. He sums up his position by saying, "If somebody I accept as an artist offers something as art—then it *is* art for me and I ask no further questions." A natural and healthy curiosity rooted in this view of art and artists has led Gilbert endlessly into what he calls "new things."

In 1978, fascinated with the work of Daniel Buren, Silverman offered the artist a commission to do a work for his home. Buren accepted and subtly transformed the Silverman residence with a program of his trademark striped panels marching around the building at a fixed level. The three pages of notes and sketches Buren scrawled for the project naturally went into Gilbert's collection of instruction drawings. In 1980, curious about Dennis Oppenheim's new work, Silverman provided major support for a large sculpture the artist constructed at the Cranbrook Academy of Art. He counted himself fully repaid for his help when he was presented with a shopping bag full of drawings, scribbles and calculations which Oppenheim had penned as shop orders for the student work teams who fabricated the dozen or so major units incorporated in the final piece.

The instruction drawings come together in what is, by its very nature, a private collection—and a very personal one. John Balsley's instructions were sent to Silverman to ensure the correct reassembly of a sculpture piece which Balsley had dismantled and shipped to him. The Nakashima sketch grew out of a meeting between collector and furniture maker when Silverman decided to commission a desk for his office. Selecting a suitable piece of seasoned wood in his curing sheds, Nakashima made three quick sketches of the forms he saw as possible to build from a plank. He then jotted the price for the work on the sketch, transforming it into an invoice as well as a working drawing—another instruction—and another autograph in the collector's curious new adventure (see fig. 36).

The collection wanders. It has its prosaic moments as travelogue, but, on the other hand, it has its great moments and, like many things

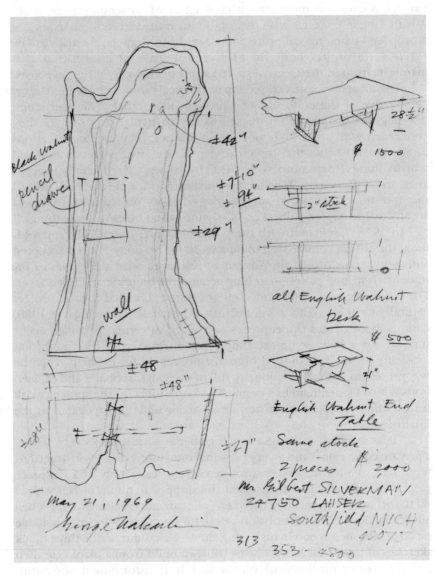

Figure 36. George Nakashima, *Study for Desk,* 1969
Pencil on paper, 11 × 8½".
Collection Gilbert and Lila Silverman.

which are unlike other things, it waits for some larger consensus to assess its best being and value. It grows and changes in response to the intuitions and sensibilities of Silverman, the collector. In the final analysis, the instructions argue their own best arguments. But in recognizing their power of persuasion and in gathering them around him, Gilbert Silverman has established himself as a genuinely innovative collector. Beyond this, he and his special collection stand firmly behind an advocacy positing inquiry as the most provocative and perhaps the most compelling aspect of the art of our time.

The Hemphill Perspective:
A View from a Bridge

In 1981, the Milwaukee Art Museum mounted a major exhibition of the Herbert W. Hemphill, Jr. Collection of American Folk Art. As Hemphill's friend and colleague, Michael Hall was asked to provide some comment on the collector and his collection for the museum's exhibition catalogue. In his text, Hall interspersed interview comments from Hemphill on various aspects of his life as a collector between paragraphs containing his own assessments of the collector and his collection. Hall's segment of this exchange is both history and critique. It is reprinted here as an uninterrupted narrative. (Note: The Hemphill Collection was acquired by the National Museum of American Art in 1986 and will soon be on view to the public in Washington, D.C.)

* * *

I see this exhibition of selections from the Hemphill Collection as a truly historic event in the field of folk art. I was pleased to be asked to include something for this catalogue which might document and shed some light on what might be called the "Hemphill View." My fifteen-year association with Bert Hemphill has afforded me a rather privileged involvement with the ongoing formulation of his great collection. More important, it has given me a firsthand contact with the instincts, sensitivities and intelligence of one of the rarest of beings, the true collector.

I am incredulous that this man, whose collections and publications are so frequently cited, has never been the subject of an in-depth essay. He has seen much. Bert knew many of the pioneer dealers and collectors in the 1950s. In the 1960s, as one of the founders of the Museum of American Folk Art in New York (and as its first curator), he mounted a series of small but very influential exhibitions which extended folk art perspectives in the art capital. And finally, with the publication in 1974 of his book, *Twentieth-Century American Folk Art and Artists,* he ratified the alternative tastes and values found in his own collection. His book became a major force for extending the range of folk art appreciation

to include contemporary material in a field that historically valued only the "antique."

Bert has a natural reluctance to talk about things that he considers self-evident or self-explained. On the other hand, he has a special understanding of art and is possessed of a candor that I believe to be worthy of sharing. He is an authentic innovator who persistently acknowledges his roots. His collection links what is best described as the traditional "Index of American Design" folk art taste to the more far-reaching contemporary investigation of "Outsider" and "Isolate" art. I hope that my comments reveal some of Bert's thinking and that some of my impressions can be pertinent to the problem of understanding the Hemphill Collection. I share with Bert the hope that this catalogue offers information and insight for both the curious and the serious viewers of this exhibition.

Whether he was always a collector I do not know, but he was always an acquisitor. When he first left college and moved to New York in the early 1950s, he began buying African sculpture and minor works by well-known modern European and American painters. The first folk art objects he found evidently synthesized his appreciation for both the primitive and the modern. He collected, read and learned. My impression of that period of Bert's life is that it was one of discovery. Of course a small old guard of Americana collectors had preceded him and had already defined the folk art idiom in terms of categories of objects and criteria of design that established the "classic" in folk art. Moving out, Bert aligned himself with an emerging, adventurous group of dealers and artists exploring a new aesthetic locatable in recently discovered objects—an aesthetic they felt redefined the spirit (and importance) of American folk art.

Hemphill's search for the things he would ultimately introduce into the folk art debate began in the days when great folk art turned up regularly in Second Avenue junk shops. Bert did, and still does, frequent those haunts. But in the fifties he also kept his eye on important auction sales. It was in the well-publicized 1956 Parke-Bernet sale of the Haffenreffer Collection of trade store carvings that he found the *Indian Brave* and the *Indian Squaw* (see fig. 37). He had the "eye" and he used it. He found and bought the offbeat and the curious and juxtaposed them with classic portraits, shop signs and weather vanes. It was this juxtaposition that gave even his early collection the basic stance that it has today.

His was the collector game of search and capture. Bert was never a reductivist in his approach to collecting nor was he exclusive or elitist in the exercise of his taste. He was an "impulse buyer" and his commitment to objects was 90 percent sensibility-based. His natural curiosity

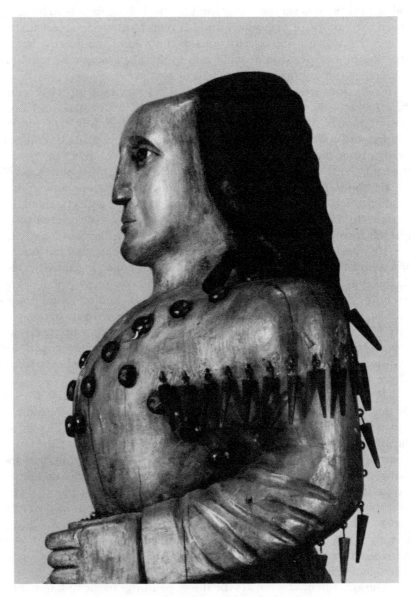

Figure 37. Anonymous, *Indian Squaw* (Detail; Trade Sign), ca. 1870
Carved and assembled wood; painted and stained, 48½".
Collection the National Museum of American Art,
Washington, D.C. Gift of Herbert Waide
Hemphill, Jr. and museum purchase made possible
by Ralph Cross Johnson.

and acquisitiveness set the foundation for the bridge he was to build between the canons of orthodoxy and his own hard-won maverick alternatives. He was not necessarily born to the role of the heretic, but his appetites and disposition brought him to the place where he would be branded as one by many in the field of folk art.

Collections are built a piece at a time. Understanding is probably built the same way. Bert's first understanding of folk art formed from a pre-existing matrix of thought which he inherited from folk art's pioneer scholars and collectors. The source books he read recapitulated endlessly a rather basic litany of exhibitions (Whitney Studio Club, 1924; Newark Museum, 1930; etc.) which first defined and circumscribed American folk art. Hemphill, however, matured generationally and temperamentally to a rather different perspective on the field in which he collects. From time to time, he talks about the people and events that contributed to the specific formulation of his personal history as a collector.

His consuming involvement with the early exhibitions at the Museum of American Folk Art were pivotal in shaping his collecting at mid-career. To be tapped as curator of the Museum, he had obviously paid his dues, but in the role of curator his taste "went public," and he found himself bombarded by more exposure to objects and ideas than he had experienced previously as a private collector. Each exhibition he researched and put together for the Museum took his interest into a new area of folk art. His collecting patterns zigzagged throughout the late sixties to follow where his curatorial responsibilities led him.

My wife Julie and I met Bert by chance on a summer day in 1966. On our way to the Museum of Modern Art, we chanced into the Museum of American Folk Art to get a better look at some objects we could see through the window that faced the street. Bert was "keeping the store" (guard, docent, sales desk manager and curator all rolled into one) and, as there was no one else in the entire Museum, we soon fell into conversation. It was that simple; we discovered folk art and Bert all in the same afternoon. Our enthusiasm over the things in the exhibition prompted Bert to ask us if we would like to see his collection. When we agreed, he simply closed the Museum, hailed a cab, and minutes later we were in his apartment feeling like Howard Carter first peering into Tut's tomb "seeing amazing things."

The apartment was always the thing: paintings frame to frame, floor to ceiling; objects wall to wall (see fig. 38). I never take a step there without fearing that my sleeve is going to catch on something and set off a cataclysmic chain reaction of collapse which will bring five hundred objects crashing down around my head. Yet, Bert makes it a hospitable place. Small and crowded, it has, nevertheless, been the scene

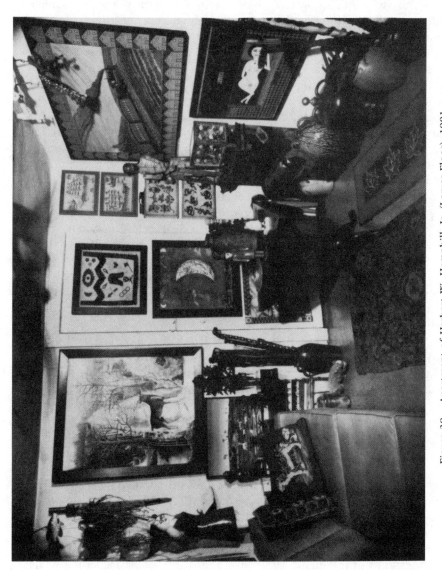

Figure 38. Apartment of Herbert W. Hemphill, Jr. (Lower Floor), 1981
New York.
(Photo courtesy Herbert W. Hemphill, Jr.)

of an open ongoing forum on American culture. No one curious about folk art has ever been turned away.

The apartment is a kind of a laboratory where the aesthetic merit of hundreds of folk art objects has been tested over the years. I remember one night when another collector brought his latest acquisition (a weather vane) to the apartment for Bert's inspection. Bert cleared a table in the center of the room, placed the vane on it, and we all sat down to study the piece. The other vanes in the room sat in judgment on the newcomer and soon it was clear that the new vane was not faring very well. Good objects test everything else and Bert's place is always full of great objects. And yet, the apartment is a home. It has always been filled with famous objects but it has also been filled with Bert's very intimate inquiries into folk art. It is a private repository for a number of as yet unrevealed sub-collections within the larger collection itself. The public and the private Hemphill coexist in the apartment and somehow, despite all the crowding, they get along together.

The profusion of things in Bert's collection is baffling. The complexity of the collection is particularly hard on dealers and new collectors who, in recent years, have tried to key off of the Hemphill eye. Confronted by the whole collection, they are generally disappointed by what they view as the uneven and almost prosaic character of his entire statement. Bert himself takes this in stride and, in fact, may even enjoy the sense of enigma that his collection injects into the competitive new folk art scene.

It is doubtful whether the entire collection could even be housed any longer in the apartment. Bert's life is always disrupted when a group of things that have been on tour returns home. My latest count puts the number of objects in the collection at well over three thousand, though it is most unlikely that all of them will ever again be together in the same place at the same time. Bert talks about the "study objects" and the "crown jewels" among his things. In the end, his consciousness of folk art distills something from everything he ever acquired and he finds his personal identity located somewhere between the objects which he owns because they distract and provoke him, and those which he is confident enough about (and comfortable enough with) to dub as "pure Hemphill pieces."

Given Bert's thesis that objects per se are always part of a larger whole, it would follow that for him any folk object exists as one or another kind of fragment. Almost in the manner of an archeologist, he has dug his way through a mound of cultural refuse salvaging a shard here, a blade or a scraper there. The condition of an object has never bothered him. He is not looking for the perfect "artifact cum art object".

Instead, he seeks anything, no matter how deteriorated or fragmentary, which retains enough of its essential recognizability to argue that it did indeed exist at some point in the past and which, through its introduction into his collection, can argue for the validity of its perpetuation into the future.

It is interesting to note that The Reverend Howard Finster, a folk painter from Georgia, in his portrait of Hemphill, boldly scribed an epigram into his picture designating Bert as "the man who preserves the lone and forgotten" (see fig. 39). I find Finster's insight almost uncanny. Having only met Bert once or twice before he began the painting, Finster nevertheless discovered something about his sitter which cuts to a critical core of Hemphill's absolute identity.

Sometimes Bert's apartment feels like an orphanage and maybe that is because the things he finds and brings home are often the things that are so close to us as to be overlooked and cast off the most easily. Bert has a sense of mission in finding the beauty in the disregarded and the eccentric and in offering his collection as an alternative perspective on our folk art—and thus on our culture.

Bert has always been more than a little compulsive about his collecting. He even describes himself as manic in his pursuits. Confronted with something new and exciting that he might be able to acquire, he flushes, fidgets, and sometimes breaks into a small nervous coughing fit after he completes his purchase. The rush, the adrenaline are the symptoms of his addiction. Julie and I always enjoy "picking" with Bert because he is a true collector and because his enjoyment of objects and the discovery of them is something he shares easily with fellow collectors.

And the best part is that he knows what he is looking at. His eye is honed. He is in his rarest form working his way through a flea market. His pace is unhurried and his inspection of every booth is methodical and thorough. He probes under tables, in drawers and on top of cupboards—the quintessential hunter. And then he scores. He pulls a terrific little carving out from under a pile of quilts and smiles triumphantly. Julie and I, of course, had already been through that booth and missed the carving.

Bert Hemphill is a mentor for many young collectors today. His exhibitions and his book have brought a new group of young scholars, dealers and artists together into a curious and decidedly ad hoc coalition which suddenly has a great deal of visibility in the field of folk art. The older, established dealers handling expensive traditional antiques and folk art are being challenged by an aggressive younger breed building reputations selling things that ten years ago would simply have been viewed as too unconventional or too "late" to be considered collectible. The

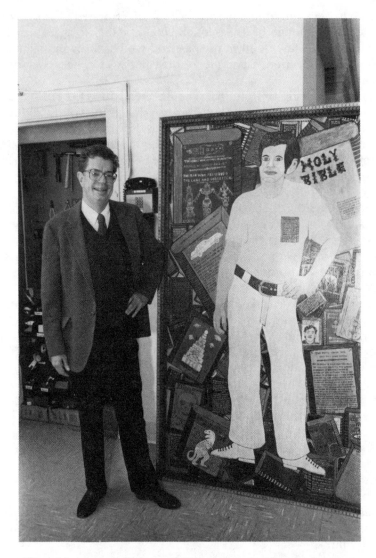

Figure 39. Collector Herbert W. Hemphill, Jr. and Portrait by
 The Reverend Howard Finster, 1986
 Portrait: Oil on plywood (painted 1979), 79½ × 50″.
 Collection the National Museum of American Art,
 Washington, D.C. Gift of Herbert Waide Hemp-
 hill, Jr. and museum purchase made possible by
 Ralph Cross Johnson.
 *(Photo courtesy the National Museum of American
 Art, Smithsonian Institution, Washington, D.C.)*

concentration of power and excitement that used to attend perennial events like New York's East Side Antique Show now also accrues to newly instituted shows that attract the newer dealers and collectors involved with forms of folk art that gained respectability directly through Hemphill's collecting and writing. Bert's impact on the scene is enormous and the changes he has wrought have initiated a whole kaleidoscope of reactions in the folk art world. I find him sometimes dismayed by it all. Like any parent, he feels pride in his offspring, but he also feels the weight of the responsibility for the negative ramifications of what he has precipitated. Sometimes he muses, "What is happening to the baby?"

Folk art is typically referred to as "the people's art." This idea has produced unfortunate cliches about the common man and his artistic creations, but Bert has successfully collected around a host of stereotypes and rarely found himself trapped by them. Taking his cue from the idea of a people's art, he has assembled a collection that represents an unbelievably diversified America. I can't think of any other folk art collection (public or private) that is so broadly based in the whole political, social and geographic fabric of the United States. His collection is a great American mirror because it is the most complete microcosm of the "melting pot" yet assembled.

Bert seems constantly engrossed in a process of bringing together and sorting. Change, not constancy, nourishes him. He calls Julie and me on the phone and is ecstatic about something he has just found in Santa Fe or about a new painter he just discovered working in Georgia. The collection grows; a new vista is added to the special travelogue Bert narrates about America. The Hemphill Collection is special—not only for the wonders it contains but for its persistent witness to art as a human structure that bridges time and thought with the most fugitive building material of all: creativity.

Part Four

Parallax: Folk Art/Variant and Polemic

You Make It with Your Mind: Edgar Tolson

Edgar Tolson was born in Lee City, Kentucky in 1904. He died in Campton, Kentucky on September 8, 1984. Michael Hall was instrumental in brining Tolson's sculpture to the attention of collectors and museums in the late 1960s. The following article is based on a 1976 taped conversation with the carver and is bracketed by comments and commentary by Hall. As an artist/critic, Hall attempts to probe the inner workings of one folk sculptor's mind. The profile presented here was first published by *The Clarion* in 1987.

* * *

Along with Elijah Pierce, Mario Sanchez, Martin Ramirez, Inez Nathaniel Walker, Joseph Yoakum, Miles Carpenter, and others, Edgar Tolson today is part of an elite group of late-twentieth-century folk art masters who have spawned a national debate on folk art. Traditionalists, discounting the work of these artists, insist that authentic folk art passed from the American scene with the advent of industrialization and urbanization. The argument against this assertion is that the work of Tolson and others demonstrates that self-taught artists working in various styles and media still contribute vitality to American art.

Central in this debate is the question of the authenticity of the artistic vision of the contemporary folk artist. All too often, the artists themselves have not been questioned about their work and the motives and ideas which bring it into being. My spring visit to Campton, Kentucky in 1976 had two purposes. Of course, I went expecting to spend some time with Edgar Tolson and his family, but I also wanted to try to persuade Tolson to let me formally interview him and tape-record recollections of his life and work (see fig. 40).

Folk art had suddenly become a hot issue. The Whitney Museum and the Brooklyn Museum had both inaugurated the Bicentennial with folk art exhibitions. Contemporary folk art was being shown in galleries from

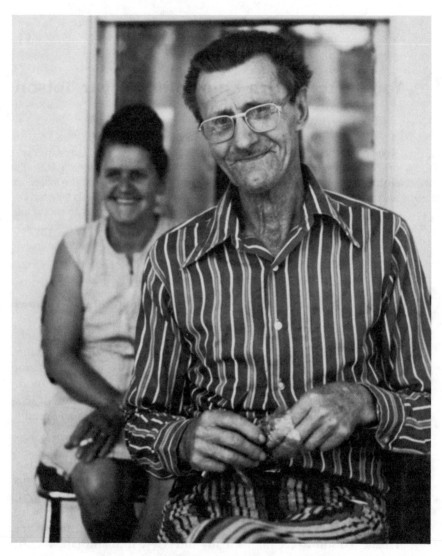

Figure 40. Edgar Tolson and His Wife, Hulda,
 June 1972
 Campton, Kentucky.

Chicago to San Francisco. And I, as a folk art partisan, was suddenly being asked questions about Tolson and his work and needed answers that had to come from the artist himself. I hoped in this visit to gather some solid support for the assertions I had been making for the previous eight years about the cultural and artistic value of Tolson's sculpture.

I found Edgar healthy. I was relieved. He had been ill during the preceding winter and when I left Detroit I was unsure about the state of his recovery. Spring, however, is generally a good season for him and this one was no exception. In spring, the winter chill and dampness leaves the mountains and Edgar gets relief from the respiratory problems that chronically plague him. He was animated, jocular and happy to see me after so many months. He had been busy carving and had new work to show. He beamed with obvious pride as I went over each of his latest pieces. His dentures, as usual, were out so when he smiled his face broke into a wreath of wrinkles. I was glad to be with my old friend and mentor again.

At age 72, Edgar was in his prime as an artist. He seemed to want to talk and he rather enjoyed being the center attraction in an interview. At first, he made small talk, bragged and joked, but then he settled down to answering my questions.

Tolson's art evolved from something common into something extraordinary. He had not always been the sculptor he is today. By his own account, he always "whittled" and made things. But the vision and power in his work came late—it came with the first stirrings of his sense of himself as an artist.

He grew up in an environment where whittling is a common pastime. He was raised in an Appalachian region where craft traditions are strong and where craft work, as a cottage industry, has been encouraged by government and private agencies for decades. However, by the time I met him in 1967, his carvings had transcended whittling and craft (see fig. 41). By then, he had established himself as a folk sculptor to be reckoned with. I asked him about whittling and carving. He replied:

Well there ain't no difference in it. (*Pausing*) Well there are differences in it. When you're carving something you've got your mind with it. You have your whole being in it. You have to.

But just sitting there whittling on a stick, you ain't got nothin' in it but just a little time.

But when you're a-doing something—it's just not just your hands a-workin'. All together, there have to be something up there [in your mind] a-workin'.

And it'll get on your nerves, boy. An' I don't mean just maybe. If something gets a little wrong—or you get rushed pretty heavy, then everything goes wrong. And that's a lot of trouble. It's like getting over a hangover—you don't want to do nothin'.

Figure 41. Edgar Tolson, *Dolls* (Unfinished), 1967
Carved poplar wood, 10–12″.

One of the most prevalent romantic misconceptions about folk art is that it is produced by makers who are not self-conscious or self-critical. This assumption has caused folk artists to be branded as naive. Tolson hardly fits such a stereotype. He has always been self-critical, and less than humble, about his work.

> The first ones (dolls) I made were too slim—too long, and as the old saying is—too peaked out. That was my first work.

> I always know what's wrong. I can tell when I finish a piece what I like about it. Then I try to correct it on the next one.

> I can still see a lot more I can do to it But you're never going to get on top. When you do, you can say farewell. There wouldn't be anymore you could do.

> I've always argued you've never got perfect No matter what you build, nor how good it looks—there's something that you could have done a little better.

> God made the first Adam and Eve and I made the second. But I lack a long shot of being God.

I turned the conversation to current events. A die-hard Democrat, Tolson has a quick grasp of politics and a canny understanding of the political process. He also has a sense of humor about it all. I was reminded of a story he told me once. Some years earlier, a Republican governor stumping for re-election had come to the mountains to make a campaign speech. Edgar decided to use the occasion to present the governor with one of his carved walking sticks. He went to the rally and waited until it concluded before he stepped forward to greet the governor. The candidate seized the opportunity as a great political windfall. He immediately began posing with Tolson for photographers who snapped all the right pictures. Everyone in the campaign entourage could almost envision the next day's headlines: "GOVERNOR RECEIVES SUPPORT FROM MOUNTAIN CARVER." Edgar always laughs when he recounts what happened next. "Governor," he said, "that there is a Democrat walking stick—and you'd better learn to walk with it!"

I asked Edgar if he knew who he would be voting for in the upcoming presidential election. He did:

> Jimmy Carter, cause he's got two chances. He's never been in Washington to learn the dirty tricks and we could get four years of good service out of him before he learns.

The quip was typically Tolson. Perhaps it was typically Appalachian. From Campton, Washington, D.C. is viewed skeptically as a place filled with people who perhaps take themselves a little too seriously. Shenanigans in the capital come to Campton as just another T.V. sit com.

The local sheriff sells beer in Wolfe County on Sunday, doesn't he? So politicians all have their hands in something.

Tolson does, though, have a political bottom line. Throughout the summer of 1974, he followed the Watergate hearings on television. The deceptions and breaches of public trust that the inquiries revealed prompted him to carve what must be regarded as the finest piece of his late period—the construction he calls *The Beheading of St. John/King Herod and the Christians.*

This piece is constructed as three plateaus. In a fenced enclosure at its base, a family (father, mother and child) cowers before three lions just released from a pit. On the second level, a seated King Herod dispassionately surveys the lions and their victims in the arena below him. The King is flanked by two guards standing at attention. On the top tier, a headsman has just decapitated a kneeling St. John while Salome and her brother look on.

Tolson explains that the piece depicts the abuse of power. Herod abuses the power of his office. He turns a deaf ear to the plight of his subjects. Salome abuses the power of her sex. She unleashes suffering through her willfulness and arrogance.

As a metaphor, the piece is obvious. The Watergate hearings exposed a government abusing its power on many levels. Tolson, the artist, part cynic/part sage, registered his outrage over the abuses the televised proceedings exposed. His carved and constructed narrative leaves little doubt that he held no esteem for the Nixon White House. A year and a half after its winddown, he was still blistering over Watergate. I asked him if he had anything to say to the powers in Washington and he unleashed a volley:

> I always wanted a chance to tell old Nixon and Ford and Kissinger what I thought of 'em.
>
> I'd tell old Nixon that he was too low down for the dogs to bark at You betrayed your whole family, you lied to 'em like a hound and they finally caught up with you.
>
> And Ford is worse than you for pardoning you—he's lower down than you are, he pardoned you—when he knowed you was a criminal. And besides that—you and him had it cut and dried.
>
> And your secretary [Kissinger] ain't nothing but Hitler Number Two; a sellin' us out to China and to the Middle East.

Tolson doesn't talk readily about his art. He won't give out a verbal road map to what he is doing. Most of what I know, I have pieced together over the years from bits of conversation with him; and from prolonged exposure to his work itself.

He will, however, discuss the Biblical history that provides the thematic framework for his sculpture. For him, the two most significant events in history are the Temptation of Adam and Eve and the Crucifixion of Christ. I find it interesting that he equates the two stories; one from the Old Testament, the other from the New Testament. His work suggests otherwise. Over the years, he has produced perhaps a hundred carvings depicting the Temptation of Adam and Eve and their expulsion from Eden (see fig. 42). In contrast, I have only known him to carve the Crucifixion twice.

I asked him about this discrepancy and he had a ready answer. He believes that the Temptation set a course for history. The Crucifixion simply reiterated and reinforced all that was set into motion at the moment of the fall. He feels Adam and Eve's loss of innocence precipitated all of the dilemmas that have shaped human experience—even the events of his own life. Edgar views the Crucifixion as a tragic mirror of the Old Testament truths. Only Christ's promise of redemption separates the two events in Tolson's mind. On the subject of redemption, he says:

> And at the time we come to be accountable to know good from evil . . . we have to come back and be washed in the blood that flowed from the cross of Calvary. To be regenerated and born again.
>
> [At that time] We don't gain a thing back—only what we lost. We get our Eden home back. And the Eden home is this world.

In his conversation and in his work, Tolson often expresses what can best be described as alienation. If alienation is one of the hallmarks of modern art and literature, then Tolson's "primitive" art becomes very modern. The single carved doll figure is at the heart of his work. Each one stands alone, implacable and stoic, facing the travail which their maker sees as every man's lot in life. Nonetheless, there is something heroic in every figure. They do stand—and they do prevail [see fig. 29]. Forbearance is something Tolson understands. Acquiescence is foreign to his nature.

Edgar's sense of isolation seems rooted in his belief that every person (since the Fall) lives with a burden of personal responsibility. The individualism this concept promotes is compatible with his political disposition. He is a very American artist. His carvings and his sense of self reflect ideals that reach back into the nineteenth century to a frontier legacy that lives on in the mountains today. I asked him for his thoughts on individual responsibility.

> Every man knows when he transgresses God's law. Both saint and sinner if he's capable. If he's not capable, he's not responsible. Cause you can't try a maniac by the law. All you can do is lock him up.

Figure 42. Edgar Tolson, *Paradise* (Tableau #1 in *Fall of Man* Series), 1969
Carved and assembled poplar, pine, cedar; some paint details,
13 × 17½ × 8″.
The Hall Collection.

. . . You can't try a maniac for killin' a man 'cause he didn't know it. He couldn't punish Adam and Eve for something they didn't know. So they very well *knew* it.

Cain knew he was doing a murder job there—so he went off a sinner.

Tolson produced his first important sculpture in the late 1950s. The premier piece of this period is called *Man with Pony,* from 1958. The sculpture depicts a stocky black man standing beside a large spotted horse. In one hand, the man holds the horse's reigns. With his other hand, he reaches to grasp the saddle on the animal's back. He restrains and domesticates a beast (see fig. 43).

The implications of the piece are complex and wonderful. The work represents Tolson's view of the order of things in a Christian world. Man, in the image of God, has dominion over the creatures of nature. The form of the horse is horizontal. A straight line runs from its head to its rump aligning the animal in the plane of the earth. The man is vertical. He stands erect in the world. His shirt, tie, boots and trousers are painted crisply— each element outlined in low relief and then filled in with color. The horse is painted unevenly—the spots which cover its form blur and blend together. The divinity in the man is ordered and rational. Nature (as represented by the horse) is shown as chaotic and unpredictable. The head of the man is large and well modeled. His face expresses dignity and in- telligence. The head of the horse by contrast, is simple and toy-like—its eyes stare blankly ahead. Tolson portrays man and brute, and affirms his belief that understanding transcends (and in the end, subdues) instinct: To understand is to be as God.

I find it curious that *Man with Pony* is so like Marino Marini's celebrated bronze, *Horse and Rider* of 1950. Italian Catholic high art and Appalachian Baptist folk art, it seems, are not so distant from each other. I asked Tolson again about meaning in his work. He spoke to the ques- tion of looking at art:

Just glancing on it is just like reading a story or something. You don't understand that story just looking at it and going on.

If you don't give it a thought you never know what's down under the surface—do you? Well that's just the way it's supposed to work. Now that's life!

In numerous presentations, I have staunchly contended that Tolson's is a highly symbolic art. Others have disputed this, alleging that the work is strictly as it seems; simple story telling depiction—valid as illustration, perhaps, but certainly not as art. Though Edgar does have a gift for story telling, he is much more than a country yarn spinner.

His epic eight part *Fall of Man* had just been shown at the Brooklyn

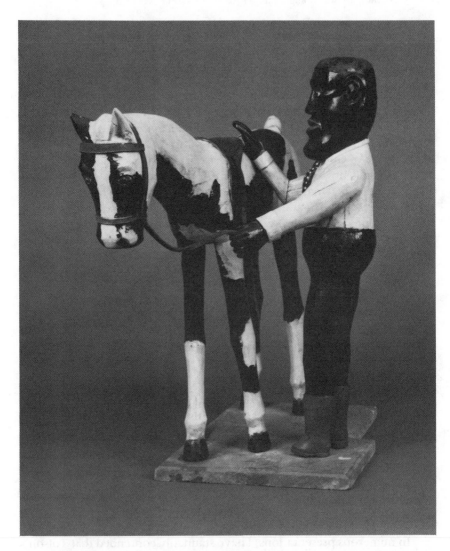

Figure 43. Edgar Tolson, *Man with Pony,* 1958
Carved and assembled wood; painted, 22¼ × 30½ × 12″.
The Hall Collection.

Museum (*Folk Sculpture U.S.A.*) and so it seemed appropriate to ask him about the meanings he associated with this piece. He launched into a rather lengthy recounting of the events represented in the eight tableaus of the *Fall* and then concluded with the following:

> [The series] represents all the stories possible—all through the Bible. That's from the beginning to the end, from Genesis to Revelations.
>
> It's from the beginning of time—to the winding up of time.
>
> It's about the whole thing . . . that's something to think about!

(Here, I interrupted him to tell him that at least this audience of one had thought about it; to tell him that I did grasp the broader historic and symbolic implications in the piece. He brushed my comment aside with a gesture of impatience and frustration. He shook his head.)

> No—you don't know that. It's about the whole thing. There ain't many fellers what's *done* that!

Curiously, in rebuking my acknowledgment, he confirmed two things. One, my contention that he is locked in a certain alienation and, more importantly, that he does see his work as symbolic and universal. He believes that the *Fall of Man* answers the "why" that might be asked about any condition in the world. In one climactic, symbolic event, mankind came to the destiny Tolson sees as our fate. Edgar's carvings *are* symbolic and allegorical. In his Adam and Eve theme, he endlessly describes the fragile and imperfect condition of sentient beings caught in the turmoil of the spiritual and the physical. He metaphorically portrays himself (and all people) as existing somewhere between materiality and ideals. In his own words:

> They didn't even know that they was naked. They were just like a two hours old baby. They just knowed they was here.
>
> But—after this gentlemen [the serpent] got through with 'em—they knowed to commit the crime. . . . That's what brought Christ to the cross. It's just what she done there in the Garden. And He knew she was a'going to do it. And He told her not to.
>
> You know why? So she'd be responsible for what she done.
>
> And, the serpent said, "The Lord knows the day that you take this fruit and eat it that your eyes will be opened and you'll become as one of God's, a-knowing good from evil." And Adam said it was pleasin' to his eye and she took and eat it and gave it to Adam. And he eat it and they was drove out.

Late in the afternoon, I queried Edgar on the subject of talent. His skills with a pocketknife are extraordinary. Watching him deftly cut an

eye into one of his dolls, I am always amazed. His concentration and coordination allow him to carve the eye shape with no more than five or six strokes of his blade. Practice, of course, is part of it but there is something more. He has a talent. He talked about it that day:

> Everybody's got talent, of some sort—but there ain't one fourth of the people uses their real talent. They try to use the other man's talent God give every man a talent that if he would follow it, Mike, no matter what it is—he can make a success at it.
>
> The biggest trouble of it is, there's too many people trying to do the other feller's job. It won't work. See, I tried that all along till I got sick (he suffered a stroke in 1955). Then I found my talent. I knew my talent before that but I wouldn't fool with it. I wouldn't think about it
>
> The thing that you really desire deep down in our heart to do—that's your talent.

Finally, I asked Edgar about what might be called his vision. I sought his own description of the way he sees, the way he understands what we call the creative process. His explanation was emphatic and consumately simple:

> Before I start it, I see it. I know what it is. . . . Anytime you do a piece of work—well—anything, it's got to be pictured in your mind before you do it.

This comment paraphrases something that he had told me in 1971 during one of our first conversations about his art. He had explained that his work consists of images and meanings. It grows from both belief and experience. The sculptor in him creates. His hands serve his creativity. I had scrawled down his statement five years earlier. On my return home, I retrieved it from my files. I recount it here because it bears witness to the fact that the self-consciousness of art and art making does inform the awareness of so-called folk artists. At least this is so in the case of Edgar Tolson. His is an authentic artist's vision:

> A man who makes those things. If you could open up his skull to see his brain, you see the sculpture there—perfect as it's made.
>
> I can put my knife in the wrong place and my hands will move it. It will stop. My mind will stop it.
>
> You don't make it with your hands. You *form* it with your hands.
>
> You *make* it with your mind.

Memory and Mortar:
Fred Smith's *Wisconsin Concrete Park*

With help from the Wisconsin Arts Board and the National Endowment for the Arts, the Kohler Foundation, Inc. purchased the *Wisconsin Concrete Park* from its maker's family and began restoring it in 1977. This renovation was entrusted to artists Sharron Quasius and Don Howlett, who began re-footing Fred Smith's figures and landscaping his one and one half acre park. A violent summer storm interrupted this work. The restorers cleared the storm-ravaged site and finished their project in the fall of 1978. Broadening this preservation effort, the John Michael Kohler Arts Center has undertaken major research and documentation on Smith and his art. Hall's 1979 essay is an excerpt from the Center's upcoming book on the *Wisconsin Concrete Park*.

* * *

A discussion of Fred Smith's *Wisconsin Concrete Park* must consider the park as a part of the full spectrum of American folk art. Such a discussion would also focus on Smith's work as a key masterpiece within the rather specialized idiom of folk environmental constructions and monuments. To discuss Smith's park without discussing its iconographic sources and its morphological relationship to other known environmental works is, in a way, to deny Smith's achievement and the considerable esteem it warrants.

Fred Smith's park is far from unknown or unappreciated, but I sense that, unfortunately, as a work of art it still seems "protected" by the affection and enthusiasm of a small coterie of admirers who prefer to measure folk art solely by what cultural historian Kenneth Ames calls the "immersion and tingle" method of aesthetic evaluation. This process involves nothing more than standing before an object and measuring the "shudder" that results from extending one's consciousness to it. Presumably a very high "tinglemeter" reading establishes a work as a masterpiece.

Trudging knee-deep through the snow in Smith's park in the winter

of 1979, I confess to experiencing a Richter scale series of aesthetic trembles. But since my intention here is to consider Fred Smith's contribution and legacy contextually, I will limit myself to a rather short rhapsodic account of my own feelings visiting Phillips, Wisconsin for the first time. In a word, Smith's park is wonderful. It is something special and generous set into the North woods like a big red valentine. In spirit, it reaches out to everybody who ever chalked a heart with an arrow through it on a sidewalk or a wall (see fig. 44). Enough said.

Environments like the *Wisconsin Concrete Park* occur frequently and can be designated as a particular category of folk art. The major monuments that have been "discovered" and documented to date have almost all been created within the past fifty years. For all their heroic size and formidable physical presence, the environments seem to be highly fragile and are vulnerable to vandalism and natural deterioration in a way that makes them among the most fugitive of folk art forms. Early examples are not generally known. The fact that no eighteenth- or nineteenth-century monument survives in situ today does not mean that it was not made. I believe that such works have consistently appeared throughout American history. However, the particular artistic vision of immortality which causes environment builders to create works defying translocation ironically condemns these same works, one by one, to the bulldozers of progress.

Many early carved whirligigs and rusty iron weathervanes have escaped the assault of change, but their survival is directly attributable to the fact that they (unlike the monuments) could be moved, stored, maintained and, above all, collected. Fred Smith's *Wisconsin Concrete Park,* to my knowledge, is the first environmental folk piece to be professionally conserved and maintained. This good fortune, of course, accrued to the park only after it was "collected" by the Kohler Foundation. It still required the combined efforts of the park's owners and friends to save it from the severe storm damage that nearly destroyed it in July 1977.

Obviously, something which has attracted such admiration and support finally has to find its way into our expanding awareness of what art is all about. Smith's park enters history as something special but not so unique that it is totally without precedent. One or two old photographs document a large figurative construction built by Clark Coe in Killingworth, Connecticut in the early years of this century. The old photos show that Coe's environment sported figures incorporated into an ingenious water-driven, cam-operated, kinetic construction. Coe's work conformed closely in scale and imagery to several modern American folk environments, including the *Wisconsin Concrete Park.* Only a few of the carved and clothed figures from Coe's monument are extant, having found

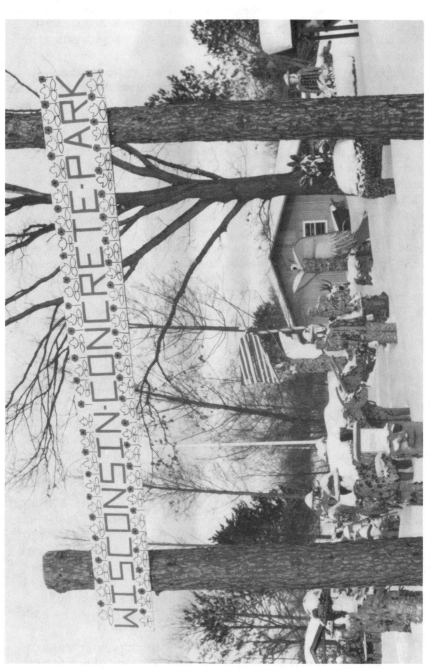

Figure 44. Fred Smith, *Wisconsin Concrete Park*, 1948–64
1½ acre site, Phillips, Wisconsin (photograph 1979).
Donated by the Kohler Foundation, Inc. to Price County, Wisconsin.

their way into private collections. The most famous of these images is *Girl on a Pig*. Stripped of its original hat and dress and long separated from its fellow carvings, this fragment lives on as some magic scarecrow talisman.

European environments are also known. One of the most popular and widely publicized of these is the fantastic mausoleum, Le Palais Idéal, built by a French postman named Ferdinand Cheval. Enough European environments and fragments of earlier American ones can be documented to create the outline of a history that will allow us to link Fred Smith's park to a broad tradition. Surveying this rich and varied tradition, we find environmental folk monuments to be something more than pure phenomena or the quaint fantasies of isolated eccentrics.

Like many folk artists, Fred Smith had an easy way of creating a gentle figurative art. In his work, he always sought to convey some specific and narrative content. This content can generally be traced to the things the artist knew from the world immediately around him: local lore, regional historic episodes and the mythology built around the lives of popular heroes. Fred Smith's is a vernacular art stylistically expressed in decorative figurative forms. Viewed as a whole, the park could be described as a collection of narratives, character studies and anecdotes compiled rather randomly out of Smith's own life and cultural exposure.

The sources of Fred Smith's images reside in memory—his own and that of the regional subculture of which he was a part. His themes (like those found in Currier and Ives prints) are quasi-literary. They derive from popular oral and written history and are structured pictorially in terms of stereotypes easily recognized by a popular/local audience. A Currier and Ives print, depicting a family wrapped in mufflers and blankets bundled in a horse-drawn sleigh for an outing through a snowy landscape, echoes images persistently laced through a rather mundane body of American song and poetry. Such work expresses a self-conscious sentimentality that hinders its aesthetic viability. It is precisely in his avoidance of this trap that Fred Smith demonstrates some of his best instincts as an artist. His "double wedding" is a depiction of a turn-of-the-century Wisconsin nuptial reverie recounted to him by someone who had witnessed the event. Smith took this story and visually narrated it, emphasizing the details that most pointedly communicated his sense of the scene. His incorporation of a real buggy and Rhinelander beer bottles in the tableau particularized the image for the regional audience he knew would view it. But the wedding, like all pieces in the park, never condescends or plays to the crowd.

Smith's sculpture is characterized by its inclusion of both representational and highly abstract information. Smith was fond of juxtaposing

specific pictorial details and schematic or generalized forms. His simple blocky figures become Indians when they sport red faces and feathered headdresses; another becomes Paul Bunyan by standing twice as tall as any other figure in the park. In a similar way, a rack of real moose antlers tops the well-modeled body of a bull moose disguised and decorated with a mosaic of inlaid, colored glass (see fig. 45).

Smith's "realism" is consistent with the narrative notions of art common to most vernacular expressions. But the abstraction in Smith's sculpture must be attributed to some contrasting impulse or conditioning which predisposed him to complement his storytelling with his own unique investigation of plastics, his involvement with color and texture for their own sake. It is enticing to speculate that Smith's sense of geometry and order (manifest in his marked preference for frontality and symmetry) and his obvious love of pattern and texture could be traced to some cultural tradition—perhaps to the creative dispositions of his German forebears whose folk arts and crafts manifest these same qualities.

Working from this speculation, we find that history and tradition do inform Smith's art. The bits of broken glass, tile and shell which he embedded in the surfaces of his figures imbue each sculpture with a specific quality of memory—the prior life of the glass and shells themselves. The act of embedding this material in the concrete can be interpreted as an almost ritualistic act, giving the figure a past which presumably sustains it into the future. It would be possible to argue that this investiture is nothing more than the expression of some simple decorative turn of the artist's fancy, but my feeling is that Smith's concern with his surfaces was ultimately too obsessive to be viewed as just a whim.

Instead, I would examine his surface treatments in the context of an entire folk decorative tradition. In America, this tradition generated a number of highly embellished art and craft forms. The Victorian "memory jug" was one of the most popular and widespread. These curious objects were fashioned by applying wax or putty over glass or pottery jars and then embedding shells, glass, small trinkets and other memorabilia into the soft surface before it hardened. The makers of memory jugs obviously intended to create something they considered beautiful, but they also sought to create something which had the sense of an offering about it—a votive object which would accumulate its power and sentiment directly from the history invested in its surface.

Victorian things were plentiful and popular in the American Midwest well into the twentieth century. We can assume that Fred Smith was exposed to these things (if not specifically to memory jugs) as a young man. Because we know that Smith evolved his work from the life and history

Figure 45. Fred Smith, Lumberjacks (from *Wisconsin Concrete Park*), 1948–64
Concrete over wooden armature with glass, tile and shell details
(photograph 1979).
Donated by the Kohler Foundation, Inc. to Price County, Wisconsin.

around him, it is reasonable to expect that he also drew his artistic style from the same source. Smith may well have consciously discovered within the Victorian tradition of surface inlay a potential for expression that suited his own personal artistic sensibility. Standing before the sculpture in the park, I definitely sensed that each piece of mirror, shell or insulator glass, "recycled" on the surfaces of Smith's forms, invested each image with specific reminiscences from a chronicle in which Fred Smith's life itself was only a part.

The *Wisconsin Concrete Park* directly celebrates life and living. Almost nothing in the park exists as a metaphor or an allegory. Though the sculpture is not so abstract as to be self-referred, it at least attempts to be self-explanatory. Smith's loggers are just that—loggers. In the same way, his angel is obviously an angel. This aspect of the monument (which is almost too self-evident to warrant mention) is nevertheless its diagnostic characteristic. Typically, we could interpret this stolid quality in Smith's work as some basic "yep . . . nope . . . " form of country forthrightness and then celebrate it politically as an embodiment of "grass roots" American individuality. But it seems to me more meaningful and productive to de-mythologize folk art and to inspect Smith's sculpture in a comparative context which will reveal its broadest social and artistic value.

My list of the great American folk monuments it topped by S. P. Dinsmoor's *Garden of Eden* in Lucas, Kansas; Simon Rodia's *Towers* in Watts, California; and Fred Smith's *Wisconsin Concrete Park* in Phillips. Each of these works holds a high place in my esteem because it epitomizes the artistic tendency from which it derived. Dinsmoor, Rodia and Smith, for me, represent three very distinct and persuasive artistic sensibilities expressed in the production of three very different but equally valid and provocative forms of environmental folk art. Where Smith's work is generous and affable, Dinsmoor's is strident and preachy. Rodia's towers, by the same measure, seem detached and even cryptic. Where Smith's park exudes a guileless congeniality, Rodia's monument thrusts it spires heavenward in search of the sublime. Dinsmoor's garden, by contrast, is almost bombastic in its proselytizing histrionics.

Each of these three environments tell us something about their makers. Fred Smith's park reflects the hand of a patient, worldly creator who probably had a good-natured "live and let live" philosophy of life and who created art more to entertain and to enrich than for any other purpose (see fig. 46). The facts of his life tend to bear out this conclusion and thereby support the notion that all forms of art are, in one way or another, autobiographical.

A look at Dinsmoor's garden gives us a glimpse of an entirely different artist whose known biography again offers a personality profile

Figure 46. Fred Smith, Figures and Oxen (from *Wisconsin Concrete Park*), 1948–64
Concrete over wooden armature with glass, tile and shell details
(photograph ca. 1977).
Donated by the Kohler Foundation, Inc. to Price County, Wisconsin.

matching accurately the one that can be read in his monument (see fig. 47). Dinsmoor, like his art, was arrogant and compulsive. He was resourceful and strong-willed and took himself more than a little seriously. The bearded, cunning, old reprobate who peers out of the faded photographs in his cabin home is clearly the same wry eccentric who fashioned the serpent light poles and the laughing Satan which top the *Eden* environment.

Simon Rodia, the most enigmatic of these three artists, predictably produced the most enigmatic art (see fig. 48). Small of stature and humble in demeanor, Rodia quietly and almost reverently worked on his towers for over thirty years. Then one day, having reached some sense of personal revelation in his work, he walked away from his project and left it to its own destiny. Despite all that has been learned about them, the *Watts Towers* remain a mystery. They may well have been that for their creator too. After having seen the towers in person, I can easily believe that Rodia may have built them as nothing more or less than a metaphor for the mystery of his own existence.

The mind of the monument maker is an interesting subject to consider. Few specific facts about these artists are known. It is difficult to generalize about their ambitions or their motives. However, certain considerations implicit in monument building do tell us something about the artists who work within the idiom. For example, Rodia, Dinsmoor and Smith all share a common sense of time relative to the production of their work. Each obviously understood from the onset that he would expend an unbelievable amount of energy (both physical and emotional) over a protracted length of time before even coming close to seeing his work in a "finished" state. Whereas a gifted whittler might carve a complete piece in a day, a monument builder might require several days just to assemble the raw materials needed to construct one small passage in a project. Likewise, whereas the nineteenth-century American itinerant painters could finish a pair of portraits in a couple of sessions with their sitters, a monument builder needs years to see an image truly come to life. If Dinsmoor, Smith and other monument builders share one thing in common, it is their dogged persistence and their absolute conviction that in time they would prevail in their endeavors.

Something else can be said about environment makers. They are all builder/architects, as it were, of visions. This fact explicitly puts a physical and even structural cornerstone into the "monument builder consciousness." Each of the true monument makers starts from the ground up, constructing and shaping some sculptured epic which is larger than life. Surprisingly, the sheer scale of the work of Smith, Dinsmoor and Rodia does not overwhelm us with the feeling that its maker intended it to be heroic. The overt heroism so typical in much monumental

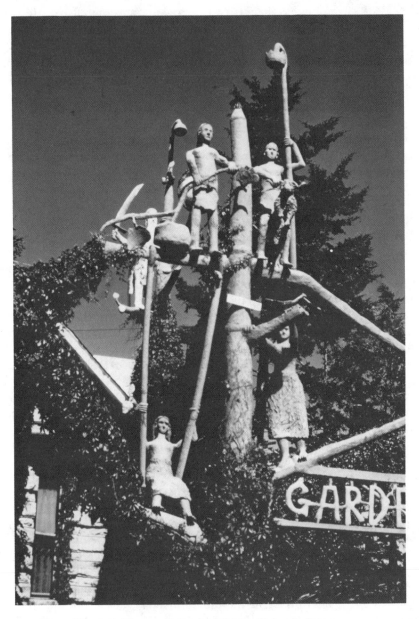

Figure 47. S. P. Dinsmoor, *Garden of Eden* (Gateway Entrance
Detail), ca. 1907–30
Concrete, metal, paint. Half-acre site, maximum height 45′.
Lucas, Kansas.

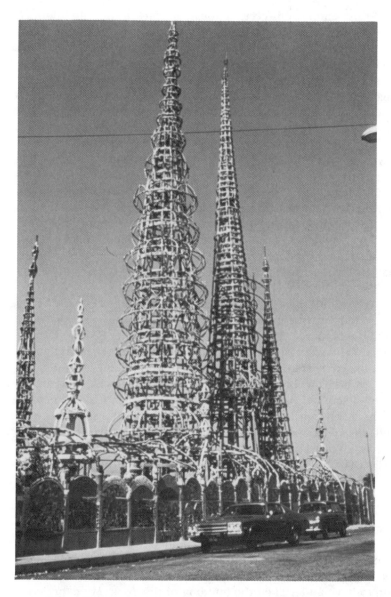

Figure 48. Simon Rodia, *Watts Towers*, 1921–54
 Concrete, steel, ceramic, stone, glass, shell and im-
 pressed found objects, 1/10 acre site (4,800 sq. ft.),
 maximum height 99½'.
 Watts, California.
 (Photo: Michael Hall)

modernist sculpture is conspicuously lacking in the folk idiom. This in no way, however, suggests that folk monuments or their makers lack a healthy measure of ego. Instead, I would speculate that the "one coffee can of cement at a time" method of fabrication used by the folk builders infuses their constructions (even at monumental size) with a certain intimacy. It is this which tempers and ingratiates the ambition in the work, residing forever in the steel and mortar as a discernible record of the patient dialogue so much a part of the sculpture's making.

The idea of art as a dialogue pertains very much to the *Wisconsin Concrete Park.* The silent figures and animals Smith fashioned converse eloquently with one another as shapes and color patterns which constantly change as a visitor moves through the park. Smith's sculptural language is fascinating, for it combines seemingly exotic and idiosyncratic elements with obviously homey midwestern ingredients, blending them into one charged experience. By the time Smith built his third or fourth figure, he had mastered his construction technique and set himself to "talking" about the things that interested him to anyone who wanted to "listen" with eyes and emotions.

Fred Smith must have been aware of this business of dialogue, for he created what he called the "Quiet Spot" in his park and reportedly spent hours there, sitting and thinking. The Quiet Spot is nothing more than a small plot of ground (somewhat apart from the main figure groupings) ringed by six or seven of Smith's figures facing a spindly, painted, wooden arch. Walking through the painted "gateway" and entering the circle of sentinel figures, I found one more dimension to Fred Smith's art. As much as it grows out of life and legend, it also grows out of the land. His Quiet Spot is as magic as any ritual site that the Indians could ever have consecrated on this same midwestern soil three hundred years earlier. The final memory in Fred Smith's work is timeless and placeless; the last dialogue in his art is spoken in his typical vernacular dialect but translates easily, for its roots are universal.

People who write about folk art are fond of calling it the "art of the common man." Standing in the Quiet Spot I thought a bit about this and about Fred Smith, the folk artist. Somehow it did not fit—for no common man built the glass-encrusted marvels which surrounded me. Someone unique did, and that someone had a highly developed sense of mission to have undertaken the building of this park. My experience as an artist and as a collector tells me that someone quite rare, mixing mortar and memories for over fifteen years, created an authentic wonder in Phillips, Wisconsin. Fred Smith's *Wisconsin Concrete Park* qualifies as a true monument. It testifies to the persistence of creativity as a force in the world and, in so doing, it also commemorates its maker, a most uncommon common man.

Marsh Trek: The Dilemma of Decoys

Michael Hall has studied decoys as wildfowl portraits, as polychrome folk sculpture, and as hunting artifacts. His involvement with decoys and the collectors who seek them out traces back to the earliest period of his own folk art collecting, the late 1960s. The essay presented here was written in 1979 and was intended for publication in one of several journals circulated among decoy collectors. It was not published, however, until 1986 when it was included in a catalogue accompanying the exhibition, "The Decoy as Folk Sculpture," mounted by the Cranbrook Academy of Art Museum. It is reprinted here in its original form.

*　　　*　　　*

Of all of the collectible forms of American folk art, duck decoys are perhaps the most problematic. Loved and despised as both objects and signs, decoys themselves seem hardly the sort of thing that could start, much less sustain, a controversy. Nonetheless, a controversy rages around them. Two curious advocacies become protagonists in the dilemma of decoys. As they clash, politics and prejudices and a healthy measure of pedantry often cloud the issues. But set into this conflict, two telescoped perspectives bring into focus larger problems confronting the whole appreciation of folk art.

Not surprisingly, the collectors closest to decoys are those who know them best as gunning artifacts. An avid collector fraternity of hunters claim carved waterfowl lures as theirs—theirs through a natural right of inheritance. From quite an opposite position, another collector group of art connoisseurs lay claim to the carvings as theirs—theirs as an art expression rightfully belonging to those with cultivated aesthetic understandings. They contend that it is they who have the necessary "objective distance" to appraise and admire the art to be found in folk art. For hunters, this argument seems effete and condescending. It should be obvious that someone who never shot a duck could never understand a real decoy. From the other side, this response is met with smug amusement.

It should be more obvious that the ownership of a shotgun is the last condition necessary to the appreciation of an art object. Check and checkmate—two claims for the same turf.

The hunters have a point. It was they who carved and used decoys originally. Their hands crafted bird forms in wood and applied the paint to them in patterns that made them effective as tools to lure wild birds into shooting range. It was they who knew from observation the real birds that their decoys were meant to fool. From blinds and sneak boats, they watched their lures bobbing on the waters of marshes and bays effecting the deadly deception which was, of course, their function.

Hunters have another claim. If art involves ideas and feelings given form in materials—and if form can trigger responses of empathy, awe and wonder in viewers—then decoys function as art for the audience of hunters collecting them. Decoys, for hunters, evoke both memory and meaning and are signs of continuity in a changing world. Hunters typically look forward to the fall season with a special impatience. Time for them is cyclical and they set their clocks by the enduring annual migrations of wild birds. Decoys as signs touch the deep psyche of hunters much as the image of a crucifix touches a part of the being of someone raised a Catholic.

To those who know decoys from the duck blind, each carving has its own story to tell. Most carvings pass through many hands. Hunters examining brands and other marks on the bottomboards and keels of decoys read a history that is a social and economic document of great interest. Identifying the species of bird that a carving represents and determining its place of origin, they connect social history to natural history. A patina of information builds up on the surface of an old decoy as it is used, bequeathed and finally retired from the boat shed to a fireplace mantle. Of all the collectors involved with decoys, it is hunters who appreciate them most as material culture—a term that is not necessarily synonymous with the term art but a designation which acknowledges the cultural/social relevance of all types of artifacts.

Some hunters read decoys as a family album. Class, social station, breeding and birthrights are all recorded in this album. A collector possessing a bird gunned over on the Chesapeake in the thirties by Walter Chrysler owns a talisman invested with its magic by the genteel, the high born and the rich (see fig. 49). It recalls affluent sportsmen retreating to exclusive hunting clubs for shoots in the crisp fall dawn while retriever dogs, guides and chefs attended to their every need. This decoy speaks to a collector of a stable social order built and maintained by successful powerful men from the worlds of politics and business. In other decoy images, hunters find the market shooters and outlaw gunners whom they place side by side with the famous sportsmen in their family tree of real

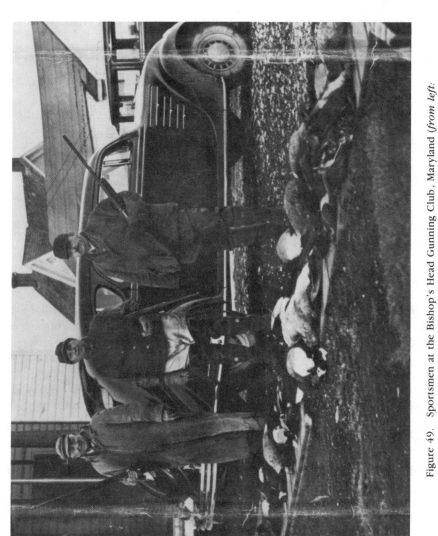

Figure 49. Sportsmen at the Bishop's Head Gunning Club, Maryland (*from left*: Grayson Winterbottom, Walter P. Chrysler, Col. Albanus Phillips), ca. 1936.

(*Photo courtesy R. H. Richardson*)

or imagined forebears. These objects they distinguish as "working decoys"—tools made and used by hearty individuals living off the land—Jack London heroes, outside the law and outside the polite restraints of civilization. Their decoys tell of men who matched wits and cunning with nature—and won.

Genealogies alone, however, are not art. Collectors concerned only with their patrilineal family tree of sporting uncles and poaching grandfathers have missed something. They have underestimated the full totemic significance of the objects they collect. A deep kinship, both spiritual and real, is embedded in a decoy carving as absolutely as it ever was in the lodge poles of the Haida or the Kwakiutl. Decoys link hunter/collectors to an ancestry traced in story to a solitary Indian crouched in the tall grass on the shore of an ancient lake. Through the timeless eyes of their carvings, hunter/collectors watch a flock of ducks wheel in over the crude tied decoys set out just beyond the concealed Indian brave. Totems bind clans and tribes to their mythic origins. Hunters, understanding decoys as totems, touch to all that is primal, ritualistic and binding in primitive art.

As votive objects, decoys are part of a symbolic ritual that brings the sky to a hunter's feet. Hunters who collect decoys find themselves surrounded by something more than an assortment of wooden birds. They know firsthand how mundane tools can become transformed from simple artifacts into compelling "anxious objects." Their decoys become reminders of man's dislocation within a divine plan—seducers implicated in a willful disruption of Paradise. In a hunter's scheme of things, a lifelike carving painted to realistically imitate a given bird's plumage is often accorded the highest esteem. Hunters perceive realism in a decoy as a quality that makes the object transcendent—a part of a larger world where lore and intimate observations of nature shape and frame aesthetic expectations.

But wait! Art oriented collectors want none of this. For them the hunter's myth and magic is only blood and butchery. Proper art should be suitably distanced from such things. Why not just as well collect Ku Klux Klan hoods? Art collectors acknowledge the hunting history in decoys but they perceive it differently than hunters do. "Distance," they say, "give us distance." Let's talk form; let's talk sculpture. Pushing their point, they invade the decoy turf.

In a fine art history the lesson of modernism was that "pure plastics" communicate. Modernism posited that non-representational art, devoid of associative contexts, would be free to speak through its form alone. Ideas and information in good sculpture are abstracted. Brancusi carved birds, didn't he? And they were about transcendence and flight and man and nature and all that stuff, weren't they? And his carvings, they are mysterious and beautiful, aren't they? (See fig. 50.) Well then, ask the

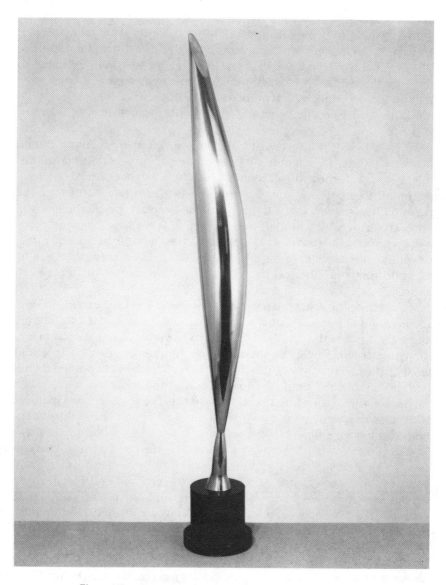

Figure 50. Constantin Brancusi, *Bird in Space,* ca. 1924
Bronze, 49¾".
Philadelphia Museum of Art: Louise and Walter
Arensberg Collection.
(Photo courtesy Philadelphia Museum of Art)

modernists, why can't we have bird sculpture that isn't all caked with duck blood? Expressing this sentiment, decoy collectors from the art world are not just being squeamish. They are simply aligning themselves with an aesthetic grounded in percepts different from those of the hunters. They expect transcendence in art to involve a flow from the general to the specific instead of from the specific to the general.

Collectors familiar with modern aesthetic theory expect a sculptural object to have its own artistic life as a composition of lines and shapes. If the form of a sculpture evinces something that could be called birdness, fine. But in the formalist view, the birdness in a carving should properly embody a sculptor's creative interpretation of all that a bird might be as a form and as a symbol. Birdness as an abstraction would be the antithesis of ornithological specificity. In affective abstract art, the descriptive gives way to the stylized and the general replaces the specific. For a collector with a modernist perspective, a realistic decoy (perhaps a masterpiece in a hunter's eye) is perceived less as art than as some three-dimensional equivalent of Audubon's bird studies. Not surprisingly, most art collectors who discover decoys are drawn to works which they can approach as abstract sculpture.

Two types of abstract decoys do exist in the world of carvings. Some are intentionally *made* that way while others *become* that way as time and wear obscure the details of their form and paint. Certain carvers (anticipating recent studies in animal psychology) knew that birds would decoy to forms that were little more than generalized shapes overlayed with boldly painted simplifications of waterfowl feather patterns. Such carvings embody the same abstraction that academically trained painters and sculptors sought in their own work during the early years of the twentieth century (see fig. 51).

A second group of carvings, reworked by the hand of time, become abstract as their surfaces abrade and their contours soften from use and exposure to the elements. A derelict decoy, cracked and faded, often reveals its sculptural essence better than it did in its pristine state. The age and origin of such a carving are lost. In this ambiance of anonymity fine art collectors can better focus their visual and perceptual assessments of a form. Discussing abstraction and decoys it is not inappropriate to invoke Brancusi. The wonder of flight and the mystery of nature that he captured in simplified shapes is readily found in some decoy carvings. The transcendence one can experience contemplating a decoy can be as sublime as that experienced confronting any other form of sculpture.

Still, decoys pose yet one more problem for the fine art collector who assumes that important works of art are unique and individual. How does one find something truly rare and unusual in the world of decoys?

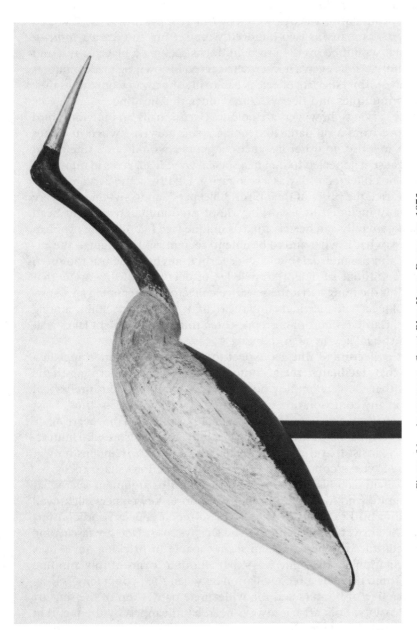

Figure 51. Anonymous, *Great Blue Heron Decoy*, ca. 1875
Carved and assembled wood; painted, 16 × 36½ × 7".
Southern New Jersey.
Private collection.
(Photo: Paul Lee)

They were made by the tens of thousands. Some professional carvers turned out virtually identical birds by the hundreds in an assembly-line mode of production. Decoys were *used* in groups. Rigs of as few as a dozen up to as many as two hundred were set out to create a *tableau vivant* that would be inviting to wild flocks seeking a place to rest and feed in safety. Thus, even a hunter who carved his own rig made numbers of the same form. Fine art collectors habitually shy away from things they regard as multiples and decoys come under this heading.

Some carvings, however, are unique. Occasionally an individual bird broke loose from a rig, later to become a sole survivor when its mates were lost in a fire. In other instances, a gunner would put a single bird away because it appealed to him in a special way. It survives in mint condition to be collected today as a true rarity. Finally, some carvers intentionally varied the poses of their birds. "Sleepers" and "swimmers" were occasionally included in a working rig of predominately straight head lures and generally can be classified as unique (see fig. 52). The problem is to know what is what and to be able to recognize the original, the expressive, and the unusual in whatever form it might come. All too often collectors without sufficient knowledge of decoys foolishly argue that the "eye" is the thing—that the sensitive collector eye scanning an assortment of objects will unerringly find the right or "important" thing among the many. Hardly! A host of misrepresented things and outright fakes wait to prove the fallacy in such thinking.

Most collectors of fine art expect to elevate and isolate things in a manner that facilitates their contemplation. The modern aesthetic demands that viewers employ both their sensory and their intellectual faculties in any confrontation with a work of art. Modernists, thus, insist that only by distancing decoys from the contexts in which they were made and used can the art of a carving be aesthetically confronted. Hunters, conversely, insist that the real appreciation of a decoy happens only at close range where context and object both come into sharp focus.

The dilemma boils down to a historic collector argument over what it is that ignites and sustains an aesthetic response. Newcomers might well ask whether bird carvings even warrant so much concern and consternation. The answer is emphatically, yes! Decoys as artifacts are fascinating and as sculpture the best of them seem capable of pricking our senses and imaginations in the same ways that all other forms of folk and fine art do. Should there be a reconciliation between the "zoom lens" close-up perspective of hunters and the wide-angle pan vision of the fine art world? Possibly. Folk art has always been handicapped by the fact that it is both stifled by partisans who lavish too much protectiveness on it and abused by elitists who refuse to know it for itself.

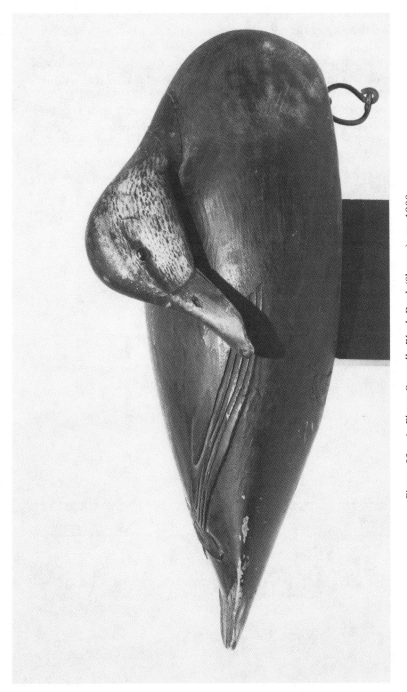

Figure 52. A. Elmer Crowell, *Black Duck* (Sleeper), ca. 1900
Carved wood; painted, 7 × 15½ × 7″.
East Harwich, Massachusetts.
Private collection.

All collectors in one sense are gamblers—betting that what they search out will bring enrichment and fresh meaning to their lives. Decoy collectors might well heed a line from a recent country song, "Every gambler knows that the secret of survival is knowing what to throw away and knowing what to keep." Decoys have survived a long time. Collectors hold their future. By maintaining discerning aesthetics and discarding unneeded prejudices, collectors can evolve an even better appreciation of decoys. Synthesizing their understandings and expectations, those caught in the decoy dilemma today can open doors that will allow their carvings to reach a wider audience tomorrow. After all, objects that touch to both the primal and the sublime would be art in anyone's book.

Brother's Keeper: Some Research on American Face Vessels and Some Conjecture on the Cultural Witness of Folk Potters in the New World

Inquiring into the social and utilitarian nature of folk-made objects, folklorists and other social scientists are currently offering explanations and interpretations of folk art that radically differ from those generally offered by collectors. Michael Hall's appreciation of folk art has its sociological as well as its aesthetic concern. His speculations on American face vessels were first presented in the Cranbrook Academy of Art "Faculty Lecture Series" in 1982. Since that presentation, Hall has continued his research on figural pottery and has expanded the face vessel text he first read at Cranbrook. The 1986 paper printed here is the first published account of a sixteen-year study.

* * *

At one time or another, almost everyone encounters something in life that brings them up short, something peculiar and enigmatic enough to trigger the response we call wonder. Such was my response when I first confronted an American face jug. The sculptor, the potter, the historian and the collector in me were all transfixed by the odd little object which leered out from its plexiglass display case in a museum. That was in the summer of 1966. Since then, I have handled and documented almost two hundred face jugs and my fascination with them has only grown.

The jug I first saw was a small piece, some five inches in height, made from a rather coarse stoneware coated with a semi-transparent green-brown alkaline glaze. The face on the jug was crudely formed from small bits of clay applied to its surface. These modifications only minimally transformed the profile of the basic wheel-thrown vessel to which they had been added. The dramatic and distinguishing features of the piece were its bulging whitish eyes and its gaping mouth filled with white teeth. The museum label indicated that the work was of unknown authorship, but was believed to have been made in the area of Edgefield, South Carolina by Negro slaves sometime around 1850 (see fig. 53).

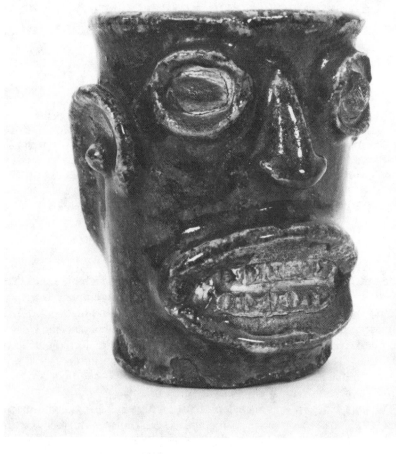

Figure 53. Anonymous, *Face Cup,* ca. 1860
Stoneware clay with kaolin details, alkaline glaze, 4″.
Edgefield, South Carolina.
Private collection.

The presumption that face vessels are black folk art can be traced to a single historic account. This base might well be questioned and reconsidered today. No known document on black history mentions face vessels or alludes to any black custom that would certify such objects as survivals of an Afro-Atlantic slave culture in North America. My contention is that face vessels originated in a white world and are linked to the American temperance movement. I will demonstrate that their production correlates with the growth and spread of temperance throughout the eastern United States from the early nineteenth century into the first decade of the twentieth. To be understood as temperance signs, face vessels must be studied in what George Kubler calls a "history of things," a line of inquiry "intended to reunite ideas and objects under the rubric of visual forms."[1]

This text will address the way in which popular prejudice on one hand, and academic myopia on the other, have frustrated the proper placement of face vessels in a history of things. Reassessed, these objects force us to examine our understanding of folk art and to recognize that, within an idiom presumed to be "primitive," even simple artifacts reflect a condition in which "every trait of a thing is both a cluster of subordinate traits as well as a subordinate part of another cluster."[2] Face vessels testify to the coherence of folk culture. They confirm the belief that ordinary citizens (tradesmen and artisans) exert suasion in the American political process. And, finally, they attest to the fact that complex symbolic meanings can be communicated in a visual language shared as a sign system by individuals enmeshed in a cultural matrix.

To launch a reexamination of face pottery, we retrace a history. The village of Edgefield is in the southeastern corner of South Carolina, near the more easily located town of Bath. The district around Edgefield was a pottery producing center in the early nineteenth century. The first potters in the area probably emigrated from England. Tradition maintains that the first pottery near Edgefield was founded in 1796. Foremost among the early potters were Thomas Chandler and Collin Rhodes. These men produced solid functional ware and, from time to time, turned out large, slip-embroidered jars which have considerable quality as works of decorative art.[3] Edgefield ware, however, would probably have remained something of a footnote in ceramic history had it not been for a reference to Edgefield face vessels published in an early volume on American ceramics written by Edwin Atlee Barber.

Born in 1851, Barber was trained in his youth as an archeologist. Sometime after 1885, he began studying American ceramics and in 1893 published what is probably the earliest important survey of American pottery and porcelain.[4] In a later revised and enlarged version of his book, Barber made the first known mention of American face vessels. His comments are almost universally cited when face vessels are discussed. To my knowledge,

however, his complete statement has never been reproduced. Because I believe it to be critical to the discussion I am initiating, I would like to quote it in its entirety:

> Before the great influx of business came to the little pottery which was operated by Colonel Thomas J. Davies, at Bath, S.C., about the commencement of the Civil War, the negro workmen had considerable spare time on their hands, which they were accustomed to employ in making homely designs in coarse pottery. Among these were some weird-looking water jugs, roughly modeled on the front in the form of a grotesque human face,—evidently intended to portray the African features. These were generally known as "monkey jugs," not on account of their resemblance to the head of an ape, but because the porous vessels which were made for holding water and cooling it by evaporation were called by that name. Colonel Davies informed me a few years ago that numbers of these were made during the year 1862. These curious objects, which I have seen in several collections, labeled "Native Pottery Made in Africa," possess considerable interest as representing an art of the Southern negroes, uninfluenced by civilization, and we can readily believe that the modeling reveals a trace of aboriginal art as formerly practiced by the ancestors of the makers in the Dark Continent. By the ingenious insertion of a different clay, more porous and whiter than the body of the jug, the eyeballs and teeth attain a hideous prominence. A purplish glaze was roughly flown over the surface, presenting the appearance of a composition of sand and ashes, as described to me by Colonel Davies himself.[5]

Later authors writing on American pottery, notably John Spargo and William Ketchum, Jr., cited Barber as the source for their discussions of face pottery.[6] Through its persistent reinforcement in print, Barber's impressionistic notation transformed into a complete cosmology of history and interpretation. Americana enthusiasts came to regard most face vessels as black folk art. Scholars came to view Edgefield as the epicenter of a pottery production that would anchor Afro-Atlantic cultural studies. A close look at Barber's statement, however, raises some questions.

In the first place, it is important to examine the source of his information. Colonel Davies was an educated and successful Carolina cotton planter before the war.[7] He was involved with numerous business ventures and his pot shop was certainly among the least important. Barber knew, in fact, that the pottery developed as an offshoot of a Davies firebrick manufacturing business. The brickworks and the pottery were run by Anson Peeler, a carpenter; Davies, it seems, simply supplied the capital and the slaves to make the enterprise go.[8] The pottery closed in 1865 and Barber did not begin his study until 1885. Thus, Davies, as an informant looking back into the past, could only provide Barber with general recollections. Nothing he shared could be considered hard information.

Secondly, Barber's account is shaded with inflections and suppositions that have had rather broad and unfortunate consequences for face vessel study. His reference to Negro workmen with "considerable spare time on their hands" sowed the seeds for later presumptions that face jugs were "end of

the day pieces"—botched or damaged vessels which potters brought to life at quitting time.[9] Alluding to the jugs as "homely," "weird-looking" and "grotesque," Barber set a tone which would cause collectors (and to some extent scholars) to perceive face vessels as ugly, alien and bizarre—aberrations that certainly could have no place in mainstream American culture.

Surmising that the faces on the jugs "evidently intended to portray the African features," Barber's attempt to interpret the iconography of face vessels was biased by his preconceptions. Very little in the exaggerated features we see in Edgefield face pots can be characterized as portraying African features.[10] His contention that the vessels were "uninfluenced by civilization" betrays his apprehension of them as barbaric. His assertion that the eyes and teeth attained a "hideous prominence" seems indicative that his was a highly condescending (if not racist) perception of the pottery objects he was describing—a perception that would incline later authors to refer to face vessels as ugly jugs, grotesques, voodoo jugs, and effigy pots.[11]

Barber alone, however, did not establish face jugs as black folk art. With the fine arts as a reference, Americana collectors in the thirties and forties came to view folk art with an aesthetic influenced by the enthusiasm for tribal and primitive arts engendered by Picasso and other pioneer modernists. The modernist myth of primitivism reinforced Barber's conclusions on face pottery. It begat a specious assumption which reduces to a simplistic syllogism:

A. Face jugs look exotic and evince something votive in their appearance.

B. African tribal arts look exotic and are generally votive in nature.

C. Therefore, face jugs are survivals of African art brought to America by slaves.

Barber's vague and largely unsupported craft history inadvertently colluded with modern art history to popularize face vessels as black folk art and relegated them to the role of simple curious regional, ethnic artifacts.

It was not until the 1960s that Edgefield face jugs were finally reexamined. Given the emerging awareness of black identity, folklorists and social historians resifted the ground at Edgefield looking for their own evidence to support Barber's original assertion that face jugs represented a survival of African culture in the new world. This time, however, the arguments focused on more sophisticated data than that which Barber gathered. New research utilized stylistic comparisons between Edgefield vessels and specific forms of African art. One author, comparing an Edgefield jug to a Kongo charm figure, observed that the details of the carving reveal "an extraordinary affinity with the Afro-Carolinian vessel style. The eyes with pupils pin-pointed with embedded glass correspond to the whitened teeth and the high-bridged

nose."[12] Another cited specific African pottery traditions in his comparison. He noted that "the Lwena, who live to the south of the Kongo, and the Mbundu make spherical water jugs with human heads fashioned on their tops."[13]

Much new cross-cultural speculation focused on the white kaolin features typically incorporated in Edgefield face pots. It was argued that the decorative and symbolic use of white chalk and shells in African sculpture constituted a distinct tradition which slave potters would have inherited and that this tradition was reasserted by Afro-Americans inserting white kaolin eyes and teeth into figural vessels made of brown stoneware. "The face jugs with bulging white eyes and the small wooden [African] statues with eyes made from white shells are end points of a stylistic continuum stretching the breadth of the ocean."[14]

At least half-a-dozen distinctive "hands" are recognizable in the Edgefield works that have been found. Dr. Franklin Fenenga, an authority on southern pottery, and Dr. Robert Farris Thompson, Professor of Afro-American Art History at Yale, worked together briefly on this problem. They attributed various pieces to authors they identified with such names as "the Master of the Diagonal Teeth," "the Master of the Transverse Handle," etc. Fenenga and Thompson confirmed that at least a dozen Edgefield jugs were discovered in the cabins of southern blacks.[15] As for their purpose, one informant told Dr. Fenenga that face vessels were used by black parents to intimidate misbehaving children—that they were a type of "bogey-man" image used in the discipline of children.[16]

Despite all of the information I have just related, the discussion of face vessels still seems more informed by folklore and political bias than by reliable sociology and art history. No one examining the artifacts and data available at Edgefield has been able to reliably account for the significance and the signification of the vessels within the community where they were made and used. The acceptance of Barber's history and its fortification with new broad theories on the slave transmission of African culture to North America overlooks one major fact. Edgefield face jugs form but one small part of a much larger corpus of face vessels traceable to virtually every major pottery manufacturing area of the eastern United States.

Simply looking at work from Pennsylvania, Ohio and North Carolina, we see that the black production of face vessels at Edgefield was bracketed chronologically and geographically by a white production of strikingly related works. Reason dictates that all these works must be considered together if the inquiry into face jugs is to reveal the richness of an artistic tradition and its importance in a history of things.

One group of face pots produced in Pennsylvania reliably predates its South Carolina counterpart by fifty years. A face pitcher from this group,

illustrated in Warren Cox's book *Pottery and Porcelain,* is of primary interest and importance. The visage on this piece is brutish and dour. From its heavy brow to its jutting goatee, it is decorated with blue cobalt designs. Under its handle, the piece is inscribed "Whitpain Township, Montgomery County, 1805, Henry Dull."[17] The inscription suggests that the author (or the recipient) of the pitcher was of English ancestry, but the style of this pitcher is derived from a broad Euro-American pottery tradition. Potters of mixed European backgrounds worked in eastern Pennsylvania and readily combined forms and decorative motifs from English and Rhenish traditions. Thus, the Henry Dull pitcher may be viewed as an amalgamated folk expression, deriving its form and style from European cultural sources. Its meaning, however, can be shown to derive from something wholly American.

At least four other large double-faced harvest jugs have been located which strongly resemble the Henry Dull pitcher (see fig. 54). Found near Philadelphia, they all exhibit the same sharp noses, protruding goatees and, like the Dull piece, are all salt-fired and embellished with incised and slip-painted sideburns and eyebrows. As harvest jugs, however, they also have paired spouts which form horns on their tops. Another related pitcher, from the Smithsonian Collection, has been attributed to the Remmey family, and if properly attributed, would have been made in Baltimore or Philadelphia sometime between 1810 and 1835. This pitcher, the Henry Dull piece, and the Pennsylvania harvest jugs form a body of work from which we can assert that face vessels of Euro-American origin developed in North America long before they were made by blacks in Edgefield.

In the Midwest, there exists yet another production of face pottery which can be studied—this time in Ohio. The vessels here are large, imaginative, and boldly figurated. The pieces characteristically possess grimacing mouths, bulging eyes and conspicuous "coleslaw" hair, beards, and sideburns. They were produced in many of the major shops in the northeastern and south central counties of the state. The makers of these pots are known to have all been white. Many of them were employed at the Stein Pottery near Lancaster, Ohio.[18] Signed examples exist and attributions of unsigned pieces can be constructed from the stylistic characteristics of the jugs themselves. The high period of Ohio face jug production was between 1870 and 1890.

Shifting our inquiry again, we inspect the late nineteenth- and early twentieth-century face vessels produced by white potters in North Carolina and northern Georgia. Here, members of the Brown family, the Gordy family, the Dorsey family, and others all made face jugs.[19] These works are plentiful compared to examples from Philadelphia or Edgefield. Perhaps as many as one fifth of the face jugs currently housed in public and private collections were fashioned by various members of the Brown family. Brown face jugs are highly stylized and are particularly distinguished by their fierce open

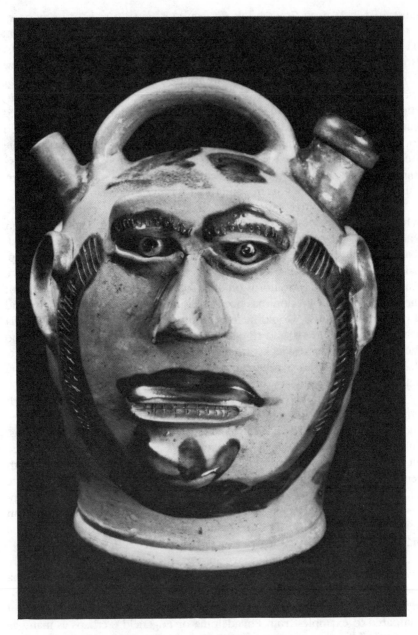

Figure 54. Anonymous, *Face Jug* (Devil), ca. 1810
Stoneware clay with cobalt decoration, salt fired, 11″.
Philadelphia area.
Private collection.

mouths filled with white tile chip teeth. Their other prominent features include pointy ears, moustaches, and goatees.

The simplest way to account for such a broad-based manufacture of face vessels is to cite the universal disposition of potters to transform functional ware into figural images. Given the whole of ceramic history, face vessels form a category of objects which can be found across time and in almost all cultures. In some ways, the idiom constitutes a natural potter's expression. The inherent plasticity of wet clay makes any freshly formed pot receptive to a pinch here and the addition of a coil there which can transform it into a figurative image. A potter who can weld lugs and spouts on jars and churns all day long can just as easily add a nose and ears to the same form and dramatically figurate his work. Formed in this manner, face vessels are suspended somewhere between the abstraction of pottery and the explicit descriptiveness of sculpture. A universal face vessel morphology is revealed if examples from all over the world are examined.

Yet I have difficulty accepting the suggestion that the various face vessel productions in the United States were all of independent origin. It would seem absurd to contend that same "Henry Dull" invented the face jug as a personal encounter with his craft, and that the Edgefield masters fifty years later and the Ohio masters and the Brown family later yet all did the same. I can accept the independent invention of face vessels in different cultures, but my instincts and my researches compel me to seek some tie—some common thread linking all American face vessels to an American history of things. Some groundswell of social pressure set American potters to their production of face jugs in the opening decade of the nineteenth century. This pressure remained a viable impulse in their trade for the next one hundred years. To discover this impulse, we turn to a consideration of potters and their craft.

Origins for potters are always in clay. The contemporary potter Henry Varnum Poor framed a vision of a potter's spiritual bond to his clay in the opening chapter of his book, *A Book of Pottery.* For his clarity and his poetry, I quote him:

> As rock broke up into sand, and sand disintegrated into clay or dirt, or mud, the live surface of the globe came into being. How organic life began no one knows, but it sprang most directly from mud, and is most dependent on mud for its continued existence. The miracle of life and growth involves air, water, and earth, all activated by heat, and of these the tangible element of earth is most closely bound up with the life of man.
>
> From the beginning man knew that he came from earth and returned to earth. . . .
>
> And mud has preserved the most perfect records of life that existed before man. The delicate tracery of leaves, of ferns, of fragile forms long vanished are preserved in shale as vividly as are the specimens that lie pressed between the blotters of a botanist's book. Of all inorganic substances, clay most approaches the organic; it seems almost to contain in itself the breath of life. And it is the host that holds loam, the soluble salts, and all the other elements that support vegetation.[20]

Poor's eloquent prose ties his personal artistic identity to that of generations of potters who had read or heard Genesis 2:7; "And the lord God formed man of the dust of the ground, and breathed into his nostrils the breath of life; and man became a living soul." Ample proof of the continuity of the impact of scripture on potters in the Western tradition can be found in the inscriptions scratched into or trailed on the surfaces of historic pieces of pottery. An early English plate carries the inscription, "Earth I am, it is most true/ Distain me not, for so are you."[21] A Pennsylvania pottery inscription in German from 1800 translates as, "This dish is of earth and clay/ And men are also thereof."[22]

The words clay, dust and earth are frequently used interchangeably in the Bible and this fact combined with the frequent biblical metaphor which describes man as a "vessel" seems to have endowed Euro-American potters with a peculiar and somewhat paradoxical sense of their place in the world. Their craft touched both the mundane and the sublime. Asserting themselves artistically, they symbolically emulated the divine act of creation—but in their repetitious production of simple vessels, they performed a prosaic, tiring, and repetitious chore.[23]

The most powerful biblical reference outside of Genesis which might bear on the thinking of early American potters would be the parable of the potter found in the eighteenth chapter of the Book of Jeremiah:

> The word which came to Jeremiah from the Lord, saying, arise, and go down to the potter's house, and there I will cause thee to hear my words. Then I went down to the potter's house, and, behold, he wrought a work on the wheels. And the vessel that he made of clay was marred in the hand of the potter, so he made it again another vessel, as seemed good to the potter to make it. Then the word of the Lord came to me saying, O house of Israel, cannot I do with you as this potter? saith the Lord. Behold, as the clay is in the potter's hand, so are ye in mine hand, O house of Israel.[24]

Folk potters shared an important "social contract" with their community. When they embellished or decorated their work, they did so with incised or painted marks and depictions which were conventional and which were fully recognizable and legible within their society. Much that was common in their culture was inherited; much that they did was dictated by tradition. Their communities were stabilized by certain norms including adherence to many social and intellectual strictures derived from Christian belief. Most potters, like most Americans, were influenced by Christian moral teachings. Western belief would answer the biblical Cain in the affirmative when he cried out, "Am I my brother's keeper?" Secular thought would follow this model and shape the moral, social and political values in the society around folk potters in America. Turning jars, jugs and churns for the preparation and storage of his community's foodstuffs, the folk potter, in a very real way,

was his brother's keeper. An American-made flowerpot dating from about 1822 bears an incised inscription which corroborates this contention.

Is this a Christian world?
Are we a human race?
And can man from his brother's soul
God's impress dare efface?[25]

Folk potters accepted the Christian abjuration of vanity and arrogance. As tradesmen, they knew their place. They shied away from artistic pretensions that would challenge or usurp divine prerogatives and yet they seem to have been fully aware of the unique Promethean essence of their art. By tradition, their impulse to transform pottery into some figural form of sculpture was inhibited by two factors. As practical men, they made their living producing standardized ware—not time-consuming "one of a kind" objects. As Christians, they refrained from engaging in a creative enterprise which might be construed to parody or insult God's original forming of man from the clay of a riverbank.

Some force in the nineteenth century did, however, compel potters to ply their hands at sculptural figuration. When they did, the figures they formed were most surprising. We find them to be strangely caricatured, frozen, and slightly bizarre. Their pointed ears, jutting goatees and grimacing mouths impart a demonic aspect to their visages. The persistence of this demonic visage establishes a motif in an art we have not yet explained. A search for an explanation compels us to take a closer look at the prototypical Pennsylvania face jugs related to the one marked "Henry Dull."

In a European iconographic mainstream, the imagery in these jugs is very familiar. We recognize their fill and pour spouts as horns. The goatees, heavy sideburns and eyebrows signal the hirsute personage of the devil. Finally, the applied heavy brow ridges distort the diabolical face, transforming it into the specter of the fiend who apes both God and man. Henry Dull's devil jug carries centuries of accumulated visual history in its image. Why, though, should it appear in Montgomery County, Pennsylvania in 1805? And to what purpose? Why would the potters around Henry Dull suddenly begin producing ceramic representations of fallen gods and fallen men? More curious yet, why would potters in the South and the Midwest continue to create demon faces on their wares for the next hundred years?

Social history provides our answer. Potter "Dull," in his time, felt the first stirrings of the groundswell that was to become the temperance movement. As the century unfolded, secular habits and social conscience began to clash and potters, as tradesmen, found their craft conscripted into the service of social reformers crusading against the evils of drink. The "Dull" face pots became signs. Their makers turned their hands to the production of visual

object lessons—didactic propaganda for the movement. By applying horns, exaggerated facial features and a goatee to an ordinary harvest jug, potter "Dull" fashioned an image of a lustful, evil spirit—an image understood by his community as the symbol of spiritual and physical perversity. Sodden man, for temperance advocates, was fallen man. Fallen man, in turn, was one with the fallen archangel, Lucifer.

Alcohol was, of course, popularly consumed in America from the time of the first settlements in Virginia and Massachusetts. The colonials were, nonetheless, fundamentally quick to rebuke excess. For them, "all such indiscretions signified an abuse of nature's wholesome gifts, and were, therefore, violations of the Divine Will in regard to man's use of natural blessings."[26] By 1789, this attitude had accelerated and what would have to be designated as the first temperance society in America was formed in Connecticut. This body was "a voluntary association of forty prominent citizens, who pledged themselves to carry on their respective business interests without the use of distilled spirits, and to serve their workmen only mild beverages such as beer and cider."[27] By the time potter "Dull" and his contemporaries began making devil jugs, demon rum was under fire.

The interesting convergence of forces which would link Satan and the Gentle Creature (as spirits were often called) into an archetypal pottery image is documented in the literature of the temperance movement. By 1830, the learned Dr. Thomas Sewall of Washington, D.C. had published his findings on the conditions which befell drunkards:

> Dyspepsia, jaundice, emaciation, corpulence, dropsy, ulcers, rheumatism, gout, tremors, palpitation, hysteria, epilepsy, palsy, lethargy, apoplexy, melancholy, madness, delirium-tremens, and premature old age, compose but a small part of the catalogue of diseases produced by ardent spirit.[28]

Sewall's admonitions conjure up myriad images of the very grotesque distortions of the human form which had always informed the images of art depicting the horrors of the infernal realms. Sewall and potter "Dull" had come together to set the stage for the emergence of a pottery expression that would preach an American temperance sermon.

An early nineteenth-century preserve jar from New York confirms the fact that potters readily incorporated pro-temperance sentiments in their work. The jar is decorated with an incised and glaze painted figure lifting a flask to his lips. On its opposite side, it bears the inscription: "There is a man in our land./ Upon his feet he cannot stand./ The reason why you all know./ He drinks too much afore he'll go."[29]

The first half of the nineteenth century saw churches and reformers join together in a giant crusade against alcohol which was not concluded until the passage of the Eighteenth Amendment almost one hundred years

later. The fever pitch of the early phase of the movement generated huge camp meetings and pledge signings throughout the Northeast. This fever spread and refocused itself several times in various other regions of the country during the 1900s. The social awareness kindled by the cause of temperance and later fueled by the mid-century antislavery issue committed Americans to the expectation that everyone was in one way or another *rightly* his brother's keeper. Folk potters set their craft in the service of the expanded social concerns of their world. To support my assertion that face vessels in America were predominantly linked to the cause of temperance, I would need to correlate the several major productions of such vessels with the growth and spread of temperance. Specifically, I would need to trace a parallel development of face jugs and of temperance activity throughout the pottery-producing regions of the United States. This can be done. The organized temperance movement began in Connecticut and spread principally into New England and Pennsylvania in the early 1800s. It is here that we find the first face pots. And as has been demonstrated, it is in the Philadelphia area that we find the earliest formulation of the Satan face jug that would become the paradigmatic form of the idiom.

In the 1830s, temperance gained strength in the South, especially in Virginia and the Carolinas. By mid-century, South Carolinians were hotly debating the issue. In an 1852 Edgefield town council election, a "no license" group won a majority of seats. This victory "attests to the influence of the Sons [of Temperance] in that community, numbering about 50."[30] We also note that "Grand Worthy Patriarch A. M. Kennedy, in 1852, at the State Convention of the South Carolina Sons of Temperance, urged state-wide prohibition. . . . "[31] South Carolina Governor William Henry Gist (1858–60) was an ardent advocate of restrictions on liquors and his sentiments clearly reflected those of the citizens of the town of Due West, South Carolina which, in 1854, passed a local prohibition law making the sale and consumption of alcohol illegal.[32] Due West is barely forty-five miles from Edgefield. Churches in South Carolina also became actively involved—particularly in rural areas. In Edgefield itself Rev. John Landrum, a Baptist minister who also owned one of the area potteries, expelled his own brother from the church in 1839 for drunkenness.[33]

The face pots Barber described from the Davies pottery in the 1860s were produced in the midst of this ferment. On close inspection, they exhibit most of the typical demonic features (sharp noses, pointed ears, heavy brows and goatees) which could be said to have derived from the established lexicon of pottery temperance signs established in Pennsylvania (see fig. 55). It may well be that, ironically, face vessels came into southern black life not as African retentions but as temperance admonitions from whites who had very practical reasons for turning blacks away from the consumption of spirits.

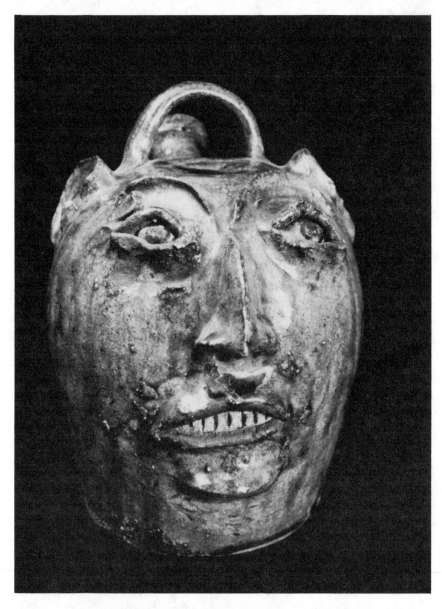

Figure 55. Anonymous, *Face Jug,* ca. 1860
Stoneware clay with kaolin details, alkaline glaze, 9".
Edgefield, South Carolina.
Private collection.

"Intemperance among his slaves cost the owner money in terms of sickness, time lost, and physical deterioration. One South Carolinian cited a figure for his state which estimated the depreciation and damage to slaves caused by intemperance at 20% per year."[34]

Temperance next caught fire in Ohio. Face jugs followed its path. Many of those settling the Western Reserve migrated from New England. They brought with them a temperance fever instilled by the early movement in the East. Resettled and prosperous in Ohio, they needed only a spark to reignite the temperance flame that had flickered out during the Civil War. The spark was struck by Dr. Dioclesian Lewis. A temperance lecture he delivered in Hillsboro, Ohio in the winter of 1873 set off a blaze which became known as the "Women's Crusade."[35]

Women all over the country were restive because male leaders had not successfully controlled the evil. "The ladies were primed and ready to shoot. Dr. Lewis pulled the trigger."[36] Hundreds of Ohio women inspired by Dr. Lewis's message began to crusade and close saloons throughout the state. Lewis himself reported that "in the first two months of the crusade seventeen thousand drinking places were abandoned in Ohio alone."[37] The crusade was particularly effective in small and medium-size towns. From Akron to Springfield, the crusaders closed bars and distilleries.

It is precisely along this line and to the East that we find the great Ohio face jugs. Pottery production in Ohio in the last quarter of the nineteenth century ran from Akron in the North to Portsmouth and Cincinnati in the South. Stoneware devils, satyrs and even a Bacchus can all be traced to the hands of potters working in this area.[38] With the Ohio story, coincident occurrences in Pennsylvania and South Carolina begin to align themselves in patterns. Where temperance crusaded on American clay soil—face jugs joined the file.

To corroborate my contention that face vessels are temperance signs, I have the testimony of an informant with a most interesting account. In 1982, I taped an interview with Aileen Smith, a black domestic living in Detroit, Michigan. In the interview, Mrs. Smith recounts her upbringing in Montgomery, Alabama and describes three face vessels which she remembers in her childhood home. Mrs. Smith recalls that the jugs belonged to her great-grandfather and that he frequently admonished the small children in the house to leave the vessels alone. Smith contends that her great-grandfather referred to the vessels as "jimmie jugs." She has no recollection of having ever heard the term "monkey jug" or "ugly jug." They were "jimmie jugs" to her because, as she says, "that is what the old people called them."[39]

The term "jimmie jug" at first seems confusing. Is it an appropriation of a maker's or owner's name? Could it be a confusion of Jim Crow? Might

it be a creolized African term? In the end, these speculations prove unfruit-ful. Tracing American slang, we find "jimmies" as a term denoting "delirium tremens."[40] As a colloquialism, "the jimmies" derives from "the jim jams"—a popular euphemism for the D.T.'s which appears in American literature as far back as 1852.[41] Mrs. Smith's statement establishes that face vessels, even in black American society, were signs of the spirit of temperance—signs com-pletely consistent in form and meaning with a paradigm recognized throughout nineteenth-century America.

By 1860, the satanic model for the face vessel began to change. A religious motif began to secularize and become more domestic. The bulging eyes and grimacing mouths found on middle period face pots do not link to a purely satanic iconography. Instead, they illustrate the secular variant of the devil as a drunkard in the throes of the jim-jams—the sodden mortal who was the pathetic reality of a fictional demon. The *Edgefield Advertiser* in 1859 published the following description of a sufferer with delirium tremens:

> There he lies upon his bed of straw, with parched lips, bloated countenance, and blood-shot eyes, the very personification of ruin. Tossing upon his hard and comfortless couch, panting for breath, and calling for help, but all in vain. Death marks him for his victim, and now, if for a while he is relieved from frightful ghosts and demons which hitherto haunted his disordered imagination. . . .[42]

Perhaps the potters of Edgefield fashioning the face jugs Barber described as having eyeballs and teeth of a hideous prominence were simply giving visual form to the accepted period stereotype of the debaucher led astray by drink. Recognized as regional stylistic interpretations of a broad tradition parodistically depicting the fiend in the drunkard, Barber's "weird-looking water jugs" finally find a place in a legitimate context of meaning. They become part of the ancestor tree of the "jimmie jugs" Aileen Smith knew as a child.

Having established face vessels as temperance folk art, new issues must be dealt with. First an explanation must be found for the persistent reference to these vessels as grotesques, monkey jugs and the like. Second, there is a need to investigate and explain some of the seemingly eccentric iconographic motifs which distinguish a few of the most interesting and unique works in the face jug corpus. Finally, the links should be forged that would connect face vessels to other known forms of American temperance pottery such as the snake pots from Ohio and Illinois.

Barber actually never referred to face vessels as "grotesque jugs." Rather, he described them as having "the form of a grotesque human face." His language exhibits a dash of high Victorian affectation but he appropriately uses the word *grotesque* as referring to things characterized by fanciful or

fantastic representations of human and animal forms—things that appear as bizarre hybrid composites using distortion or exaggeration of the natural or the expected to the point of comic absurdity or ludicrous caricature. As temperance signs, face jugs are thus properly and intentionally grotesque. Once the term "grotesque jug" entered the popular lexicon, however, it gained a pejorative aspect. Collectors have refused to see face vessels as hybrid composites intentionally distorted to achieve high comic absurdity and ugliness. Face pots become absurd only when they slip into their paradoxical social role as critics/comics. In this role, they function in a temperance drama much as Shakespeare's fools functioned in his plays.

The antic intent of some face jugs is confirmed by a detail on one particularly outstanding Ohio piece. This large jug is constructed from two rather average sized clay globes joined together, one on top of the other. The smaller top globe is skillfully modeled into a reptilian human face. The chin of the figure sports a small goatee. Under the protruding goatee, a small hole has been drilled which penetrates into the interior of the vessel. This particular jug, when raised to the lips, would not pour cleanly out of its top spout. Instead, its contents would dribble out of the hidden hole and down the vest of the unwitting victim foolish enough to be tricked into partaking of its intoxicating contents. This prank is part of the long American tradition of practical joking. It suggests more, though. The embarrassed drinker is made a fool. He is soiled and embarrassed and his knee-slapping companions have precipitated his symbolic fall. All of this was presided over silently by the sardonic face atop the jug which viewed the ludicrous goings-on as a piece of absurd theater.

Barber did cite "monkey jugs" in his discussion of South Carolina face vessels. He notes the term as applied to them was a name for porous pots that kept water cool by evaporation. Contemporary researchers have sought to confirm a place for Barber's face decorated monkey jugs in black history. They have found that non-figurated vessels called *monkeys* are "known to have been made by slave potters from Barbados in the nineteenth century."[43] They also point out that a variety of such monkeys from the West Indies are related in form to certain pottery water coolers made in the Kongo *and* to one of the basic vessel shapes on which South Carolina black potters modeled faces.

Investigating further, John Vlach found that "some Blacks in South Carolina still use the word monkey to mean a strong thirst caused by physical exertion."[44] Thompson suggests that there may well be various Kongolisms concealed in this single word and states that "*mbugi,* Ki-Kongo for 'devil,' is surely one origin for 'monkey,' in the sense of evil spirit"[45] From these and related inquiries, Afro-Americanists have interpreted the monkey jug from nineteenth-century South Carolina as expressing black slaves'

memories of their Caribbean/African roots. Interestingly, the same information can be reinterpreted to root the same jug in American temperance. If the word *monkey* in black society alludes to both ceramic forms *and* to thirst and evil then "monkey jug" might be a colloquial name for a temperance jug.

A look at a European history reveals still more on "monkeys." In Antwerp during the 1560s, Pieter Bruegel painted a slightly melancholy picture of two monkeys in a tower window. In Bruegel's time, monkeys were a symbol "commonly used to represent man's bondage to his bestial side."[46] Bruegel and his contemporaries intuited what Charles Darwin would scientifically assert three hundred years later, namely, that monkeys are tied to man and somehow at the low end of a chain. Throughout nineteenth-century America and into the twentieth, monkeys have been associated with the brutish and the ludicrous. The monkey was duly appropriated as a temperance sign—for the debasements induced by alcoholic spirits were seen to make a monkey of a man. Thus, as a term which may well have synthesized Afro/Caribbean and European connotations, "monkey jug" becomes a fitting designation for the "jimmie jug"; the pottery reminder that "He who stepped over the shadowy line of moderation, was an outcast from the community."[47]

The term "effigy jug" comes into the literature on face pottery somewhat late. The word *effigy* denotes a likeness, visually "a crude representation of a person who is hated or held in contempt."[48] This word provides an insight into the not-so-veiled racial prejudice that informs the imagery in certain late face vessels—a prejudice that also seems to have conditioned collector perceptions of face vessels from Barber's time to the present.

To ground a discussion of face vessels as effigies, I must establish a historic context that goes back to the age of discovery. The early navigators and explorers followed maps which beckoned them westward with painted images of Christ or the Virgin Mary worked into their western borders.[49] This had a great deal to do with the mental and spiritual geography of the medieval world. Up until Columbus's time, Europeans were in general agreement that the biblical Garden of Eden lay somewhere to the east. However, because its precise location had never been ascertained, Eden became oddly transposed into a vision that entreated explorers to seek its whereabouts in the West. The regaining of Paradise and Christ's promise of redemption merged in this dream.

Such speculations coincided with the discovery and popularization of the magnetic compass. Once it was known that a suspended lodestone would orientate itself north and south, the world had a base for standardizing the attitudes of its maps. North and "up" became one and the same and south and "down" likewise became synonymous. Two quite different maps began to superimpose themselves in the minds of Europeans. The theological map

of Christian thought placed God, goodness and enlightenment up toward heaven; and Satan, evil and depravity down toward hell. The geographic charts used by the navigators placed Europe up at the top of the map and put Africa and South America down toward the bottom of the map. In one of the most troublesome coincidences in history, the skin colors of the peoples of the then-known world distributed themselves in a tonal gradation that ran from light in the North to dark in the South. Ironically, this pattern precisely fit the up/down and the good/bad models imprinted on Christian consciousness. Refining these maps, Columbus and those who followed him did much that would place the dark serpent of racial prejudice into the shining paradise they sought in the West.

Dark-skinned savages discovered in southern and tropic climates were abhorrent to the early Spanish and Italian explorers, both for their nakedness and for their presumed barbarism. Rumors that they practiced cannibalism particularly shocked and repelled explorers. The journals of the early navigators are full of lurid descriptions of alleged savage cannibal rites.[50] A century later, sailing from their northern island fortress, the English had even less experience with dark peoples than had the Spanish and the Italians. Dark people were Moors and Ethiopians to the English of Shakespeare's world.

The bard himself, time and again, polarizes things in black and white. His Aaron the Moor in *Titus Andronicus* is portrayed as a "walking, plotting, fornicating symbol of evil."[51] Like most of his countrymen, Shakespeare perpetuated early stereotypes of peoples from southern climes as devilish, evil, bestial and remarkably potent sexually. The colonists debarking with Raleigh and Smith for Virginia and Massachusetts carried with their belongings the Elizabethan dispositions on the subject of race and color which would significantly shape their attitudes toward the Indians and blacks with whom they would share their new world. In the wave of settlement that followed exploration, the colonists, potters among them, arrived in North America. In the nineteenth century, expansion settled potters throughout the eastern United States. They built shops wherever good clay deposits could be found and where riverways or railroads provided access to markets. They adapted their work to the peculiar conditions of the various locales where they set up their wheels and kilns. They probably did not speculate much about the transgenerational transmission of images and prejudices but their hands were conduits for both.

If the real subject of temperance figural pottery was fallen man, and if potters truly had inherited the dual European map of up/down, light/dark, good/evil, then at some point one among them would logically create a jug that would depict fallen man in the form of a black devil. This evocation would evolve from the cultural assumptions which prescribed the belief

system a potter lived within and the meanings associated with the words he spoke. Somewhere, some potter had to explicitly depict blacks, the fallen scorched ones, on his temperance pots as the incarnation of Satan.

One did, and his name is known for he signed one of his jugs "John Dollings." Dollings potted at the Stein Pottery in the White Valley area of Ohio around 1880.[52] His hand is unmistakable. The seven face vessels known to have been produced by him all display the same technical and sculptural authority. They are also all degraded by the same mawkish interpretation of their black subject. Dollings lived in a time when expunging devils was not accomplished gently. In the South, men still felt the sting of their defeat in a war over who was whose keeper. In the North, men still had very little experience living with Shakespeare's Aaron. In the midst of the events that swept Dollings and his contemporaries toward the twentieth century, it is doubtful that anyone noticed that the virtue of temperance and the vice of racism had been married in one bizarre set of ceramic artifacts from Ohio.

Despite their lack of artistic merit, the Dollings jugs are true effigies. Ohio townsfolk understood these vessels as depicting an amalgamation of two evils many of them feared and held in contempt—alcohol and blacks. In the next century, numerous collectors, perceiving face jugs as Negro portraits, would consider all face pots similarly as effigies. Their prejudicial misconceptions would be only slightly more subtle and veiled than those of John Dollings.

As the temperance movement spread west and south throughout the nineteenth and early twentieth centuries, its icons predictably changed. In a broadening stylistic evolution the form of the face vessel was dramatically altered by potters swept into late temperance activity in Ohio, Illinois, Georgia and Alabama. In the North, the bridging piece in this history is an Ohio jug which is distinguished by a transverse stirrup handle that has been modeled into the form of what appears to be an alligator (see fig. 56). As recently as ten years ago, this jug would have been attributed to the hand of a black southern potter. Its coleslaw hair would have been read as an allusion to the woolly texture of Negro hair. The alligator image would have cinched the attribution, given the many references to alligators that can be found in black folklore. Even the fact that the piece was discovered in Ohio would not have deterred this attribution. Its presence there would have been explained away by the presumption that it came north with runaway slaves on the underground railroad.[53]

Today this jug would be attributed quite differently. It is obviously late, white and northern. The clay body from which it is made is typical of those used in potteries along the Ohio river in the 1870s. Ignoring its figurative details, we see that the jug itself was fashioned with a technical finesse singular to Ohio. Simple inspection confirms that this pot never wandered vary far from its place of origin.

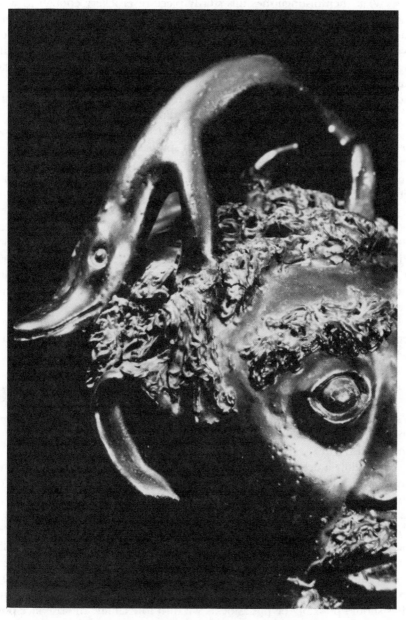

Figure 56. Anonymous, *Face Jug with Crocodile* (Detail), ca. 1875
White stoneware clay with iron glaze, 9″.
Central Ohio.
Private collection.

What then distinguishes this sturdy piece of crockery enough to warrant all this attention? Much! The hirsute personage peering out from its surface rings a familiar bell. It is the "Henry Dull" Satan. Lucifer had moved west with the rest of the sinners. But what about the alligator? Something new rather than something transplanted complicates the iconography in this jug and begs explanation. A perusal of lore on alligators yields little but it does cross-reference to crocodiles. These reptiles, in turn, cross-reference to scripture. The crocodile in Ezekiel is the caiman—the dragon of the Nile.[54]

The crocodile also appears in Revelations as a dragon from the great river Euphrates. From its mouth, unclean spirits spew forth. In Revelations, these spirits are described as being like frogs "out of the mouth of the beast, and out of the mouth of the false prophet."[55] As the most malevolent in a host of fiends, the crocodile complements the devil face on this jug. The reptile is incorporated as a metaphor for the treachery of false prophets. Fused on the jug as a handle, the crocodile signals a shift in the temperance pottery sign system we are tracing. A narrative element begins to inform an idiom that in its classic early phase was essentially iconic. Fallen man is no longer a frozen specter coaxed to the surface of a freshly formed clay vessel. Instead, he becomes a much-reduced presence caught up in a larger graphic vision.

Other Ohio jugs, contemporaneous with this piece, are even more narrative. In these works, face imagery gives way to fully sculptured tableaus which entwine around vessels. In one, a hapless drunkard is caught up in the jaws of a giant crocodile which arches up over the top of the pot to form a handle and then turns down and around its spout. A menagerie of clay demons witnesses all of this from below. This host includes a serpent, a scorpion and a turtle. Assembled on this jug is a quartet of creatures from the dark realms ordained to rend, sting and torment the inebriant flung into their midst.

Certainly a deep cultural memory fed the imagination of the artist who shaped this jug. A durable oral and visual culture, sustained in a history of things, outcrops in the images formed here. After 1870, potters in the North became storytellers as well as sign-makers. It would be tempting to suggest that the single faces on early temperance pots were eclipsed by more complex narrative figurations as Americans themselves began to feel personally overwhelmed by the problems and promises of the urban industrial new world they were creating. Psychosocial speculations such as this could be expanded but would carry us too quickly into contemporary concerns and thus should probably be put aside as we turn to examine the late face pots of the South.

Though much has been written on Georgia folk pottery, little comment has been focused on the region's face jugs as a distinct expression within

the overall genre. Perhaps this is because it is presumed that these jugs were simply late imitations of Edgefield originals. Certainly the recent self-conscious revival of face-jug making in Georgia has tended to muddy the waters around the authentic folk pieces. Whatever the reason, this oversight should be addressed. Temperance images were formed in Georgia clay well into the twentieth century and they deserve their own place in a history.

Actually, the fact that face jugs were made late in Georgia should not surprise us at all. Many writers have alluded to a certain cultural conservatism that has seemingly kept the South out of step with its time. "As an index of this regional time-lag, the height of folk pottery production in Georgia occurred during the late nineteenth and early twentieth centuries, whereas in New York State, for example, folk pottery activity reached its zenith in the 1820s and was on the decline by the 1840s."[56] The relatively late emergence of the temperance movement in the deep South, however, contributed to the delayed evolution of face vessels in Georgia and in its neighboring states. Though temperance crested late here, when it did, it broke with a vengeance.

In 1907, Georgia became the first southern state to adopt statewide prohibition.[57] The process that brought this about had taken decades. As Due West, South Carolina had voted itself dry in 1854, so too did many other towns throughout the South between 1840 and 1900. With the passage of each new local prohibition, temperance gained strength. The battle that would be won with the enactment of the Eighteenth Amendment in 1920 was fought town to town and county by county in Georgia, Alabama and the Carolinas. Georgia, however, led the charge and "within nine months of Georgia's action [prohibition], four more states had done likewise."[58]

Georgia potters responded by reasserting the face vessel. In general, it can be said that Georgia face jugs are diverse and individualized in appearance. They are usually made from the typical coarse stoneware clay found in the region. Though they do not exhibit the technical finesse evident in Pennsylvania and Ohio ware, they do have unique stylistic and iconographic characteristics.

Stylistically, the face jugs produced during the high period of deep South temperance push the limits of sculptural figuration afforded by the vessel form. Throughout the piedmont plateau and west into Alabama, potters transformed jugs into full figures. These works sport heads, torsos, arms, hands and even suggestions of dress apparel. Preeminent among the southern figural vessels is a piece referred to as the *Gospel Singer.*[59] Allegedly from eastern Alabama, this piece reflects stylistic characteristics specific to jugs known to have been made in the Georgia piedmont.

The *Gospel Singer* is an outstanding piece of figural pottery and it typifies the highest ambitions of late Georgia and Alabama face-vessel makers. The

small spout at the top of this jug flares out to become a broad-brimmed hat. The figure's face is minimally detailed but wondrously expressive. The main body of the pot is transformed into a torso by the addition of two coils of clay which simulate the lapels of a coat and by two additional coils which curve down from the shoulders of the pot and terminate in a pair of clasped hands.

The maker of the *Gospel Singer* may also have fashioned other less developed but still fascinating figural pieces discovered in Georgia.[60] In concert, these works attest to the development of one artist's expression from its genesis in a common tradition to its culmination in a highly personalized gesture which exploits the sculptural potential of the potter's language. As completely as Ohio potters became narrators, potters from Georgia, Alabama and North Carolina became sculptors.

They also brought a certain sense of humor and whimsey to a traditionally sober idiom. The rakish, laughing devils made by Georgia's E. J. Brown exemplify the metamorphosis of late southern face pot demons into imps. Brown made his genial ten-gallon polychromed monsters in the nineteen-twenties and thirties and placed them along the roadside near his North Carolina pottery to attract tourists (see fig. 57). Three or four survive— the rest fell victim to shotgun blasts leveled at them by "good old boys" joy-riding in their cars up and down mountain roads.[61]

No one in the Brown family today recalls the jugs as anything other than roadside attractions. "Henry Dull's" sinister Pennsylvania fiend obviously changed greatly to end up as the horned jester placed outside the Brown shop. As temperance advocates in the early twentieth century were about to grasp their long-sought dream, their pottery sign, it seems, had become forgetful and even playful. By 1920, prohibitionists nationwide had saved all their brothers with a constitutional amendment.[62] As prohibition became law, face vessels would become history. As whimseys, they would persist in the folk pottery idiom but they would no longer signal a message that an American community could decode.

Despite a hundred-year history of manufacture, almost no face vessels have been found signed or otherwise documented. It is almost unthinkable that so many artifacts could have remained so largely undifferentiated one from another. Somewhere in all of this production, some great master must have taken the common themes from the visual tradition around him and aspired to convert them into something so original and uncommon that it would identify itself in art history. Such was the vision of Wallace Kirkpatrick—an Illinois temperance potter without peer. His amazing sculptured snake jugs brilliantly end-game the history of American temperance ceramics.

Born in Ohio in 1828, Wallace was part of a pottery-making family which migrated west from Pennsylvania. The events of his life placed him in Ohio

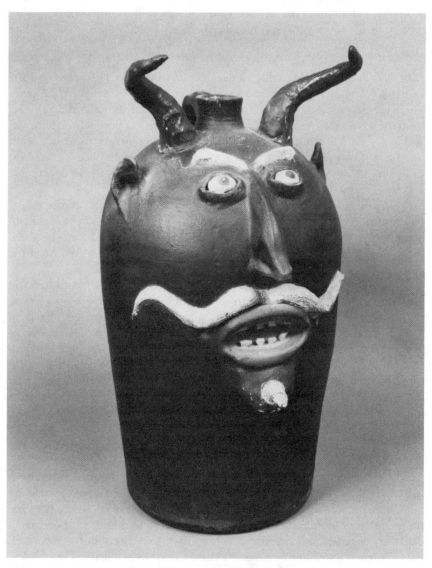

Figure 57. E. J. Brown, *Devil Jug,* ca. 1920
Stoneware with painted features, 21½″.
North Carolina.
Private collection.

at precisely the right time to have absorbed all the temperance impulses which fed the narrative movement described earlier. In 1857, he joined his brother in a pottery at Mound City, Illinois. Two years later, the brothers built another pottery in the town of Anna, Illinois, the site where Wallace would create his masterworks.[63]

As a member of the United Friends of Temperance,he took the cause to his clay and fashioned perhaps a dozen epic temperance jugs between 1865 and 1880. Among these, we find a piece he entitled *The Drunkard's Doom*. The jug is so encrusted with figures and reptiles that the underlying vessel form itself is almost obscured. Central in the piece is a figure whose buttocks and legs protrude from one side and whose head emerges from the other (see fig. 58). Around the buttocks, Kirkpatrick inscribed "Nice Young Man Going In." Bursting out, the nice young man is engulfed by a host of serpents and by the epitaph, "The Drunkard's Doom."

Elsewhere on this vessel, three drunken revelers sprawl across railcar coach seats while snakes and lizards look on. Opposite this scene, a pair of dung beetles are busy pushing a large ball of waste back and forth between themselves. Nearby, frogs and locusts perch to survey the scene. Atop the piece, a coiled serpent as a stopper seals the mouth of the jug.

Kirkpatrick's art was a fully synthetic expression, both sophisticated and provincial, traditional and modern. A closer look at *The Drunkard's Doom* reveals that its handle is hollow. In a gesture of uproarious abandon, Kirkpatrick took his complex sculptured editorial and reasserted its grassroots in a pottery tradition.[64] Upended, the jug pours its contents out of the mouth of the frog squatting on its handle. Yet, Kirkpatrick signed or otherwise identified most of his work. The "self-expression" in this pottery suggests that its maker was temperamentally more a twentieth-century artist than a nineteenth-century folk craftsman.

Temperance face vessels disappeared from the American scene by 1930. A few self-conscious contemporary potters have attempted to revive the idiom producing commissioned works imitating the "look" of early face vessels. The face jug as a functioning sign in a history of things, however, is not theirs to revive. It belongs instead to a past time. An educated count would set the number of known pre-1920 temperance face vessels somewhere between three and four hundred. I would assume that a hundred or more await discovery in attics and basements where they have been stored for years.

The creators of our face vessels passed into history leaving only a few cryptic inscriptions that do little to explain their work. By refusing to decode this work for us in a manner appropriate to our habit of literacy, they left their art vulnerable to misunderstanding. They did, though, leave the vessels they made. In a medieval rather than a modern way, folk potters bequeathed their pots as witness to their existence but not to their ego. The temperance

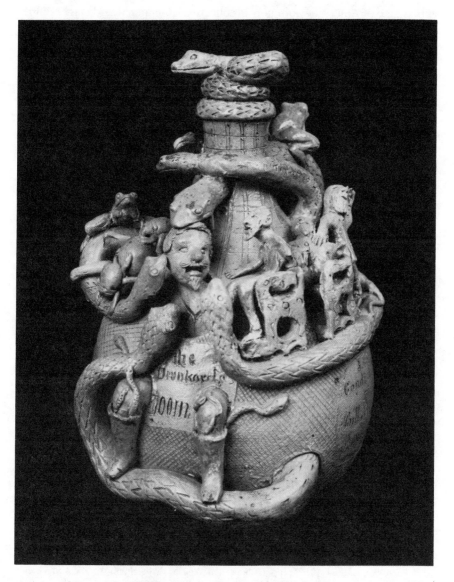

Figure 58. Wallace Kirkpatrick, *The Drunkard's Doom,*
ca. 1870–75
Stoneware clay, salt fired with incised, applied and
cobalt blue decoration, 9½".
Anna, Illinois.
Private collection.

experience of American potters was collective. It gathered and carried forth in time that which seemed central and useful to folk communities. Conversely, it also shed that which would not allow potters to remain continuous in their world. The history of things of which American face vessels are a part is not easily broken down for convenient filing in Dewey's system of classification. Yet, meaning resides in the corpus of face jugs we inherit. The phenomenon is an entity. Our aesthetic inspection of this entity extends our perceptions of the art in folk art.

The folk potter, in some manner, knew all of this. Hunkered over his turning wheel, he was centered in his universe. Wherever he set up another shop, he recentered himself, and his hands again transmitted cultural memory, social value and personal creativity to the pliable clay which turned between them. The silence of the fragile baked images he fashioned inspires a peculiar wonder for us today. The pieces are suspended forever between the centrifugal and centripetal forces which shaped them. Turned inward, they store the perishable history of a people. Turned outward, they stare enigmatically into an indifferent present time as ceramic curiosities. As folk art they are both objects and signs—objects which can now be appreciated as signs of the temperance fire that once burned fiercely in the kilns and imaginations of American potters; a fire that flickered out in a new age which dismissed both potters and their face pots from service as their brother's keepers.

Notes

1. George Kubler, *The Shape of Time* (New Haven: Yale University Press, 1962), p. 9.

2. Ibid., p. 36.

3. Stephen Ferrell and T. M. Ferrell, *Early Decorated Stoneware of the Edgefield District, South Carolina* (Greenville, South Carolina: Greenville County Museum of Art, 1976), n.p.

4. Edwin Atlee Barber, *The Pottery and Porcelain of the United States: An Historical Review of American Ceramic Art from the Earliest Times to the Present Day* (New York: G. P. Putnam's Sons, 1893).

5. Edwin Atlee Barber, *The Pottery and Porcelain of the United States: An Historical Review of American Ceramic Art from the Earliest Times to the Present Day*, third ed., rev. and enl. (New York: G. P. Putnam's Sons, 1909), pp. 465–66.

6. John Spargo, *Early American Pottery and China* (Garden City, New York: Garden City Publishing Co., Inc., 1926), pp. 347–48; and William C. Ketchum, Jr., *The Pottery and Porcelain Collector's Handbook* (New York: Funk & Wagnall's, 1971), p. 71.

7. Nancy C. Mims, personal communication, December 1986. Ms. Mims directs the Visitor Center in Edgefield, South Carolina and is knowledgeable on the subject of Edgefield history. Her family has long ties to the temperance movement in South Carolina.

8. Edwin Atlee Barber, *The Pottery and Porcelain of the United States*, pp. 248–49.

9. Harold F. Guilland, *Early American Folk Pottery* (Philadelphia: Chilton Book Company, 1971), p. 133.

10. Personal field work. I have handled over twenty-five Edgefield face vessels. Observation does not bear out Barber's statement that the modeling on these vessels was "intended to portray the African features."

11. Michael Kan, "American Folk Sculpture: Some Considerations of Its Ethnic Heritage," in Herbert W. Hemphill, Jr., ed., *Folk Sculpture U.S.A.* (Brooklyn: The Brooklyn Museum, 1976), p. 56. William C. Ketchum, Jr., *Pottery Handbook,* p. 71.

12. Michael Kan, "American Folk Sculpture," p. 58.

13. Robert Farris Thompson and Joseph Cornet, *The Four Moments of the Sun: Kongo Art in Two Worlds* (Washington, D.C.: The National Gallery of Art, 1981), p. 159.

14. John Michael Vlach, *The Afro-American Tradition in Decorative Arts* (Cleveland, Ohio: The Cleveland Museum of Art, 1978), p. 86.

15. Robert Farris Thompson, personal communication, November 1986. In January 1969, Dr. Thompson visited the Edgefield area to gather information on Afro-American face vessels. He met a Mrs. Eve who had in her possession a number of face jugs. Her son, William Raiford Eve, had collected the jugs between 1939 and 1940. Mrs. Eve informed Dr. Thompson that her son had found all of the pieces in black homes in the countryside around Edgefield.

16. Franklin Fenenga, personal communication, June 1976. I visited Dr. Fenenga in his California home to discuss his field work on face pottery. In the conversation on his findings, the information related here was revealed. Dr. Fenenga also shared his collection of face pottery with me, recounting as much specific information as he could on each piece that he offered for my inspection.

17. Warren E. Cox, *The Book of Pottery and Porcelain,* vol. 11 (New York: Crown Publishers, 1944), p. 986.

18. David Good, personal communication, December 1982. Mr. Good is a knowledgeable collector of Ohio pottery. His personal field work has uncovered a great deal of useful information on Ohio face vessels. He has established that members of the Stein family as well as E. Hall and John Dollings all worked in the Stein pottery on Kent Run in the Zanesville area of Ohio in the third quarter of the nineteenth century.

19. John A. Burrison, *Brothers in Clay: The Story of Georgia Folk Pottery* (Athens, Georgia: The University of Georgia Press, 1983).

20. Henry Varnum Poor, *A Book of Pottery: From Mud into Immortality* (Englewood Cliffs, N.J.: Prentice-Hall, Inc., 1958), pp. 17–18.

21. Ibid., p. 22.

22. Edwin Atlee Barber, *Tulip Ware of the Pennsylvania-German Potters,* reprint of 1928 ed. (New York: Dover Publications, 1970), p. 208.

23. *The Holy Bible* (King James Version),"The Acts" 9:15: In this chapter of Acts, God admonishes Ananias to go and seek out the blind Saul of Tarsus and to lead him into Christian fellowship:

 . . . Go thy way; for he is a chosen vessel unto me, to bear my name before the Gentiles, and Kings, and the children of Israel.

24. *The Holy Bible* (King James Version), "Jeremiah" 18:1–6.

25. Edwin Barber, *Tulip Ware,* p. 216.

26. John Allen Krout, *The Origins of Prohibition,* reprint of 1925 ed. (New York: Russell & Russell, 1967), p. 1.

27. Ibid., p. 68.

28. Ibid., p. 229.

29. Georgeanna H. Greer, *American Stonewares: The Art and Craft of Utilitarian Potters* (Exton, Pennsylvania: Schiffer Publishing Ltd., 1981), p. 255.

30. Douglas Wiley Carlson, "Temperance Reform in the Cotton Kingdom," unpublished thesis (Urbana-Champaign, Ill.: University of Illinois, 1982), p. 250.

31. David Duncan Wallace, *South Carolina: A Short History, 1520–1948* (Columbia, S.C.: University of South Carolina Press, 1948), p. 86.

32. Benjamin Ryan, *The Tillman Movement in South Carolina,* n.p.

33. Ferrell & Ferrell, *Edgefield District,* n.p.

34. Douglas Carlson, *Temperance,* p. 65.

35. Herbert Asbury, *The Great Illusion: An Informal History of Prohibition* (Garden City, N.Y.: The Country Life Press, 1950), pp. 68–87.

36. Ibid., p. 71.

37. Ibid., p. 85.

38. David Good, personal communication, December 1982.

39. Aileen Smith, personal communication, April 1982. Mrs. Smith was born Aileen Taylor in Greenville, Alabama in 1929. The face vessels in her childhood home belonged to her great-grandfather, Caesar McPherston. Caesar had been born a slave and brought the jugs with him into Alabama sometime after the Civil War. Mrs. Smith is not certain of the events of his early life but she indicates that he came to Greenville from somewhere to "the east" (Georgia? South Carolina?) Her testimony establishes that Caesar repeatedly asked the children in the house not to touch the face vessels saying, "Those are *my* jugs." It is not certain whether he was claiming ownership or authorship of them. That he called them "jimmie jugs" is, however, clear in Mrs. Smith's recollection.

40. Eric Partridge, *A Dictionary of Slang and Unconventional English,* 8th ed. (New York: Macmillan and Co., 1984), p. 620.

41. Stewart Berg Flexner, *I Hear America Talking* (New York: Van Nostrand Reinhold, 1976), p. 128.

42. Douglas Carlson, *Temperance,* p. 122.

43. John Michael Vlach, *Afro-American Tradition,* p. 87.

44. Ibid., p. 86.

45. Robert Farris Thompson and Joseph Cornet, *The Four Moments of the Sun,* p. 163.

46. Timothy Foote and the Editors of Time-Life Books, *The World of Bruegel, c. 1525–1569* (New York: Time-Life Books, 1968), p. 69.

47. John Krout, *Prohibition,* p. 27.

48. *Webster's New World Dictionary of the American Language* (Cleveland and New York: The World Publishing Company, 1958), p. 462.

49. Ronald Sanders, *Lost Tribes and Promised Lands: The Origins of American Racism* (Boston, Mass.: Little, Brown and Company, 1978), p. 10.

50. Ibid., p. 101.

51. Ibid., p. 246.

52. Robert Doty, *American Folk Art in Ohio Collections* (New York: Dodd, Mead & Company, 1976), n.p. The signed example cited is in the collection of the Ohio Historical Society. The jug is marked in glaze on its bottom with the maker's name and the note "White Valley." Interestingly, the Ohio Historical Society refers to the piece as an effigy jug.

53. Reginia A. Perry, *Spirits or Satire: African-American Face Vessels of the 19th Century* (Charleston, S.C.: Carolina Art Association, 1985), n.p.

54. *The Holy Bible* (King James Version), "Ezekiel" 29: 3–5. In this chapter, Ezekiel was sent to prophesy against Pharaoh in the name of the Lord. His message rages:

3 . . . Behold, I am against thee, Pharaoh king of Egypt, the great dragon that lieth in the midst of his rivers, which hath said, My river is mine own, and I have made it for myself. 4 But I will put hooks in thy jaws, and I will cause the fish of thy rivers to stick unto thy scales, and I will bring thee up out of the midst of thy rivers, and all the fish of thy rivers shall stick unto thy scales. 5 And I will leave thee thrown into the wilderness, . . .

55. *The Holy Bible* (King James Version), "Revelation" 16: 13.

56. John Burrison, *Brothers,* p. 56.

57. John Samuel Ezell, *The South Since 1865* (London: The Macmillan Company, 1963), p. 399.

58. Ibid.

59. Illustrated and discussed in John Michael Vlach, *Afro-American Tradition,* pp. 92–93.

60. Personal field work, north Georgia, August 1981.

61. J. Roderick Moore, personal communications 1975–85. Professor Moore directs the Blue Ridge Institute at Ferrum College in Virginia. He is a well-known authority on southern folk art and has a special interest in face vessels. He has interviewed various members of the Brown family over the years and obtained the story of E. J.'s devil jugs during his extended field research.

62. John Krout, *Prohibition,* foreword.

63. Ellen Paul Denker, "Kirkpatrick Jug Acquired by Folk Art Center in Williamsburg," *Ohio Antique Review,* vol. 4 (March 1978), pp. 9–10. For more information on Wallace Kirkpatrick's background and his temperance activities in Anna see, Ellen Paul Denker, *Forever Getting Up Something New: The Kirkpatricks' Pottery at Anna, Illinois, 1859–1894* (Ann Arbor, Michigan: University Microfilms, 1978).

64. Personal observation. I have had access to *The Drunkard's Doom* for many years and have been able to study it completely. The "puzzle jug" detail of this vessel is engineered in a most sophisticated way. An internal "re-routing" of the jugs contents causes liquid to pass through the container's handle rather than through its spout when it is upended.

15

The Problem of Martin Ramirez:
Folk Art Criticism as Cosmologies of Coercion

This article is adapted from Michael Hall's 1985 panel statement at Philadelphia's Moore College of Art. The college's Goldie Paley Gallery sponsored a symposium attending the exhibition "The Heart of Creation: The Art of Martin Ramirez." That exhibition brought to the public for the first time a large body of the remarkable work of Mexican-born Martin Ramirez, a diagnosed schizophrenic and self-taught artist who lived most of his adult life in a northern California state institution. The Moore College address was later transcribed. It was published by *The Clarion* in 1986 and is reprinted here from that publication.

* * *

Twenty years ago, when I began collecting American folk art, study on the subject was still in its nascence. Material had been gathered and great collections had been formed; but criticism in the area was, at best, like the material itself—primitive. Criticism at that time could well be described as chauvinist and sentimental. I'm not attempting here to depreciate the work of some of the early researchers and enthusiasts, however, two camps historically dominated interpretations of the material called folk into the 1960s.

The first of these camps embraced folk art as a ratification for modernism. This position was based in the formalist theory of art appreciation and was constructed around a search for universals in art discernable in what was called "the language of form"—a sort of Esperanto of color, line, and shape. We've all heard the stories about how Picasso was influenced by weather vanes. We're aware that Elie Nadelman drew inspiration from his collection of American folk carvings and styled his late works in an abstract way that aped the abstraction he saw in folk art. Modernism, in fact, had already been ratified in Europe so the American scenario simply fleshed out an argument already propped up by an array of tribal African and Oceanic and pre-Columbian artifacts

which were thought to manifest the same raw "primitive power" and purity of formal expression that modernists were seeking in their work. That modernism is still floating on a raft of primitivism is no way better evidenced than by the success of the exhibition "Primitivism in 20th Century Art" presented by the Museum of Modern Art last year. The American folk art fittings on this raft were added rather late and, indeed, formed merely a postscript to an argument that was already an apriori assumption by 1930.

The other early advocacy for folk art was essentially political. Americans in the 1930s and 1940s were still trying to legitimize themselves in the world of art. Reflecting inward, Americans sought to elevate an indigenous art to an acceptable place in the collage of world art. Despite the fact that many of the first collectors, curators and dealers (Nadelman, Cahill, Halpert et al.) were thoroughly sophisticated and progressive in their understandings of art, they unwittingly set a plank of political reaction in the platform supporting folk art with their persistent reference to it as the art of the common man—wondrous and accessible because it was an unacademic art not aligned with established schools.

The critical cosmology enveloping folk art after the 1920s began to confer on folk material the moral and aesthetic unassailability that the American myth reserves for Arcadians and noble savages. Ironically, the original informed celebration of the nonacademic in folk art evolved into a subtle coercive argument favoring the anti-academic and the anti-intellectual. As this shift occurred, America's concern with folk art moved from the aesthetic arena into the arena of populist politics. Postwar enthusiasm for folk art became emotionally charged with nationalistic verve reflecting the heady mood of a nation emerging as a world power. Although planting Old Glory in the outstretched hand of some cigar store Indian seems fine to me, I generally find that aesthetic advocacies generated out of nationalism are myopic and far from rational; I still find that a conservative chauvinist sentiment runs strong in folk art circles today.

I reiterate this mini-history only to suggest that American folk art from the onset has been curiously abused and made to serve many masters. As the interest in non-academic art spreads, new claims for its importance are formed almost willy-nilly to serve an array of new social motives. It is rather well known that there was disagreement on the pertinence of the recent black folk art exhibition which circulated in the United States with such success three years ago. At the extreme, supporters of this show felt that the exhibition was a major step forward in an appreciation of a relatively unknown and misunderstood category of ethnic

expression. They interpreted the exhibition as a social/aesthetic step elevating black folk art to its rightful place in the history of artistic achievement in America. They also presumed to identify "qualities" in the work which would distinctly characterize it as being the product of something loosely called "the black experience."

The opposition maintained that the exhibition was essentially racist in character and was an exercise in social control, shackling black folk art with yet another link in a chain of stereotypes historically leveled at blacks themselves. These critics pointed out that the catalogue essayists and the press fueled a popular concept which enormously oversimplified the problem of identifying and describing the diagnostic characteristics of black art. They argued that there was no precedent in any school of criticism for the contention that a work of art could be said to have issued from a black hand because it generated from intense religious fervor, incorporated a simple (or childlike) narrative content or stylistically manifested some vague expressive power uniquely inherent in the manner in which black artists manipulate colors and materials in their work. As social scientists and historians, they were academically contemptuous of an exhibition that characterized as black anything that exhibited a natural sense of gaudy and hallelujah.

I am persuaded through my participation with the black folk art show that the opposition had a point. I quote from a letter on the subject that I wrote in 1983, after having been challenged on my views of the exhibition.

> I am asking for a comprehensive explanation of what it might be that would make a work of folk art "black." I remain skeptical that some artistic property which could be called "blackness" can be located in a painting or carving . . . by a process that is largely intuited or simply "felt."

I believe that social rather than scholarly concerns continue to shape the dialogue surrounding folk art and the one emerging around that which has become known as "outsider art." No one is arguing anymore whether Martin Ramirez was an artist or not; no one is arguing whether so-called isolate art is interesting but the advocacy for Ramirez and his work seems to me still very much couched in the needs of a constituency attracted more to fantasy than to fact. Outsider art buffs, like folk art buffs, seem to build cosmologies of coercion to support their claims and to protect their own interests and egos. Ramirez, the outsider, is just a victim. Something innocently pernicious has, in my opinion, blocked serious scrutiny of the Ramirez legacy.

In the introduction to the exhibition catalogue *Outsiders: An Art without Precedent or Tradition,* Roger Cardinal propounds a tidy little

metaphor in which civilization is seen in the model of a city with a dense center, a sprawling suburban periphery ringed by a barren wasteland. Proper art in Cardinal's analogy radiates from the center, presumably diminishing in its luminosity as it ripples and spreads—flickering only sporadically in the desolate outback. In a sociological sense, this model is perhaps not inaccurate. It certainly could be argued that folk art exists at the periphery of high culture. Demonstrably, the acceptance of this model accounts for the enormous neglect of folk art over the years by serious art scholars and connoisseurs. For them, that which goes on in the competitive dense center is of interest and of quality and that which survives in the wasteland is to be distrusted and avoided at all costs.

The outsider advocacy, however, inverts the interpretation of this model, following Cardinal to the conclusion that those flames in the darkness, ignited by the "private Promethean vision" of the so-called "outsider" are indeed closer to being an authentic art than that which is diluted and confused in the center. The outsider argument offers that flames ignited by a friction bow are somehow hotter than flames ignited by a gas pilot light. This argument assumes that art is generated solely within the artist—that art touches to that which is most basic in human nature and, therefore, that those who would be the most in touch with themselves and have the most to say to humanity would be those most cut off from the contamination of history, competition, professionalism, and urban sophistication. This prejudice fixates on the work of prisoners, children, the insane, mystics and rustics. I believe that philosophically this position harbors a solipsism that insults both the isolate and the sophisticate.

Modern critical jargon currently interposes the term "gutsy" in discussions where the words passionate or humane might previously have been effectively utilized. The celebration of the viscera implicit in this term signals a cultural value fixated on the raw, the untamed and the explosive. The psychotic artist, thus, presumably pouring unrestrained visceral impulses into a drawing or a carving, becomes a cultural hero and the advocates of outsider art coerce the art world with a one-dimensional cant in which only an artist who is nuts can produce work with guts.

I have some problems with this interpretation of Ramirez. I believe that it is in its cultural connectedness that art is compelling. I am distressed to say that I don't find in Ramirez scholarship to date enough structured research on which to base a real interpretation of his drawing and collages. Undeniably, Ramirez's work is visually arresting and can be discussed formally as Roberta Smith does in the exhibition catalogue *The Heart of Creation: The Art of Martin Ramirez.* Ramirez's draftsmanship

is facile and inventive. The space in his pictures is often complex and contradictory. His use of line is intelligent and emphatic. However, as we look at the images and as we search for a content in the work, we are forced to confront questions that formalist dogma won't adequately answer.

What is this work really about? What does it mean? What did it mean to the artist and what can it potentially mean to its audience? Challenging the formalist interpretation, I would offer that art cannot be understood absolutely from its form. Color, line, shape, space, texture can convey meaning but they are not in and of themselves meaning. If it were indeed only a game of inventing and chasing shapes, art making and art interpretation would really rank among the most listless of human activities.

I believe that an iconographic and semiotic study of the imagery in the drawings would be highly productive. Given what we know of the artist, might we not reasonably find a heavy Catholic content in his work? Might we not also find other aspects of a Hispanic tradition residing there? Might not vestiges of the Mexican Indian art heritage outcrop also? And most significantly, might we not absolutely expect to discover threads of autobiography throughout the drawings? I think yes. We cannot adopt the man but reject or ignore his roots—smugly designating his utterances as garble because they are not in our tongue.

I am pleased to find writers now discovering in Ramirez that which derives from the Spanish Baroque. The frontality in the work and the stage format that we see over and over harkens to the stepped and symmetrical altars of most Mexican churches and those in most of the California missions. This recognition puts a history into the art and makes the artist a citizen in our world. Looking at other of the Ramirez pictures, we find Madonna figures, snakes, globes, and an array of animals—all of which can be linked to various traditional iconographies and to images in popular culture available to the artist. We don't have to speculate in the areas of the unconscious or the subconscious to discover that the train motif which occurs so often in Ramirez's work could easily have grown from his own personal experience working on the railroad. Also from life, the so-called cowboys with their bandoliers recall Emiliano Zapata, Pancho Villa and the Revolution. We might well assume that there is a political as well as a religious cultural statement in this work. Ramirez would have been 24 years old and living in Mexico at the time of the Revolution. If he had been living in the North, Zapata and Villa would most assuredly have been his heroes. He could have even served. In any case, the soldiers popularizing his drawings are as understandable as the ones that inhabit Diego Rivera's murals—given the Mexican heritage of both artists (see figs. 59, 60, 61).

Figure 59. Martín Ramírez, *Soldado*, ca. March 1954
Pencil and crayon on brown paper, 29¼ × 35½".
Private collection.

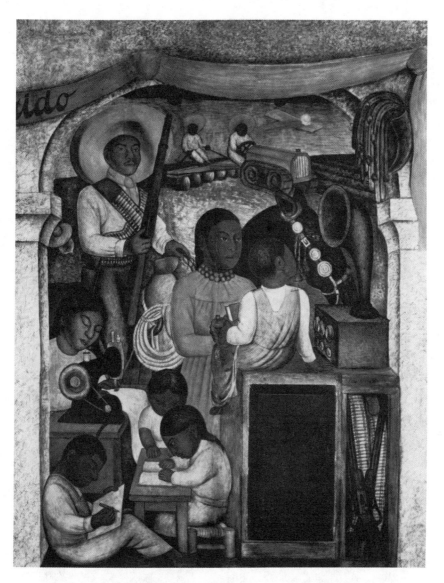

Figure 60. Diego Rivera, Soldier on Horseback (Detail from
Fresco Section Titled *Corrido of the Agrarian
Revolution*), 1928
Secretaría de Educación Pública, Mexico City.
*(Photo: Bob Schalkwijk; photo courtesy the Detroit
Institute of Arts)*

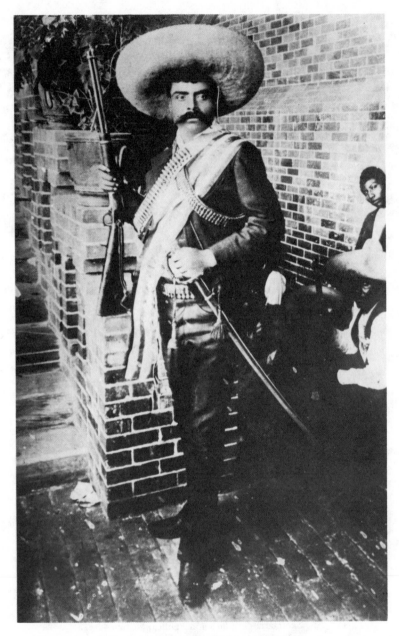

Figure 61. Emiliano Zapata (Mexican Revolutionary), ca. 1912–15
(Photo courtesy Library of Congress, Washington, D.C.)

Going even further, I believe it would be worthwhile to identify more of the motifs in Ramirez's work and to have a numerical breakdown on the frequency of occurrence of certain motifs as they can be found in the corpus. I would like to know how many train pictures there are. I would like to know how many cowboy pictures there are. I would like to know how many Madonnas there are and I would like to see this statistical data correlated and interpreted.

So too, I think, we might probe further into the stylistic evolution of Ramirez's art. Too frequently it is believed that folk art and isolate art leap full-blown from the head of Zeus and that there is no such thing as a development in the output of the nonacademic artist. My experience leads me to believe this is entirely erroneous. I watched Inez Nathaniel Walker's drawings grow and change over four or five years. I saw themes become interesting to her and then lose their appeal and fade from the work to be replaced by other concerns. More can be deduced from the sketchy chronology that we have on Ramirez's drawings. More also remains to be discovered about the conditions that existed and changed around the artist in the several periods of his work. Only after the broadest inquiry has challenged the prevailing cosmologies of coercion and convenience can we legitimately establish a parity between Ramirez and the other fine artists—Van Gogh, for example—with whom his name is so frequently linked.

My own speculation on the criticism of non-academic art and on the persistence of interest in folk and isolate art in our time has to do with the broader issue of twentieth-century man and his grapplings with modernism in the largest sense. If indeed technology and urbanization have alienated modern man, it is predictable that he would have discovered in things primitive, nonurban or nontechnological something to be recovered and set against the anxieties presumably precipitated by change.

In the first two decades of the century, we saw artists collecting and emulating the look and feel of various objects of tribal art. They responded to the sense of pattern and symmetry found in primitive masks and they sought to appropriate some of the ritual power they felt in fetish objects and talismans of various sorts. The same period saw artists becoming fascinated with the work of children—once again a nod to the primal or the unspoiled in human nature. We also saw artists experimenting with hallucinogens, games of chance, the tarot, dream interpretation and automatism. They found in the person and in the paintings of Henri Rousseau a paradigm. His jungle scenes, Eve figures, dreaming Nubians and simple peasants all spoke to the early moderns and tugged on the essentially anti-modernist heartstrings of their own dispositions. For the artists and their associates, folk art and the art of the insane also gratified

yearnings for a belief system that would maintain the myth of the artist as a feeling person outside of society fighting a very individualistic battle against the ravages of conformity and anonymity. It is not necessarily clear who sold all of this initially but it is very clear that it was bought effectively throughout the first half of the twentieth century and remains a viable commodity into our own time.

Americans especially are disposed to embracing the primitive myth of modernism. It may have something to do with our own competitive sense of cultural insufficiency as well as something to do with our own frontier identity. We need to believe that the Lone Ranger exists. We need to believe that he possesses dignity, cunning, natural instincts and an indomitable will to prevail. We need him to be an outsider. We need him to be a man behind a mask.

But do we need Martin Ramirez to be the Lone Ranger of art—masked behind his psychosis? Nobody, it seems, really wants to know who he was. They simply seem determined to cast him as the Natty Bumpo of finger painting. His supporters want him to ride into town, guns blazing like those of his own *soldados,* laying waste to the archfiends of Minimalism and Post-minimalism. Seen as a hired gun, he is also useful as a rallying figure for the hordes of neo-Expressionists exploiting the new cult of the obsessive/compulsive.

This all may sound a little harsh but I think it's time at least to posit some argument which chips away at the condescension characterizing the discussion of non-academic art. I am, at this point in my life as an artist and as a collector, honestly persuaded that art's real value is social. The aesthetic experience—whatever it may be—is tied to understanding and perception. Art allows us to see ourselves in a cultural context. The more we know, the more we can see. The more clarified the mirror, the better the reflection. What I'm really asking for is the stripping of the peculiar handicap that seems inadvertently to hamper the full appreciation of the work of the isolates and folk artists. Five-stroke handicaps for illiterate Appalachian wood-carvers and ten-stroke handicaps for psychotics don't seem to flatter the real creative spirit of the artists among us.

I would conclude today by suggesting that the isolation in Ramirez is not necessarily the isolation of the artist but the isolation of the constituency that first framed the context within which his work has been evaluated. I'm scattershooting here at collectors, museum folk and a whole array of afficionados who for one reason or another are coddling this work to death. As a partisan, I'm hoping that events like the Ramirez exhibition which purport to reveal the work and to celebrate its maker don't end up as extended sentences for inmates who never needed to be interned in the first place. As an artist, I'm asking the court of critical revision to parole my brother, Martin, now.

The Bridesmaid Bride Stripped Bare

This essay was written for a 1986 exhibition catalogue, *The Ties That Bind: Folk Art in Contemporary American Culture*. The exhibition was sponsored by the Contemporary Arts Center, Cincinnati, Ohio and was co-curated by Michael Hall and Eugene Metcalf, Professor of Interdisciplinary Studies at Miami University, Oxford, Ohio. The exhibition and the catalogue essays accompanying it attempted to reunite folk art with the social and ideational contexts from which it is all too often estranged. Reinterpreting folk art through modern art, Hall's essay brings the inquiries presented in this book full circle in one artist/critic's discussion of American artists and their art.

*　　*　　*

Increasingly over the last few years, when I think about folk art, I find myself asking why it is that folk-made objects, once in the world of collectors and museums, seem so easily stripped of meaning and severed from the life/world context from which they spring. In some ways, it is our habit of tidiness which compels us to clean things up a bit. It could also be argued that the removal of the clutter around something makes it easier to see. Nevertheless, over the years, we have tidied up folk art more than a little. I have seen painted decoys scraped down to bare wood the better to reveal their form; I have seen old portrait paintings irrecoverably skinned in the name of restoration and I've seen carved wooden dolls denuded by people convinced that tattered clothes detract from "pure" sculpture. In the midst of these musings, I further saw that those of us who involve ourselves with art criticism can strip away the ideas and meanings that clothe an object just as easily as we could remove a coat of stubborn paint adhering to its surface. As these reflections crystalized, I determined that the text I would write here would have something to do with the stripped, the naked and the bare—*and* with a certain redress that this essay and exhibition might offer to folk art.

　　I also have a second concern and it centers around the question of why it is that, in the world of art, folk art has always been a bridesmaid

and never a bride. Most of America's folk art is archived in historical societies and in museums of decorative art. Rarely is it displayed in the context of fine art. Perhaps the notion of innocence traditionally associated with folk art blocks its acceptance as serious. Perhaps its charm, intellectual accessibility and geniality signal some softness appropriate to bridesmaids but certainly not to brides. Yet, over the past twenty years, I have seen folk art come of age. When great folk works are placed side by side with works of high art, they do not come off as second class.[1] More importantly, certain contemporary folk artists have reshaped the thinking and the work of artists at the cutting edge of the contemporary avant-garde.

In the end, my ruminations on stripping and brides prompted me to look again at Marcel Duchamp's great allegory on this subject, *The Bride Stripped Bare by Her Bachelors, Even*—a work more frequently referred to as *The Large Glass* (see fig. 62). *The Large Glass* is a multileveled work which bridges between the abstract and the explicit as well as between the intellectual and the mystical. Ever since Duchamp stopped work on the piece in 1923, critics have debated its meaning. Some have professed to find the work deeply Freudian and ironic; others have seen it as a religious allegory and still others have found it to be quizzical, quixotic, and comic. All, however, agree that *The Large Glass* is a culturally significant art document that synthesizes the literary and the visual in a uniquely modern way. Given the oracular character of Duchamp's work and my need for signs, *The Large Glass* provides a fresh modernist inspiration for my understanding of folk art.

The *Glass* is difficult even to describe. Physically it is a painting *and* a collage executed on two panels of glass set one atop the other. The complete work stands just over nine feet in height and is about five and one half feet wide. The images on the panels are formed in oil, varnish, foil, wire and dust. Shattered in transport during 1926, the work was reassembled in 1936 by its maker. He suspended the broken fragments of the original composition between new plates of glass and then stabilized the entire structure within a frame. Refurbished and mounted on a base *The Large Glass* now is free-standing and can be viewed from both sides.

The upper panel is dominated by a shape Duchamp designated as the Bride. Here, in the Bride's realm, three events are abstractly described; the stripping and blossoming of the Bride, the transmission of her desires to the Bachelors and finally, the meeting of the Bride's and the Bachelors' longings. The lower half of the *Glass,* the domain of the Bachelors, also illustrates three events. First the birth of the Bachelors' desires, then the long, perilous and frequently interrupted journey of these desires on their way to the meeting with the Bride, and finally the offering of the Bachelor longings to the contemplation of the Bride.[2]

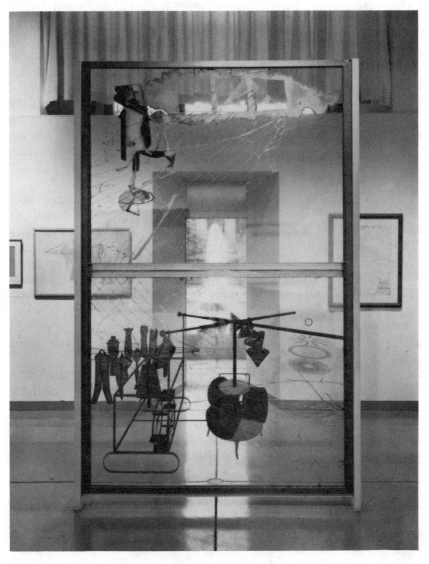

Figure 62. Marcel Duchamp, *The Bride Stripped Bare by Her Bachelors, Even [The Large Glass]*, ca. 1915–23 Glass, oil, varnish, wire, dust, 109¼ × 69⅛″. Collection Philadelphia Museum of Art, Pennsylvania. Katherine S. Dreier Bequest. *(Photo courtesy Philadelphia Museum of Art)*

Duchamp's enigmatic masterpiece appropriates nicely as a metaphoric model in a discussion of art and culture—and particularly for a study of the two recurring questions: "What is folk art?" and, "How is folk art to be understood in the world of art?" For my illustration, the Bride in the *Glass* represents art—a life center in the cultural arena roughly analogous to the life center Duchamp saw women commanding in the sexual arena. The Bachelors become the collectors, curators, historians and critics forever seeking after art's favors. In the most widely accepted traditional interpretations of the *Glass,* the Bride figure commands the activity in the composition much as art objects command activity in the art world. Duchamp himself described the Bride as a "motor" floating above the Bachelors—a group of spindlelike shapes he dubbed "malic molds"—who, charged with a mystical, energizing, illuminating gas, attempt to pursue (strip) the Bride.

The stripping bare of art in many respects is a necessary (and possibly desirable) process. It is a Western proclivity to seek "pure" definitions through a process of reduction and separation—a process that isolates one thing from another and then presumes to describe and analyze each in contexts which are exclusive rather than inclusive. The decontextualization of objects as artifacts and their recontextualization as art works is basic to what we call aesthetic inquiry. It could be argued that in the early modern period, tribal masks literally had to be stripped off of native shamans and hung on bare museum walls before they could be viewed at all as art.[3] And yet, something surely is lost in this process, something that might warrant retrieval.

The Large Glass reflects the conflict inherent in this condition. The Bachelor half of the construction is measured and geometric. The malic molds resemble chess pieces. Each has a separate and specific shape and identity. Each is tied to a mechanical structure which must receive its sparking ignition from the illusive Bride. Once ignited, however, each Bachelor takes in the nebulous illuminating gas (presumably a free floating substance) and transforms it into a cast of his own form. The metaphor is perfect: art permits; its audience wills.

Inquiring further into the nature of the permissions of art, the Bride portion of the *Glass* provides another useful analogy. It is imprecise and dreamlike. In an attempt to represent his Bride as soft and ephemeral, Duchamp devised a method for producing her shape by a means partially determined by coincidence and chance. Were art (like the Bride) not elusive, capricious, and generative, it is unlikely that it would have so thoroughly fascinated audiences throughout the ages. Indeed, an art which could not in some way be shaped to the needs and expectations of its audience would be no art at all, given the condition of utility which implicitly makes all art a social phenomenon—a part of a social contract.[4]

To identify and inspect the bachelors pursuing the bridesmaid bride, folk art, I must quickly summarize a rather well-documented history. Folk art has eluded capture through three phases of intense pursuit. In the first phase, the discovery period of the 1920s and 1930s, collectors focused their attention on folk-made objects exhibiting strong patternization, clarity of design and simplicity of form—all the qualities which were first admired in the modern art of the period. In what might be called this first "formalist" phase of folk art appreciation, collectors stripped a host of weather vanes, quilts and primitive paintings from early New England homes and recontextualized them either as homegrown critiques of European modern art or as patriotic signs embodying the virtues of American craftsmanship and design.

New suitors with a new lexicon emerged in the 1950s and 1960s to join in the pursuit of folk art. The second phase of folk art collecting focused on the expressive interpretation of folk-made objects. Collectors and curators weaned on the turbulent painting style of the New York school courted folk art for what they perceived to be its directness and raw expressivity. Crude carvings and constructions from the hands of untrained makers, along with drawings and paintings produced by inmates in prisons and asylums, were heralded as the real luminescence of folk art. Suddenly enshrined on pedestals and on gallery walls alongside the vanes and quilts that had preceded them, these objects found themselves cast into molds that shaped them to the ideological arguments and aesthetic strategies of the Expressionist period.

Sometime in the 1970s the third phase of the search for folk art began. In this, the current phase, new collectors and, for the first time, scholars from several disciplines are inquiring into the ideational nature of the subject. It is worthwhile to scrutinize the imperatives that brought this about. The Pop artists, Minimalists and Conceptualists of the late 1960s bequeathed Americans an art concern focused less on the form and expressiveness of art than on the information of art—the ideas and political convictions as well as the narratives and metaphors which constitute content and meaning in a given work.[5] It is in this mold that the present exhibition has been cast. Folk art—the bridesmaid bride—has now sparked the fancy of suitors as curious about her mind as previous suitors were curious about her form and feelings.

For me, by far the most interesting folk art today is that generated by makers responding creatively to life in the twentieth century. Examining such work, I continually find ties which bind it to my own experience and which obviously tie America's contemporary folk artists to the pluralist world all Americans share politically, economically and ideologically today. This exhibition attempts to come to grips with folk art

in this way. The works in the exhibition fall into eight rather distinct categories. Each category identifies the primary impulse that can be said to have generated a given piece. Grouping the art in this way, we have a simplified conceptual framework for seeing folk art not in the context of form and style, but in the context of the thought and creative motivation of its maker. We view it as someone's very particular response to the problems and promises of the modern world.

One group of artists seems to have dealt with that world by flatly rejecting it and replacing it with a world of their own making. In the California desert, Calvin and Ruby Black constructed the *Fantasy Doll Theater,* a kinetic environment of figures wired to tape recorders that let them sing. Some of the figures were also linked to wind-driven cams that made them dance. In Detroit, Rosetta Burke spent over ten years transforming her ghetto home into a religious shrine. She encased the entire house in a layered skin of tires, oil drums and trash which she gathered from the city streets in less than six blocks from the General Motors Building. As she worked on the environment, embellishing it with paint, bottles and hubcaps, she would sing and preach to passersby, becoming a part of the piece herself.

A second group questions political authority. Important here is an unknown painter from Brooklyn identified only by a note on the back of one of her paintings which reads: "Anna Celletti—lady barber." Celletti's paintings accost viewers with their strident politicizing. One depicts the evils of communism, another the complacency of Western leaders. In Kentucky, Edgar Tolson responded to the Watergate hearings he watched on television by carving and constructing an allegory on the abuse of power. The sculpture depicts a biblical king watching Christians being mauled by lions in an arena. The king is attended by two Prussian guardsmen—a subtle reference to Nixon's aides, John Ehrlichman and H. R. Haldeman.

Yet another group turns its attention to enshrining heroic figures. A half-dozen folk portraits of John F. Kennedy were gathered for the exhibition. In concert, they suggest that Kennedy, like Andrew Jackson, has become a symbol for an age. Black and white folk artists from both the North and the South have solidly set Kennedy into their pantheon of American heroes.

A fourth group responds to the world through their work. They perpetuate art images in traditions peculiar to certain occupations or trades. Sheet metal workers have piled their craft in the forming of advertising figures for almost a hundred years. As early as 1900, we find a metal dandy (similar to the wooden trade figures of the period) in the front window of a welding shop. By the 1940s, metal shop figures were common and had evolved into whimsical tin men of the *Wizard of Oz* sort.

Today, businesses engaged principally in the fabrication of heating and cooling systems often display logo robots and spacemen fashioned from sections of metal ventilation duct. The artist/metal workers in this group find the visual tradition they have inherited continually revitalized as new shapes with sculptural potential are manufactured to meet new demands from consumers in need of the practical skills of welders and fabricators.

A fifth category includes artists who appropriate popular images from media sources and incorporate them into their works. In Texas, a mental hospital inmate named Eddie Arning cut pictures from old magazines and then reproduced the images he had gathered in large patterned crayon drawings of his own design. Arning had a special ability to screen and abstract the visual information in a mundane world and then to transform it into something extraordinary for the world of art. His contemporaries, William Hawkins and Miles Carpenter, had similar gifts and produced their own original art using images lifted from popular media.

The pair of *Insulator Dolls* on loan to the exhibition from the Hemphill Collection bear anonymous witness to the fact that other contemporary folk artists address themselves to the creative recycling of industrial discard. Threading various porcelain electric power line insulators on to connecting wires, the unknown doll maker produced a male and a female figure strongly reminiscent of the jointed wooden dancing dolls made in the last century. The eye which discovered two figures latent in a scattering of sundry porcelain shapes was an artistic eye seeing potential in that which most eyes would simply overlook. Howard Finster's tower constructed from batteries and transistors, along with Roy Kothenbeutal's motorized *Do Nothing Machines,* appropriately join the insulator dolls as contemporary assemblages.

The last two groups represented in the exhibition suggest that still other contemporary folk artists address their work to issues of cultural identity. One group preserves its ethnicity through its art, the other confirms its religious faith. Felipe Archuleta is a Mexican-American living near Santa Fe, New Mexico. He sculpts animal images—his earliest works being likenesses of the sheep, pigs, coyotes and lynxes which are all native to the American Southwest where Felipe lives. After mortising large cottonwood logs together into a rough animal shape, Archuleta then carves and refines his form with a chain saw and a chisel. To complete the details he uses a glue and sawdust paste which he models with his fingers. Finally, after insetting plastic claws and straw whiskers into his wet putty, he paints the entire animal in a lifelike manner. Archuleta's method of constructing, carving, modeling and polychroming has a history that traces back to the techniques used by early Spanish artists to fashion statuary for the Baroque cathedrals of Barcelona and Madrid. Further on in the

exhibition, we find a cloth doll with mismatched socks. This piece also connects to a culture across the Atlantic—but this time to Africa where Kongo tribesmen believe that mismatched footwear confuses and thwarts the malevolent spirits that from time to time attempt to disrupt a person's life.[6]

The intensity of the religious folk art in the final category is not surprising. On the matter of their beliefs, people tend to get intense. Chester Cornett's large carved crucifixion once served as a figurehead affixed to the cabin of a crude wooden barge. Cornett was convinced that the Second Coming was at hand and built his barge to carry him safely out of the Kentucky mountains when the flood waters of Judgment Day rose around him. The artist left us clear testimony to his conviction. In bold painted letters around the gunwales of his boat he scrawled: "OURLORDTHIESAVIOURCOMINAGIN." Competing in intensity with the crucifixion are Joe Salvatore's paintings. His work depicts miraculous events from the lives of the Old Testament prophets. Born a Catholic, Joe joined the Italian Pentecostal Church of Youngstown, Ohio in 1958. He was ordained in 1971 and has painted fifty-two paintings illustrating the book of Jeremiah and over sixty chronicling the book of Isaiah. Salvatore also serves on the Board of Directors for the Alpha and Omega Motorcycle Club. His ideographic art is compelling, moody and obviously ambitious but it still awaits serious study and criticism.[7]

This exhibition entreats folk art to reveal its ideational side. Complying, however, the bridesmaid bride risks standing very naked not only before her admirers but also before her critics. Many of the works included in *Ties That Bind* are on public view for the first time. They are now accountable. They come from the contemporary world and they should answer to it. However, if we ask art to be a part of a cultural discourse, we should be prepared to listen when it answers us with a response complexed by the multiplicity of ideas and beliefs which make up culture.

Outside of the art world, this has actually been going on for years. Folklorists and anthropologists have persistently endeavored to utilize folk art as a cultural measuring stick—a tool to aid them in describing and understanding the habits and customs of various peoples. Researchers from these disciplines have always had a somewhat circumspect view of the collector habit of aestheticizing objects. They view the process which embraces certain cultural productions as art (and its correlative rejection of others) as an artificial and unsupportable activity—one without a grounding in, or pertinence to, scientific inquiry. The collector world, reciprocally, has disdained the folkloristic approach to art. Watching scientists measure and count objects, they believe they are

witnessing activity blind to creativity and deaf to the intonings of the muse.

One despairs that the longstanding rivalries between the factions in the folk art world will ever reconcile. The audience involved with folk art as antiques generally distrusts the scholars concerned with folk art as sociological data. The academicians, as we have seen, resist the claims of the camp wrapping folk art in aesthetic rhetoric. The naivete in all such doctrinaire posturing may be greater than the naivete in the art itself. Certainly it blinds us to one important fact: serious critical thinking in art and in the social sciences continually rediscovers the dialectical nature of human activity.

If we accept the idea that art (among other things) is a reciprocating condition in which cultural perceptions will shape the images of art, then art's images, in return, will affect a culture's perceptions and give structure to its beliefs. The nature of art in culture—including that of folk art—is dialectical. The contradictions and resolutions of dialectic would establish both art-making and the understanding of art as activities which both push and pull on a culture's sense of its identity. As the Bride in *The Large Glass* both tempts and eludes her Bachelors, so too does art tempt and elude its devotees. Scholars, critics and collectors—all seeking an understanding of folk art—both compete and cooperate in their quest. This exhibition, to be appreciated, cries out for a redirecting of the historical assumptions about folk art and for a fusion of these assumptions into a synthesized understanding of contemporary folk art.

The complexity of this expectation can be better understood if we take a closer look at one of the works in the exhibition that I am somewhat familiar with, the Rosetta Burke environment from Detroit (see fig. 63). In the exhibition, this work has been grouped with others which seem to reflect the maker's desire to reformulate the world. This may well be the conceptual (utopian) vision that brought the environment into being. However, to fully appreciate the Burke environment we should not overlook the sense of materials, the obsessive work involvement and the spirit of evangelism which all went into its physical formulation. Likewise, we should not overlook the possibility that some of the cryptic signs painted on the tires and metal drums in the construction might actually derive from some script transmitted to Mrs. Burke as a part of her black heritage. The information in the piece simply cannot be pressed into one simple mold nor can the beauty in the piece be apprehended from a single art bias.

Obviously, the power of the Burke environment compounds from several elements, some formal—others expressive, conceptual, and cultural. Standing on the street in front of the work two years ago, listen-

Figure 63. Rosetta Burke, *Environment*, 1970–85 Mixed media, continually modified, 1½ city blocks (photo ca. 1985). Detroit, Michigan.

ing to the artist as she sang and preached to a group of students, I was struck by the sensory and intellectual barrage assaulting me. I perceived something more than an environmental or site-specific work of sculpture.[8] It was an autobiography but it was also a theater and a classroom. It was grand and it was intimate, it was both raw and sensitive and it instructed at the same time that it provoked and offended.

A complete inspection of the Burke environment would of necessity be an interdisciplinary endeavor. Only someone knowledgeable in the history of both black and white religion in America could explain the spiritual aspects of the piece—especially when it is viewed as a backdrop for the sermonizing of its preacher/maker. It would take an expert on urban planning and contemporary sociology to discuss the piece in relation to its neighborhood and community. A gerontologist would have to address the work as it might pertain to the problems of aging in contemporary life. A linguist and a phonetician would be needed to dissect the repetitive word patterns and the singsong cadences that characterize Mrs. Burke's speech when she preaches. Art historians would be helpful in an examination of the sources that may have influenced the design and structure of the piece and an art critic might aid us in understanding the work's relationship to other contemporary art productions identifiable within the site-sculpture genre. Finally, someone conversant with the interpretation of signs and symbols might decode the hieroglyphic marks that embellish and punctuate so much of the surface of the sculpture (see fig. 64).

The City of Detroit entertained a ten-year engagement of Mrs. Burke and her work. The artists of the city championed it as beautiful, her neighbors described it as an eyesore. Newspapers periodically printed human-interest stories on the piece and the local art establishment regarded it fondly as a Motor City version of the *Watts Towers* [see fig. 48]. Charging Mrs. Burke with littering, the obstructing of city property, and with rat husbandry, the municipal court even became a part of the dialectic on the environment. Finally, last year, the city razed the piece and trucked it to the dump.

It blooms again in this exhibition. The photographic documentations of the work and the taped record of the artist talking, singing and preaching sustain the environment in the current dialogue on folk art. Ostensibly stripped and ravaged, Mrs. Burke's New Jerusalem remains stubbornly unassailed. Its ability to survive its own destruction may well be its vindication as art. As yet another bridesmaid bride, the Burke piece seems to confirm Duchamp's notion that the true Bride blooms forever and remains forever in control; always (like the lost Detroit environment)

Figure 64. Rosetta Burke, *Environment* (*Voices* Detail), ca. 1985
Mixed media with plants, tires, bricks and paint.
Detroit, Michigan.
(Photo: Michael Hall)

able to accept or reject the attentions of all who confront her—even in memory.

Returning to *The Large Glass,* I find that Duchamp expected that the solicitations of his Bachelors would be reconciled as they entered the realm of the Bride. He filtered their separate desires through a series of sieves which progressively become dense, dark and clogged with the residues accumulated in the filtration process. For us, this suggests that expectations shaped in even the most perfect of molds cannot address art independently. In the end, formalist dogma, scientific rationality, and conceptual argumentation must all be filtered and emulsified to gain proximity to art. Only then can our "bachelor emissions" become analogous to the potent "splash" necessary to trigger what Duchamp described as the "blossoming of the Bride."

Posing one of the great conundrums of modernism, Duchamp intentionally omitted the last piece of machinery which would have completed the reciprocation in his scheme. He left the Bachelor/Bride circuit open— technically rendering his Bachelors incapable of directly effecting the "electrical undressing" that was to bring on the climactic moment of the Bride's blossoming. But yet she blooms. In and of herself, the Bride generates her own ecstasy but does not fall. The Bachelors do not connect directly to her—only to her clothing. The blossoming of the Bride becomes magical rather than mechanical. "Duchamp appears to have been obsessed with the idea of the work of art as a symbol or substitute for the object of love or desire which cannot be touched, for to do so would break the spell."[9]

So too with the appreciation of art. Lest my text suggest that all that confronts us in this exhibition can be grasped through some perfected process of analysis, I must assert now that I expect the quest for art to entail a measure of belief. Once again a metaphor from *The Large Glass* serves as an analogy. By not completing the system of linkages between his Bride and the Bachelors, Duchamp has asserted that a mechanical stripping should not ravage that which is poetic in nature. The metaphor applies as well to the subject of art. Without our attentions and desires, art will not exist at all. Our filtered demands and needs do (in their own way) coax the bride, art, to flower.[10] Hence the search for art is not a license; rather it is a search for the fulfillments of service.

A new perspective on folk art has brought us to this exhibition. Availing ourselves of the resources now available to help us examine the works on display, we can begin to appreciate the complexity and richness of folk art as an idiom. The exhibition particularly informs us about the creative vigor of the untrained artists among us today. With the redress

inaugurated here, a history moves another small step and with a permission that is simultaneously a desire, the bridesmaid at last blooms as a bride.

Notes

1. Two important recent exhibitions placed American folk art in a contextual and visual relationship to other, more academic, American art forms. Catalogues of these exhibitions were published: The Sheldon Art Gallery, *American Sculpture* (Lincoln, Nebraska: The Nebraska Art Association, 1970) and The Whitney Museum of American Art, *200 Years of American Sculpture* (New York: David R. Godine, 1976).

2. The description here was condensed from an important analysis of *The Large Glass* written by Arturo Schwarz, a noted Duchamp authority. See Arturo Schwarz, "The Alchemist Stripped Bare in the Bachelor, Even," in Ann d'Harnoncourt and Kynaston McShine, eds., *Marcel Duchamp* (New York: The Museum of Modern Art, 1973), pp. 81–98.

3. The process that recontextualized tribal artifacts as art consistent with the expectations of the early modernists is fully documented and defended in a two-volume catalogue which accompanied a 1984 exhibition of primitive and modern art presented by the Museum of Modern Art. See William Rubin, ed., *"Primitivism" in 20th Century Art: Affinity of the Tribal and the Modern* (New York: The Museum of Modern Art, 1984).

4. For various readings, see John Michael Vlach and Simon J. Bronner, eds., *Folk Art and Art Worlds* (Ann Arbor, Michigan: UMI Research Press, 1986).

5. For a discussion of new forms of contemporary sculpture addressing these issues, see Howard N. Fox, *Metaphor: New Projects by Contemporary Sculptors* (Washington, D.C.: Smithsonian Institution Press, 1982).

6. Robert Farris Thompson, *Flash of the Spirit* (New York: Vintage Books, 1984), p. 222. The observation on mismatched socks was made firsthand by Dr. Thompson when he inspected the doll in the spring of 1986. His information comes from an informant named Ellen Walters, Curator of Exhibits at the Cleveland Museum of Natural History. It is also of interest to note that the doll in question bears a remarkable similarity (visually and structurally) to the stuffed *niombo* and *muzidi* funeral mannequins of the Kongo. See Robert Farris Thompson, *The Four Moments of the Sun* (Washington, D.C.: The National Gallery of Art, 1982), pp. 55–68.

7. "The Prophetic Art of Joe Salvatore," editorial, *MANNA*, no. 6 (Sept.–Nov. 1983).

8. For more information on environmental folk art, see Walter Art Center, *Naives and Visionaries* (New York: E. P. Dutton and Co., 1974). See also Seymour Rosen, *In Celebration of Ourselves* (San Francisco, California: Living Books, 1979).

9. John Golding, *Duchamp: The Bride Stripped Bare by Her Bachelors, Even* (New York: The Viking Press, 1972), p. 99.

10. Calvin Tomkins, *The Bride and the Bachelors* (New York: The Viking Press, 1965), pp. 6–7.

Afterword

It is not surprising that Michael Hall, a fine artist, is also an interpreter and collector of American folk art. For, as Hall points out in the first essay of this book, fine art and the folk art collected by most Americans have more in common than we generally realize. Despite the popular stereotype that fine art and folk art are dissimilar artistic forms, folk art has played a major role in the development of the twentieth-century American fine art tradition and has been, itself, remarkably influenced by fine art perceptions.

Folk art was first discovered in the early decades of the twentieth century by American modern artists. In old objects like weather vanes, crude paintings and decoys they saw the same aesthetic qualities they were trying to produce in their own work. As collectors, American artists defined and evaluated these objects, which they called folk art, in terms of the vocabulary of modernism, a vocabulary which is still used by collectors today.

Yet, as the example of Michael Hall demonstrates, the early modernists are not the only fine artists who have been involved with folk art. Notably, in the 1960s and 1970s fine artists discovered folk art again. But this time the objects they discovered and called folk art were different. For not only had the concerns and forms of fine art changed since the early decades of the century, but so had the meaning of American folk art. As Hall explains in his article "Through a Collector's Eye: A Changing View of American Folk Sculpture," by the early sixties, folk art, as it had come to be popularly understood, was no longer of interest to contemporary fine artists. It had been appropriated by collectors who, unlike the modern artists who first discovered it, did not care about folk art's contemporary significance and viewed it instead as a purely historical art form. Interest in folk art had become a branch of antique collecting. Increasingly cut off from the fine art mainstream, the folk art aesthetic had become anachronous.

Such was the general situation in 1966 when Michael Hall first

discovered American folk art. In that year, on his way to the Museum of Modern Art, Hall stumbled into an exhibition on display at the Museum of American Folk Art. This show presented the then-standard fare of historical folk objects, but Hall experienced them in a new way. Unlike folk art collectors, but like the artists a half century before, Hall interpreted the folk art objects he saw in terms of their contemporary aesthetic meanings. Schooled in contemporary art, Hall viewed the historical objects he saw with an aesthetic sophistication then unique in the folk art field, a sophistication which would soon encourage him to include not only historical but contemporary objects in the category he would understand as folk art.

However, as an artist Hall was not alone in his new enthusiasm for folk art. Other contemporary artists were discovering folk art as well. Like the early modernists, contemporary artists in the sixties and seventies began to incorporate folk art into the fine art world where folk art soon became a force in the galleries and studios of Soho. Of all the artists who would encounter folk art, however, it was Hall who was the most taken with it, and whose activities would have the most impact on folk art understanding and collecting.

Yet from the beginning, as a sculptor known for his constructivist art, Michael Hall was an unusual folk art enthusiast. For unlike folk art, Constructivism represents an unequivocal confrontation with the technology of the modern world. Rejecting traditional organic notions of art, Constructivists like Hall assemble art by welding steel rather than by modeling clay or carving wood, in the typical manner of the folk sculptor. Radically contemporary, Constructivism has little in common with the setting, materials or historical ideology traditionally associated with folk art by collectors. Thus, from the time of his first folk art encounter, Hall was encouraged by his artistic background to disregard the romantic historical views and outdated aesthetic assumptions that dominated the folk art world. He sought to understand the objects he encountered in terms of the same aesthetic which gave meaning to his own sculpture and which would link his approach to folk art to that of students of material culture, who discovered folk art at about the same time.

Like the study of material culture, which seeks to understand the symbolic cultural significance of the artifacts humans make and use, Constructivism is an artistic attempt to comprehend, in aesthetic terms, the cultural meaning of contemporary space. A response to the technological and mechanized forces of modern society, and to the often awesome and architectural artifacts that are the result of these forces, Constructivism confronts the modern world by creating architectonic and abstract symbols which embody and represent modern technological meanings. Yet such

meanings are seldom straightforward or consistent, and because of this, as critic Donald Kuspit has remarked, Constructivism is often informed, at its best, by a dramatic tension.[1]

Pulled between asserting the cultural meaning of modern space (contemporary man's complex relationship with his physical, often technological and architectural environment), and with expressing its purely technical meaning (the reality of space in modern, technological terms) constructivist art responds to a system of value which keeps the cultural and technical in tense balance. Aesthetic value in this system arises through the artist's heroic expectation not only to present together social and formal meaning, but also to acknowledge and incorporate the contradictions that arise from such combinations. It is in this way that the artist moves beyond simply validating technological process or acknowledging already existing social meaning to assert his own modern self, by proposing, through the technique of his art, the nature of cultural identity.

Perhaps this is why Hall has come to call the aesthetic that he uses to understand folk art the "one man, one pocketknife" principle. It is an aesthetic which understands individuality in cultural context, and which balances the competing demands of the social and formal meanings of folk art in a contemporary, technological world. According to Hall:

> I'm not interested in cigar store Indians or factory decoys or assembly line carousel horses. I'm attracted to works in which you find some maker's affirmation of self— "I am"—reiterated again and again. The definition that I'm using really has to do with the declaration of self or the recognition of self in time and place. When that is stated in an art gesture with authority and confidence, it matters. When it finally becomes poetic and not replaceable, not interchangeable, then it's very compelling. That's my definition of art's place in culture. Collectively, it compiles and confirms our identity as creative beings. The folk artist does that. The fine artist does that for us also. (chap. 7)

This approach has lead Hall to consider folk art in a way that differs, in at least two marked ways, from the approach traditionally taken by folk art collectors. To begin with, instead of designating folk art and artists as "primitive," "childlike," "naive," or "untrained," the condescending but common terms generally used by collectors, Hall has insisted on placing folk and fine art on equal terms; an approach, he argues, not generally supported by art historical writings which display a fine art bias and consider folk art to be a lesser aesthetic form. For Hall the only real difference between folk art and fine art is that the former originates outside of the art world dominated by fine art values and activities. This does not mean, however, that folk art is not as socially significant as fine art or as aesthetically powerful as the work of the fine artist.

The power and achievement of folk art, according to Hall's view (just as the power and achievement of fine art) comes in large part from its "limitations," from the way in which it grapples both socially and formally with the important, human issues of the culture in which it is created. This is why Hall is so taken with the Appalachian wood-carver Edgar Tolson, whom Hall first met in 1967, and whom Hall admires as a great American artist. For, in Hall's mind, it was precisely Tolson's "limitations" that made him the artist he was. Confronting the specific human concerns of his own society with the techniques and mediums culturally available to him, Tolson courageously created forms to contain and comprehend these concerns.

The second way in which Hall's approach to folk art differs from that of most collectors is connected to the first. It is his insistence that the aesthetic meaning of art is connected to, rather than disassociated from, art's social context. Just as aesthetic value entails the necessary combination of social and formal meanings for Hall as a constructivist sculptor, so for him as a folk art collector aesthetic issues cannot be discovered by removing folk objects from social context and considering only their line, design, and form. In the last essay of this volume, "The Bridesmaid Bride Stripped Bare," Hall makes this point very clear as he writes about a number of contemporary social issues which illuminate the aesthetic significance and cultural urgency of contemporary folk art. By taking such a position Hall is making a claim not unlike that made by many folklorists and students of material culture who have, in the last years, criticized folk art collectors for their propensity to comprehend folk art only on their own limited aesthetic terms. These same critics have, at times, confused Hall with other collectors, an unfortunate mistake since Hall has consistently labored against the decontextualization of folk art in the name of aesthetics.

> I am . . . at this point in my life as an artist and as a collector honestly persuaded that art's real value is social. The aesthetic experience, whatever it may be, is tied to understanding and perception. Art allows us to see ourselves in a cultural context. (chap. 15)

In the end, Hall's relationship with folk art and folk art collecting is shaped by his identity as an artist. Rather than simply a collector of folk art, he sees himself as an artist/collector, one who "puts his collecting into the service of the specific act of art making" (chap. 8). In this perspective Hall's building of a folk art collection can be viewed in terms of the same constructivist sensibility that generates his sculpture and influences the essays in this volume. All have been assembled by the careful

juxtaposition of disparate parts, parts which combine and contradict each other to create a textured and, at times, ambivalent reaction to the forms and ideas that would contain them.

Hall's sculpture sets the model. Although it first appears to celebrate the technological, modern world whose materials and techniques it utilizes, the sculpture often cuts the other way. Described by some critics as "anti-monumental," Hall's sculpture can ironically contradict the very architectural and social norms from which it seems to derive. The sculpture questions the meaning of technological culture and art by emphasizing their potential shallowness and lifelessness. In Hall's work massive fabricated forms seem, at times, unstable in their monumentality. Presenting simultaneously both a solid, planar front and the naked steel skeleton that props it up from behind and underneath, his sculptures are monuments to the duality of modern experience, to the image and the reality of technological accomplishment.

Hall's folk art collection can be viewed in a similar way. For it contradicts and subverts the values and system that support its acclaim. As an artist and a folk art collector (especially a well known collector of *contemporary* folk art) Hall is in a ironic, but not historically unique, position. Like the artist collectors of the early twentieth century, he has seen the new folk art that he (and other artists) discovered become a popular phenomenon. Today, partially as a result of Hall's own activity as a lecturer and teacher, contemporary American folk art is an increasingly accepted and collectible commodity. Yet, as was the case a half-century earlier, when folk art became a part of the popular domain of art collectors, its popularization has been a mixed blessing.

The introduction of contemporary objects into the poorly defined and overcrowded category of folk art exacerbated the already serious problem of knowing what folk art really is. Suddenly, not only such unrelated objects as old weather vanes and quilts, limner portraits and children's toys were said to be folk art, but so too were neon signs and mechanical men, tattoos and the disturbed daubings of schizophrenics. Moreover, while historical folk art collectors at least had the outdated aesthetic system of early modernism to support their aesthetic preferences, collectors of contemporary folk art have appropriated, or developed, no such system to help them agree on what kinds of objects they would collect or how these objects would be evaluated. They did, however, often agree on one thing, that contemporary folk objects could best be evaluated as art by removing them from their social context. Indeed, one popular way of comprehending certain kinds of contemporary folk art completely denies its cultural connection. Often calling this art (the work of visionaries or the institutionalized) isolate or outsider art,

proponents of this approach argue that such objects are the result of pure individual creativity and develop outside of culture, beyond any knowable social context.

Hall's folk art collection stands as an ironic anti-monument to such developments. Containing a number of acknowledged masterworks of nineteenth- and twentieth-century American folk art, the collection represents the standards by which folk art is known and evaluated, and would seem to confirm the significance and value of the collector's vision. Yet there are subtle contradictions. Among the large group of duck decoys are a batch of "flattie" shore birds which do not conform to collector criteria. Of interest largely because they are part of a complete gunning rig, they encourage not an examination of aesthetic form or the techniques of bird carving, but the activity of hunting, a preoccupation not only of the American common man endeavoring to put food on the table but also of wealthy sportsmen who have, in recent years, spent hundreds of thousands of dollars to collect duck decoys and turn them into art. Such economic issues should not be overlooked in a field such as folk art where rich collectors believe that they are supporting the power and vision of the common man by appropriating, and often profiting by, his utilitarian artifacts for their own aesthetic use.

Another interesting object in the Hall collection is equally ironic—a large, technically refined, and sophisticated looking picture of a nude woman, painted by an immigrant artist in Chicago, D. P. Skyllas. Despite the fact that Skyllas was never trained in academic or commercial artistic skills, his painting looks remarkably finished, even slick. It simply does not "look" like the somewhat awkward and ill-proportioned paintings generally associated by collectors with American folk art. Indeed, it bears more resemblance to the flashy and refined popular or commercial art that often appears in magazine advertisements. Is Skyllas's work folk art or not? Its inclusion in the Hall collection should cause collectors to puzzle over the categories they use to define and understand folk art.

However, it is not only the individual pieces in the Hall collection which may contradict accepted notions about folk art and folk art collecting, it is the collection as a whole. Containing a remarkably wide range of objects, it testifies not simply to the breadth and scope of the human impulse to make aesthetic objects, but also to many folk art collectors' inability to distinguish the qualities which could separate such objects into smaller, and more comprehendible, categories. In this way the collection represents, as a whole, not a coherent image of a unified, democratic nation as viewed through its art, but instead the possibility of an America unable to accept, or come to grips with, its multiplicity, and fundamentally divided by issues like class, race, ethnicity, and region.

Despite the eclectic nature of Hall's folk art collection there is a unity to his aesthetic vision, one which informs not only his folk art collecting, but also his sculpture and the essays in this book. At the center of all Hall's work is his concern with examining and testing the boundaries of the containers, whether physical or intellectual, we use to organize and integrate our experience. As a sculptor Hall builds systems of enclosure, massive modern spaces which vaguely remind us of everyday objects like boilers or grain bins, but which force us, through their radical and unexpected structural discontinuity, to reexamine the intangible ways in which the modern world and its technology materially circumscribe our lives. As a folk art critic and collector, Hall has acted in a similar way by helping to construct yet another container, one which encompasses contemporary objects as folk art. In this effort, as in his sculpture, Hall's work has been subversive, contesting the very folk art norms and values that would seem to support his accomplishment.

According to critic Robert Pincus-Witten, Hall's most important contribution to sculpture has been his reassessment of the constructivist tradition, a tradition prone in recent decades to simply validating, instead of critically examining, the modern technological world.[2] In the same way, Hall's most remarkable effort as a folk art collector and critic has involved his reevaluation for collectors of the concept of American folk art, an art form which has, for too long, been irrelevant to contemporary life.

Notes

1. Donald B. Kuspit, "Michael Hall: Revitalizing Constructivism," exhibition catalogue (Windsor, Ontario: Art Gallery of Windsor, forthcoming).

2. Robert Pincus-Witten, *Eye to Eye: Twenty Years of Art Criticism* (Ann Arbor, Michigan: UMI Research Press, 1984), pp. 109–17.

Eugene W. Metcalf
August 1987

Index